CORAL

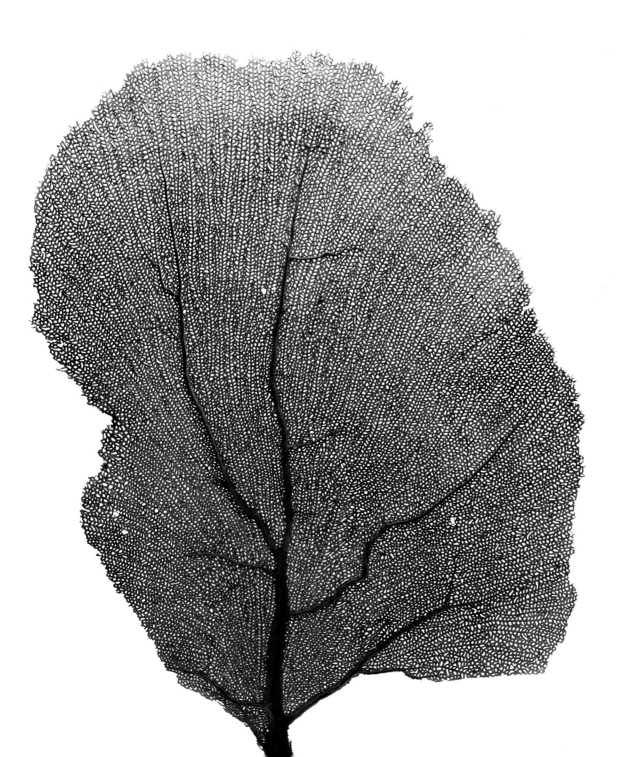

CORAL

Something Rich and Strange

Edited by
Marion Endt-Jones

First published 2013 by
Liverpool University Press
4 Cambridge Street
Liverpool
L69 7ZU

British Library Cataloguing-in-Publication data
A British Library CIP record is available

ISBN 978-1-84631-959-4

Designed by Carnegie Book Production
Printed and bound in the UK by Henry Ling Ltd

Cover: Leopold and Rudolf Blaschka, Glass model of
Corallium rubrum, 1879. Photo: Stuart Humphreys.
Courtesy Australian Museum – AMS582/MA00777.

Halftitle page: Figure 1: Sea fan (*Gorgonia albicans*),
Manchester Museum, Zoology collection. Photo: Paul Cliff.

Title page: Illustration of Great Barrier Reef corals, in
William Saville-Kent, *The Great Barrier Reef of Australia:
Its Products and Potentialities* (London: W.H. Allen, 1893),
colour plate VIII, detail.

Supported by:

BRITISH ACADEMY
for the humanities and social sciences

Contents

Acknowledgements

I would like to thank the following institutions and individuals for making *Coral: Something Rich and Strange* possible:

An 18-month Henry Moore Foundation Postdoctoral Fellowship first 'led my eyes and mind to seeing and thinking under water' (to borrow Etienne-Jules Marey's words). Alongside the HMF, I would like to express my gratitude to the British Academy, who funded my research project 'A Cultural History of Coral, *c.* 1850–2010' during a three-year Postdoctoral Fellowship. This publication was further supported by a British Academy/Leverhulme Small Research Grant. David Lomas, Dawn Ades and Carol Mavor have provided continuous encouragement and inspiration throughout my doctoral and postdoctoral research.

The expertise and generosity of all the authors who contributed texts to this book have truly enriched it.

At Manchester Museum, Dmitri Logunov, Sam Sportun and Gillian Smithson have provided invaluable support. I would also like to thank Nick Merriman, Henry McGhie and Stephen Walsh, as well as all the curators who advised me on coral-related objects from their collections and all other members of staff involved in exhibition preparations.

Thank you to all the institutions and individuals who generously agreed to lending objects to the show: Gemma Anderson, The Bowes Museum, The Fitzwilliam Museum, Frac Franche-Comté, Georg Kargl Fine Arts, Hauser & Wirth, Manchester Art Gallery, The Matthiesen Gallery, Andrew Murray, Museum of Archaeology and Anthropology, The National Gallery, Pitt Rivers Museum, Royal Albert Memorial Museum & Art Gallery, The University of Edinburgh Art Collection, The University of Manchester Library, V&A and Whitworth Art Gallery.

Thank you also to all the institutions and individuals who granted permission to reproduce images.

Renee Coppola at Tanya Bonakdar Gallery, New York, and Anna Mayer at the Institute for Figuring, Los Angeles, helped with organizing the commission of a new work from Mark Dion and a Manchester Crochet Coral Reef. Thank you also to Karen Casper, who has created a new piece for the exhibition.

Alison Welsby at Liverpool University Press has been extremely enthusiastic and helpful in bringing the book to publication.

And to my family and Evan Jones – 'thank you' does not begin to cover it.

Marion Endt-Jones
Manchester, July 2013

Foreword

When we were approached with the idea of developing *Coral: Something Rich and Strange* at the Manchester Museum, we jumped at the chance, as it is a theme that is ideally suited to us. The Museum's collections comprise over 4 million items covering both natural sciences and human cultures, and our twin objectives are to develop greater understanding between cultures and to promote a more sustainable world. The highly collaborative and cross-disciplinary framework within which the project has been developed fits very well with our own ethos.

We are also the UK's largest university museum, and our exhibition programme is largely focused on bringing the results of current academic research in the University of Manchester to a wider public. As Marion Endt-Jones's 'Coral' research project has been undertaken within the University's School of Arts, Languages and Cultures, we very much wanted the Museum to be able to showcase the results of this important project within our own institution.

The breadth and depth of our collection means that we have been able to source a significant amount of the material for the exhibition from our own resources. We have also benefited from important loans from our sister institution within the University, the Whitworth Art Gallery, and from the Manchester Art Gallery, as well as a whole series of loans from national and international institutions. This has meant that – perhaps uniquely – the exhibition brings together superb natural specimens with outstanding cultural artefacts and works of art.

As with any similar project, the exhibition is simply the most visible element of a much more complex enterprise, including a wide-ranging public programme, activities for schools and this accompanying publication, which will comprise the more long-lasting legacy of the work.

We very much hope that the book, as well as the exhibition and associated programme, will help to raise awareness of the beauty and rich cultural history of coral, and of the need for protecting coral reefs and other marine habitats.

Nick Merriman
Director
Manchester Museum

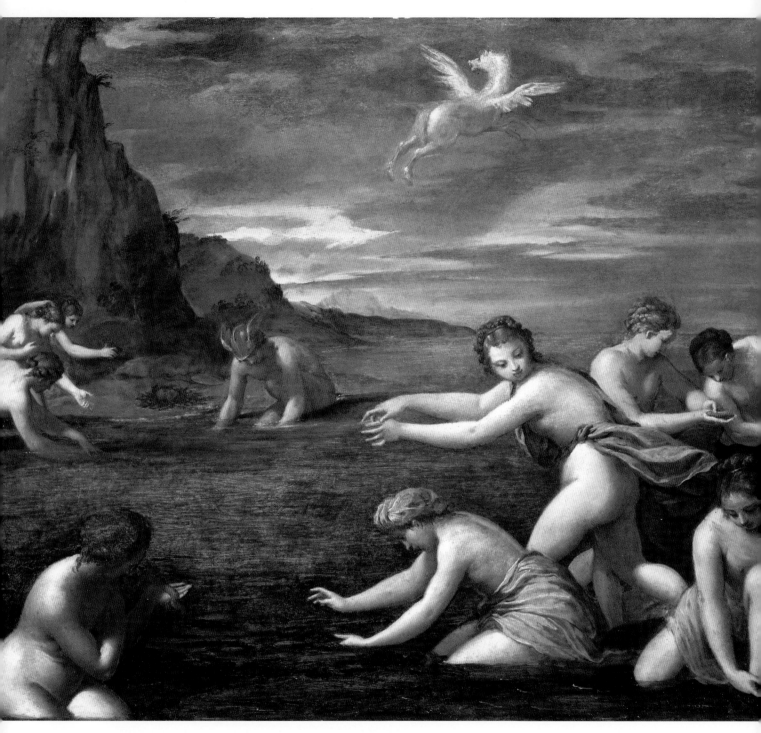

Figure 2: Ippolita
Scarsello, called
Scarsellino (1550–1620),
The Discovery of Coral, oil
on canvas, 41.5 × 50 cm.
Courtesy The Matthiesen
Gallery, London.

"Full fathom five thy father lies;
Of his bones are coral made;
Those are pearls that were his eyes:
Nothing of him that doth fade
But doth suffer a sea-change
Into something rich and strange."

William Shakespeare, *The Tempest*, 1611

Introductory Essay
A monstrous transformation: coral in art and culture

Marion Endt-Jones

The use of coral as a material and symbol is recorded in art and culture since antiquity. Throughout the centuries, different communities and cultures have valued coral for its transformative qualities. In Book IV of his *Metamorphoses*, the Roman poet Ovid describes coral's creation myth as a monstrous transformation: after Perseus has freed Andromeda from the clutches of the sea monster that held her captive, he proceeds to wash the traces of the battle from his hands. Placing the head of the horrible Gorgon Medusa, whom he defeated by using his shield as a mirror to ward off her petrifying gaze, on a bed of seaweed, the plants immediately take on the colour of the blood dripping from Medusa's snake-infested head; as they absorb the dwindling power of the Gorgon's petrifying gaze, the plants harden and turn into coral, branches of which the sea nymphs scatter all across the sea (fig. 2). Thus the process of metamorphosis is inscribed in coral at the moment of its monstrous birth; the object's adaptability and intrinsic vital force become a topos that will remain inspirational for artists and writers for centuries to come.

Christian coral

Indeed, the myth of Perseus and Medusa remained essential for the iconography and reception of coral until well into the twentieth century. Used according to popular belief for protection against the evil eye and other kinds of misfortune, coral's blood red colour and its capacity for transformation and renewal became in Christianity a symbol for the passion and resurrection of Christ. Both motifs are combined in representations of Baby Jesus with a coral necklace, which are common in illuminated manuscripts from the twelfth century and, from the fourteenth century onwards, especially in Italian and Dutch panel painting (fig. 3). In these paintings, the infant's necklace is often complemented by intricately branching coral pendants, which, showcasing the natural, tree-like ramifications of coral, symbolize the biblical tree of knowledge, the tree of life, the crucifixion of Christ and the root of Jesse, Jesus's royal lineage from the House of David. Similarly, rosaries (fig. 4), crucifixes, statues of saints and other devotional objects, crafted from the crimson red, precious Mediterranean coral (*Corallium rubrum*), refer to the blood and the passion of Christ on the one hand and signify the transubstantiation – the literal transformation of bread and wine into the body and blood of Christ – as well as the resurrection and eternal life on the other. Ovid's myth of origin and, likewise, Pliny the Elder's descriptions of coral as a marine plant that, once fished out of the water, hardened to stone,[1] had made of coral a symbol of vital forces; as a living being that bridged the elements of water and air as well as the vegetable and mineral kingdoms of nature, it stood for conversion to mineral perfection and for durability of all that was organic and ephemeral.

1 Pliny, *The Natural History*, vol. 6, trans. John Bostock and H.T. Riley (London: Henry G. Bohn, 1857), p. 11.

Overleaf: Figure 3: Giovanni Santi, *The Virgin and Child*, c. 1488, egg and oil on wood, 68 × 49.8 cm. © The National Gallery, London.

Page 11: Figure 4: Maerten van Heemskerk, *Portrait of Margaretha Banken*, 1540–1542, oil on panel, 89.5 × 72.3 cm. Photo: Alan Seabright. © Manchester City Galleries.

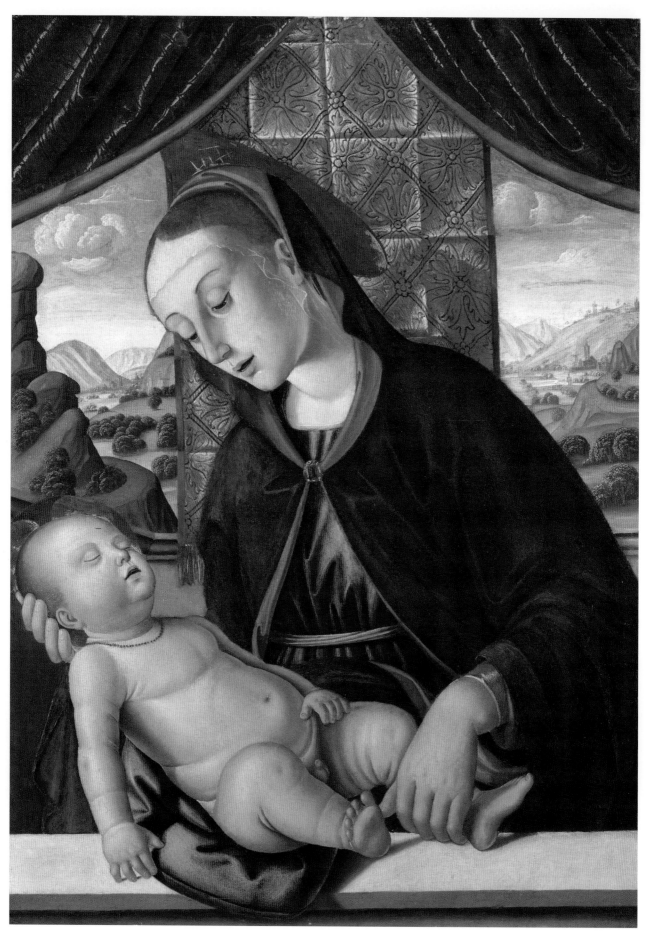

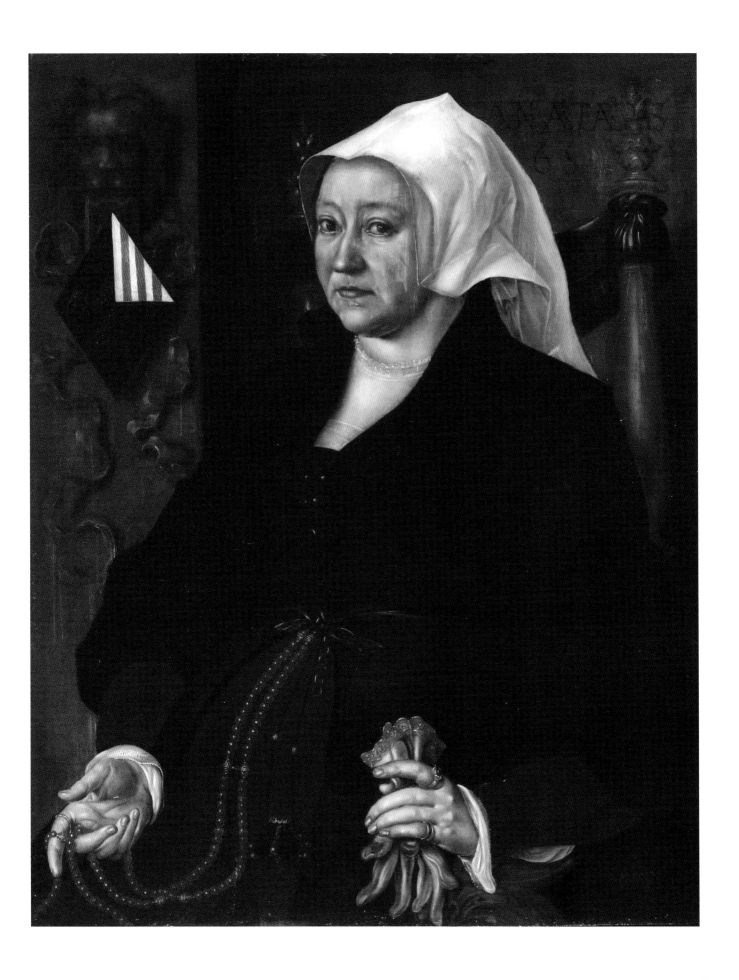

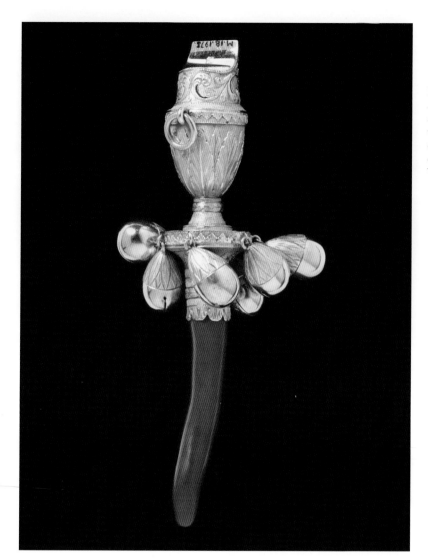

Figure 5: John Ray and James Montague, Rattle and whistle, 1811–1812, varicoloured gold with coral, h.: 11.4 cm, w.: 3.2 cm, d.: 3.2 cm. Courtesy V&A, London.

Coral magic

While the religious symbolism of coral reached its peak in the late Middle Ages and early Renaissance, vernacular beliefs in its apotropaic and therapeutic properties survived for centuries to come. Even today, one can find key chains and small lucky charms with red *cornetti* dangling from them in Italian *Tabacchi*, but usually the red coral, which is now under threat by overfishing, diving tourism, pollution and global warming, has been replaced by cheap plastic. The alleged effectiveness of coral against the evil eye can be traced back to the legend of Perseus and Medusa; that it was also used as miraculous cure-all and powerful talisman is recorded in a wealth of late Classical, Arabic and medieval sources ranging from mineralogical to alchemical treatises. Thus Camillo Leonardi praises coral in his *Speculum Lapidum*, which first appeared in print in Venice in 1502, as a 'wonderful prophylactic' which, worn on the body or hung in the home or boat, dispels ghosts, demons, shadows, illusions, nightmares, lightning, unfavourable winds, storms and wild animals. Administered crushed and diluted in wine, coral was also said to stop blood flow, alleviate diseases of the stomach and heart, and treat ulcers of the spleen, stones in the urinary tract and receding gums. Scattered across the fields with the seeds or hung between the branches of fruit trees, coral was supposed to guarantee a plentiful harvest and to protect the crop from damage by hail storms; if swallowed regularly from early age, it was also believed to prevent a child from developing epilepsy.[2] A medical treatise, which was printed in Strasbourg in 1576 and mainly collated from writings by Arnaldus de Villanova, Ramon Llull und Johannes de Rupescissa, attested coral efficacy against 'melancholic fantasy', painful teething, discolouration of the teeth,

2 Camillo Leonardi, *Speculum lapidum* (Venice, 1502).

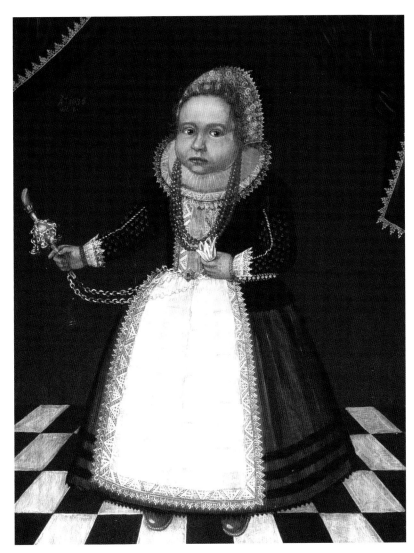

Figure 6: Unknown (Dutch), *Portrait of a Child with a Coral*, 1636, oil on panel, 89.4 × 68.4 cm. Courtesy The Bowes Museum, Barnard Castle, County Durham.

haemorrhoids and infertility. Depending on symptoms, coral powder could be dissolved and administered in rainwater, rose water, warm milk, warm wine or lime juice.[3]

Such a pronounced and unconditional belief in coral's miraculous healing powers increased its use value as a lucky charm, especially for children. All across early modern Europe, rattles mounted with a teething ring or teething piece made from coral on one end and bells or a whistle on the other proliferated as popular christening gifts, since they served as toy and lucky charm in one (fig. 5). If such a talisman then found its way onto a painted portrait of the child, the precious coral set in silver or gold confirmed at the same time the family's wealth and social status (fig. 6).

"…and he knew…that there is no more effective way to break the spell of tradition than to cut out the 'rich and strange,' coral and pearls, from what had been handed down in one solid piece."

Hannah Arendt,
'Walter Benjamin: 1892–1940', 1955

3 Arnaldus de Villanova, Heinrich Wolff, Giovanni Braccesco, Wolff Geuss, Johannes de Rupescissa, Ramon Llull and Johann Vogt, *Herliche medicische Tractat* (Strasbourg: Bernhart Jobin, 1576).

Coral curiosities

Due to their apotropaic effects, their transformative powers and their bizarre shapes and patterns, corals took pride of place in sixteenth- and seventeenth-century cabinets of curiosities. According to its inventory, the Medici collection in Florence, for example, contained a branch of coral that continued to grow[4] – a potentially ever-expanding, excessive, infinite object that eternally defied categorization and containment and aroused both fear and fascination. For collectors, polymaths, dukes and merchants, the particular value of coral, which was still widely mistaken for an aquatic plant and consequently listed in collection catalogues as 'sea tree', 'sea oak', 'sea weed' or 'sea shrub', lay in its rarity, which was further increased because harvesting it from the depths of the sea held considerable risks – a status attributed, for similar reasons, to pearls, amber and ambergris. Moreover, the value of coral could be enhanced by elaborate craftsmanship combining it with the precious metals, gold and silver. Crafting decorative cups, caskets, small statues and similar *kunstkammer* objects, artisans and their clients often exploited the grotesque, intricately branching structure of the coral twigs in order to represent similar natural phenomena such as trees or antlers. The Green Vault in Dresden, the treasury of Augustus II the Strong, Elector of Saxony, for example, holds a drinking cup which illustrates another metamorphosis recorded by Ovid: the nymph Daphne, who, in order to escape the God Apollo's amorous advances, turns into a laurel tree (fig. 7). Both the arborescent growth of coral and its alleged metamorphosis from a supple aquatic plant into a hard precious mineral ideally lent themselves to illustrating such transformation myths. At the same time, the collector's item, skilfully crafted by the Nuremberg goldsmith Abraham Jamnitzer after a design by his father Wenzel, expressed the rivalry between human virtuosity and God's boundless creative power, which was believed to be especially evident in rare, precious natural phenomena like coral.

Although the Daphne cup is now regarded as an object intended purely for display without any concrete purpose assigned to it, scholarship assumed for a long time that the electoral household had used it as *Natternzungenkredenz*, or 'Viper's Tongues Credence'. The base of such 'poison indicators', which were placed at the centre of the dining table, usually consisted of a drinking vessel or salt cellar with a coral branch mounted on top (fig. 40). Fossilized shark teeth hanging from the coral twig – believed at the time to be viper's or dragon's tongues – were supposed to reveal spoiled food: since popular belief had it that the 'viper's tongues' began to 'sweat' in vicinity to toxic substances, the dinner guests would remove them from the table ornament in order to dip them into their drink and hold them above their meal – a practice called 'dare la credenza', which gave the object its name. Alongside the coral, which acted as a prophylactic, apotropaic talisman on the one hand and as a potential antidote to food poisoning on the other, 'viper's tongues' offered a supreme combination of protective and healing magic.

Figure 7: Abraham Jamnitzer, Statuette of Daphne, late sixteenth century, silver (mostly gilt) and coral, h.: 68 cm, Green Vault. Photo: Jürgen Karpinski. Courtesy Staatliche Kunstsammlungen Dresden.

4 Joy Kenseth (ed.), *The Age of the Marvelous* (Hanover, New Hampshire: Hood Museum of Art, Dartmouth College, 1991), p. 82.

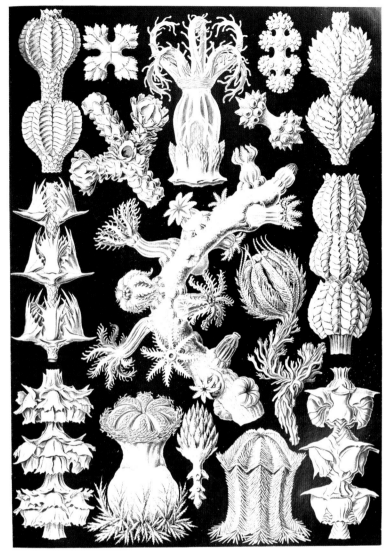

Gorgonida. Rindenkorallen.

Figure 8: Ernst Haeckel, *Gorgonida*, in *Kunstformen der Natur* (Leipzig and Vienna: Verlag des Bibliographischen Instituts, 1904), plate XXXIX.

"At once pet, ornament, and 'subject for dissection', the Sea-anemone has a well established popularity in the British family-circle; having the advantage over the hippopotamus of being somewhat less expensive, and less troublesome, to keep."

George Henry Lewes, *Sea-Side Studies at Ifracombe, Tenby, The Scilly Islands and Jersey*, 1858

Coral animals

With the advent of the Enlightenment in the second half of the seventeenth century, ancient traditions and superstitions increasingly gave way to scientific accuracy. Encyclopaedic cabinets of curiosities and 'wonder chambers' were replaced by specialized museums accessible to the newly formed, educated middle classes. These public institutions no longer displayed the unique and extraordinary, but showed exemplary objects representative of the constant evolution and progress of 'civilized' mankind. Using recently developed technical innovations such as the microscope, researchers attempted to get to the bottom of natural phenomena and advanced into environments that had previously been regarded as unreachable. At last, marine organisms such as coral were not only

fished out of the water and examined as pallid, stiff skeletons on the dissecting table, but also observed as living beings in their natural habitat under water.

Whether coral should be attributed to the vegetable, mineral or even animal kingdom remained controversial among naturalists up until the mid-eighteenth century. In the end, it was Jean-André Peyssonnel from Marseille who proved once and for all in a series of essays presented to the Académie des Sciences in Paris in 1726 that corals are 'inhabited' and produced by small creatures, polyps, which he called 'insects' – then a common term for small invertebrates. The idea that the alleged plants were in reality 'zoophytes' or 'animal-plants' first came to him during excursions he took with coral fishermen

off the coast of Marseille; back on shore, he substantiated his observations through a series of experiments in which he picked single polyps from their cups with his fingernail in order to slice them, plunge them into boiling water and douse them with acid liquids.[5] His discovery was so groundbreaking that it took some time for it to become accepted by fellow researchers and to catch on in the public imagination.

The notion of coral as a marine plant and a gemstone used for jewellery is still obstinately present in the public consciousness: as a marine organism that is eyeless, colony-building, reproducing sexually and asexually and living in symbiosis with photosynthetic microscopic algae, so-called zooxanthellae, it is extremely difficult to grasp. In his treatise on the *Corals of the Red Sea*, published in Germany in 1876, the zoologist and popularizer of science Ernst Haeckel relates an anecdote which bears witness to the still prevailing confusion about the nature of coral. Triggered by the magnificent coral necklace worn by a lady during a social gathering, a dispute arouse about the nature of the 'red gemstone'. While some wanted it understood as 'the rock-hard fruit of an Indian tree', others attributed it, like pearls, to the genre of 'sea plants'. A third group, getting closer to the truth, declared it a stony animal shell. Haeckel's assertions that the red, precious coral was in fact the inner skeleton of a composite animal colony, which had been abandoned by its inhabitants, caused considerable consternation.[6]

Aquarium mania

As Haeckel suggested in *Corals of the Red Sea*, 'every single coral colony is, in fact, a small zoological museum.'[7] The invention and spread of public and domestic aquariums in the middle of the nineteenth century allowed researchers and the interested public to examine these 'miniature museums' up close – colourful living creatures in their natural habitat rather than pale, rigid specimens in actual museums or on the dissecting table.

In rapid succession, a series of natural history crazes swept through Victorian Britain (and, with a slight delay and less fervour, through continental Europe): studying and collecting the natural world was no longer reserved for experts and members of the academies and professional societies, but became a popular pastime accessible to young and old, rich and poor, and male and female alike. Thus the explosion of interest in the aesthetic and decorative qualities of sea shells ('conchyliomanie', as the French dubbed it) was eventually replaced by 'fern fever' (pteridomania), a passion for seaweeds, an obsession with orchids and a widespread craze for 'miniature oceans'.

Popularizers of natural history like Haeckel were partly responsible for introducing corals and other marine organisms like radiolaria and siphonophores – brought to life in Haeckel's beautiful drawings – to the public consciousness (fig. 8). In Great Britain, the naturalist Philip Henry Gosse's books on the habits and habitats of marine life, such as *A Naturalist's Rambles on the Devonshire Coast* (1853) and *The Aquarium: An Unveiling of the Wonders of the Deep Sea* (1854), were published in several lavishly illustrated editions aimed at a mass audience (fig. 56).

Although experiments with both fresh- and saltwater tanks had been carried out before, Gosse was the first to use and establish the term 'aquarium' in 1854: 'The MARINE AQUARIUM...bids fair...to make us acquainted with the strange creatures of the sea, without

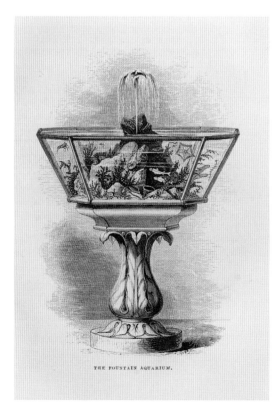

Figure 9: Philip Henry Gosse, *The Fountain Aquarium*, illustration from *The Aquarium: An Unveiling of the Wonders of the Deep Sea* (1854).

5 Jean-André Peyssonnel, 'Traité du corail, contenant les nouvelles découvertes...', *Philosophical Transactions of the Royal Society*, 47 (1751), pp. 445–69.

6 Ernst Haeckel, *Arabische Korallen: Ein Ausflug nach den Korallenbänken des Rothen Meeres und ein Blick in das Leben der Korallenthiere* (Berlin: Georg Reimer, 1876), p. 2.

7 Haeckel, *Arabische Korallen*, p. 34.

Figure 10: 'Sea-Side Studies!', cartoon from *Punch Magazine*, 38.17 (1860).

diving to gaze on them.'[8] With their characteristic blend of scientific description, religious fanaticism and practical instructions for setting up and maintaining tanks in the home, Gosse's books firmly established the 'sea in the glass' as a parlour attraction and promoted 'rock-pooling' and 'anemonizing' as recreational activities for everyone (figs 9 and 10). Different coral species, such as the honeycomb coral, Gosse explained, were ideal aquarium residents, not only because of their aesthetic appeal, but also because they attracted a 'variety of animals which make their abode in its ample winding chambers.'[9] The result was a lively, colourful scene – a moving work of art that never ceased to arrange itself into new formations and invited the onlooker's imagination to roam. Consequently, for the protagonists of *fin-de-siècle* novels and poems, such as Jean des Esseintes in Joris-Karl Huysmans's *Against Nature* (1884), the aquarium served as a springboard for an overflowing, decadent and narcissistic imagination.[10]

Whereas reef-building corals, known since Charles Darwin's theory of coral reef formation as virtuous architects tirelessly toiling for the common good, had been described as embodying industriousness and hardiness, sea anemones and cold-water corals native to the seas around the British Isles struck the owners of and visitors to aquariums as rather odd. Even as George Henry Lewes assured the British public in 1856 that the sea anemone was a less expensive and troublesome pet to keep than a

hippopotamus,[11] the creatures' voraciousness and reproductive habits were often perceived as repulsive and promiscuous; the grace and beauty of the 'animal-flowers' could not detract from their perceived monstrosity (fig. 11).

Occasionally, the 'sea monsters' managed to upset an entire household. Thus Gosse reports in his *History of the British Sea-Anemones and Corals* (1860) how the sight of a sea anemone devouring a young conger eel drove his little son to tears; the beast, which suddenly seemed to consist of nothing but a giant, cavernous mouth, becomes in Gosse's account the epitome of merciless gluttony.[12] Similarly, John Harvey, in his aquarium manual of 1858, describes an incident with a maid who screamed upon seeing the sea anemone tank: 'O pleassir, do come and look, the enemy…is a turning hisself inside out!'[13] The marine zoologist Anna Thynne notes a similar episode in her research diary: returning to the house after a few days of absence, she found her madrepores surrounded by small piles of stones; her servants, flabbergasted by the creatures' asexual reproduction through splitting, had tried to stop them 'coming to pieces.'[14]

The 'grotesque' natural characteristics of sea anemones and corals profoundly challenged the prevailing classifications of gender and species, playing into subliminal fears of a society whose belief in supposedly 'established truths' about origin, sex and religion had begun to falter in the light of modern developments. Like all fads, the aquarium wave ebbed away in the 1860s – but the desire to transport a slice of the ocean to the living room, or to experience a taste of wilderness in the safe surroundings of a 'shark tunnel', continues to the present day.

Endangered coral

For French artists and writers of the *fin-de-siècle*, Symbolist poets, and some members of the Surrealist group, coral remained of interest because of its boundary-transgressing qualities on the one hand and its associations with metamorphosis and creativity on the other. As the product of an instinct-driven communal being, which had sprung from the ocean,

8 Philip Henry Gosse, *The Aquarium: An Unveiling of the Wonders of the Deep Sea* (London: Van Voorst, 1854), p. vii.

9 Gosse, *The Aquarium*, p. 121.

10 Joris-Karl Huysmans, *Against Nature* (Oxford: Oxford University Press, 1998).

11 George H. Lewes, *Sea-Side Studies at Ilfracombe, Tenby, The Scilly Isles and Jersey* (London: William Blackwood and Sons, 1858), p. 115.

12 Philip Henry Gosse, *Actinologia Britannica: A History of the British Sea-Anemones and Corals* (London: Van Voorst, 1860), pp. 165–66.

13 Quoted in Rebecca Stott, 'Through a Glass Darkly: Aquarium Colonies and Nineteenth-Century Narratives of Marine Monstrosity', *Gothic Studies*, 2.3 (2000), pp. 305–27, here p. 307.

14 See Stott, 'Through a Glass Darkly', p. 307.

Plate IV.

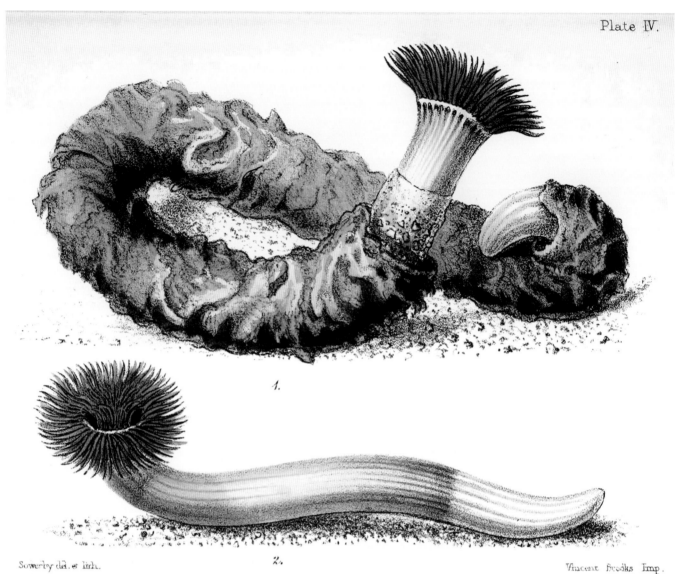

Sowerby del. et lith.

1.

2.

Vincent Brooks Imp.

Figure 11: Illustration of Edwardsia vestita, 'clothed with its leathery coat' (above) and 'withdrawn' (below), in George Brettingham Sowerby, *Popular History of the Aquarium of Marine and Fresh-water Animals and Plants* (London: Lovell Reeve, 1857), plate IV.

This worm-shaped sea anemone was first described by Edward Forbes in 1841 as a 'very voracious feeder' which constructs a membranous tube encrusted with gravel and shells for protection.

the cradle of life, it embodied the ideal of an imaginative art created by unconscious forces (figs 64–67). Works by contemporary artists like Hubert Duprat (fig. 71), Mark Dion (figs 40 and 72) or Margaret and Christine Wertheim of the Los Angeles-based Institute for Figuring (figs 78–81) now playfully suggest that we are putting this rich tradition of corals in art and culture at risk by overfishing, polluting and acidifying the oceans.

References

David Allen, 'Tastes and Crazes', in Nicholas Jardine, James A. Secord and Emma C. Spary (eds) *Cultures of Natural History* (Cambridge: Cambridge University Press, 1996), pp. 394–407.

Jan Baptist Bedaux and Rudi Ekkart (eds), *Pride and Joy: Children's Portraits in the Netherlands, 1500–1700* (Ghent: Ludion Press, Harry N. Abrams, 2001).

Horst Bredekamp, *Darwins Korallen: Die frühen Evolutionsdiagramme und die Tradition der Naturgeschichte* (Berlin: Verlag Klaus Wagenbach, 2005).

Bernd Brunner, *The Ocean at Home: An Illustrated History of the Aquarium*, trans. Ashley Marc Slapp (London: Reaktion Books, 2011).

Philip Henry Gosse, *Actinologia Britannica: A History of the British Sea-Anemones and Corals* (London: Van Voorst, 1860).

Philip Henry Gosse, *The Aquarium: An Unveiling of the Wonders of the Deep Sea* (London: Van Voorst, 1854).

Philip Henry Gosse, *A Naturalist's Rambles on the Devonshire Coast* (London: Van Voorst, 1853).

Ernst Haeckel, *Arabische Korallen: Ein Ausflug nach den Korallenbänken des Rothen Meeres und ein Blick in das Leben der Korallenthiere* (Berlin: Georg Reimer, 1876).

Ernst Haeckel, *Art Forms in Nature* (Munich: Prestel, 1998).

Joris-Karl Huysmans, *Against Nature* (Oxford: Oxford University Press, 1998).

Steve Jones, *Coral: A Pessimist in Paradise* (London: Little, Brown, 2007).

Joy Kenseth (ed.), *The Age of the Marvelous* (Hanover, New Hampshire: Hood Museum of Art, Dartmouth College, 1991).

Camillo Leonardi, *Speculum lapidum* (Venice, 1502).

George Henry Lewes, *Sea-Side Studies at Ilfracombe, Tenby, The Scilly Isles and Jersey* (London: William Blackwood and Sons, 1858).

Celeste Olalquiaga, *The Artificial Kingdom: On the Kitsch Experience* (Minneapolis: University of Minnesota Press, 2002).

Jean-André Peyssonnel, 'Traité du corail, contenant les nouvelles découvertes…', *Philosophical Transactions of the Royal Society*, 47 (1751), pp. 445–69.

Pliny, *The Natural History*, vol. 6, trans. John Bostock and H.T. Riley (London: Henry G. Bohn, 1857).

Marcia Pointon, *Brilliant Effects: A Cultural History of Gem Stones and Jewellery* (New Haven and London: Yale University Press, 2009).

Callum Roberts, *Ocean of Life: How Our Seas are Changing* (London: Allen Lane, 2012).

Maurice Saß, 'Gemalte Korallenamulette: Zur Vorstellung eigenwirksamer Bilder bei Piero della Francesca, Andrea Mantegna und Camillo Leonardi', *Kunsttexte*, 1 (2012), pp. 1–53.

Jonathan Smith, *Charles Darwin and Victorian Visual Culture* (Cambridge: Cambridge University Press, 2006).

Rebecca Stott, 'Through a Glass Darkly: Aquarium Colonies and Nineteenth-Century Narratives of Marine Monstrosity', *Gothic Studies*, 2.3 (2000), pp. 305–27.

Giovanni Tescione, *Il Corallo nelle arti figurative* (Napoli: Fausto Fiorentino, 1972).

Arnaldus de Villanova, Heinrich Wolff, Giovanni Braccesco, Wolff Geuss, Johannes de Rupescissa, Ramon Llull and Johann Vogt, *Herliche medicische Tractat* (Strasbourg: Bernhart Jobin, 1576).

Marina Warner, *Fantastic Metamorphoses, Other Worlds: Ways of Telling the Self* (Oxford and New York: Oxford University Press, 2002).

"The fact is, that the Madrepore, like those glorious sea-anemones whose living flowers stud every pool, is by profession a scavenger and a feeder on carrion; and being as useful as he is beautiful, really comes under the rule which he seems at first to break, that handsome is who handsome does."

Charles Kingsley, *Glaucus; or, the Wonders of the Shore*, 1855

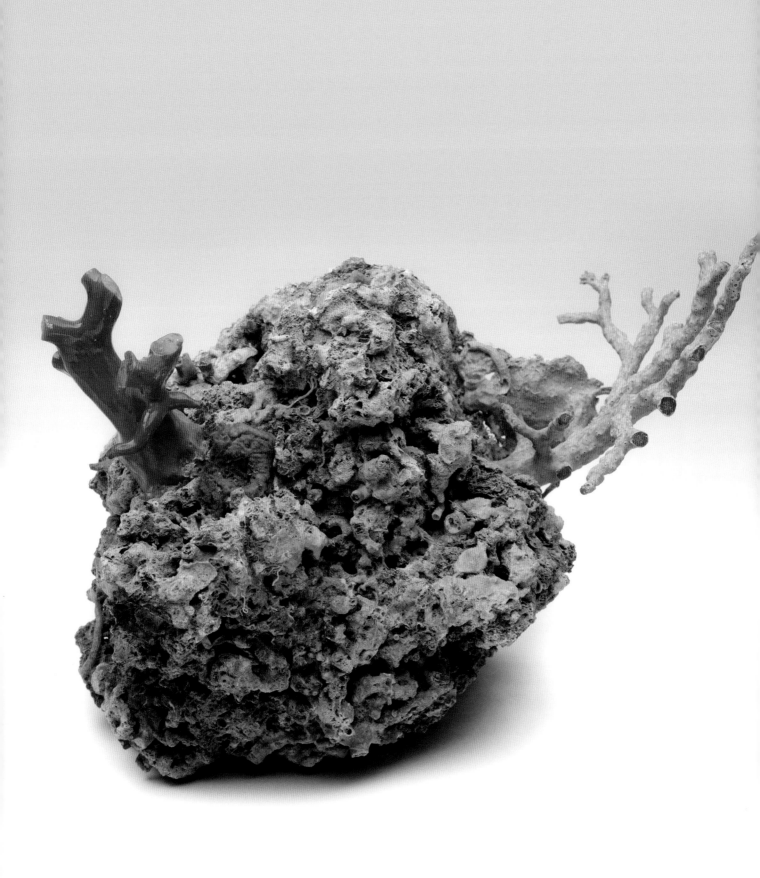

"Much hot, and not wise, discussion has occupied the hours of philosophers in trying to map out the distinct confines of the animal and vegetable kingdoms, when all the while Nature knows of no such demarcating lines. The Animal does not exist; nor does the Vegetable: both are abstractions, general terms, such as Virtue, Goodness, Colour, used to designate certain groups of particulars, but having only a mental existence."

George Henry Lewes, *Sea-Side Studies at Ifracombe, Tenby, The Scilly Islands and Jersey*, 1858

Interview

Shared forms in nature: an interview with Gemma Anderson

Marion Endt-Jones

Marion Endt-Jones: Your last exhibitions at EB & Flow Gallery (London, 7 February–6 April 2013) and Thore Krietemeyer Gallery (Berlin, 20 September–16 November 2013) were entitled *Isomorphology*, which is also, I believe, the title of your PhD research project. What does 'isomorphology' mean and what has inspired you to adopt this approach?

Gemma Anderson: I think my real fascination is with the study of natural forms, which naturally led to a deeper engagement with the natural sciences, mathematics and systems of classification. Isomorphology comes from isomorphism (same form) used in mathematics and biology. The etymology of the term is derived from the Greek 'isos' ('same/equal'), 'morphe' ('form') and 'logos' ('study').

MEJ: How does research inform your art and vice versa?

GA: Since 2005, I have been working with museums and scientists – developing my enquiry into the shared forms of animal, vegetable and mineral species, and I wanted to shape this research into a PhD.

The concept of isomorphology has developed out of years of observational and intellectual research, and I can see elements of isomorphology in all of my previous works. Such a large proportion of my practice happens within scientific collections such as those at the Natural History Museum, University College London and Kew Gardens, that I now feel more comfortable working within a scientific context – for instance, a museum or laboratory space – than I do working in a studio. The influence of academic engagement is evident in my work and research; for example, my research paper 'Endangered: a study of the declining practice of morphological drawing in zoological taxonomy' (Leonardo Journal, MIT Press, 2012) includes equal references to the philosophy of science, contemporary scientific papers and artistic practice.

I think working with the Natural History Museum, which operates as a research institute with academic rigour and formality, has made my art practice incredibly well organized. I prepare for meetings with scientists, I research before consulting specimens from the collections, and I make appointments to work in the specialist libraries. I have adapted my practice to work within scientific and academic contexts, as my work relies on the collections and academic knowledge of these places.

MEJ: *Aragonite spawning under full moon* (fig. 13) is part of your ongoing engagement with the collections at the Natural History Museum in London. Can you explain the process and technique involved in creating this work?

GA: Yes, it was quite a long process... First of all I arranged a meeting with NHM coral curator Jill Darell. I proposed the work to Jill and she kindly agreed to help me select specimens and provide a space for me to draw, as I always draw directly from life onto the copper plate. I spent several

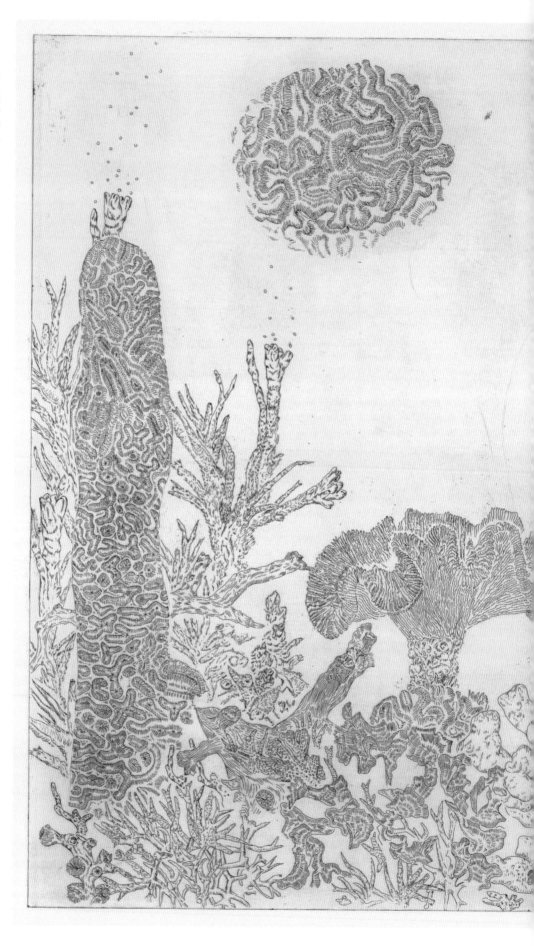

Figure 13: Gemma Anderson, *Aragonite spawning under full moon*, drawn from specimens at the Natural History Museum, Palaeontology Department coral collection, copper etching, 2011.

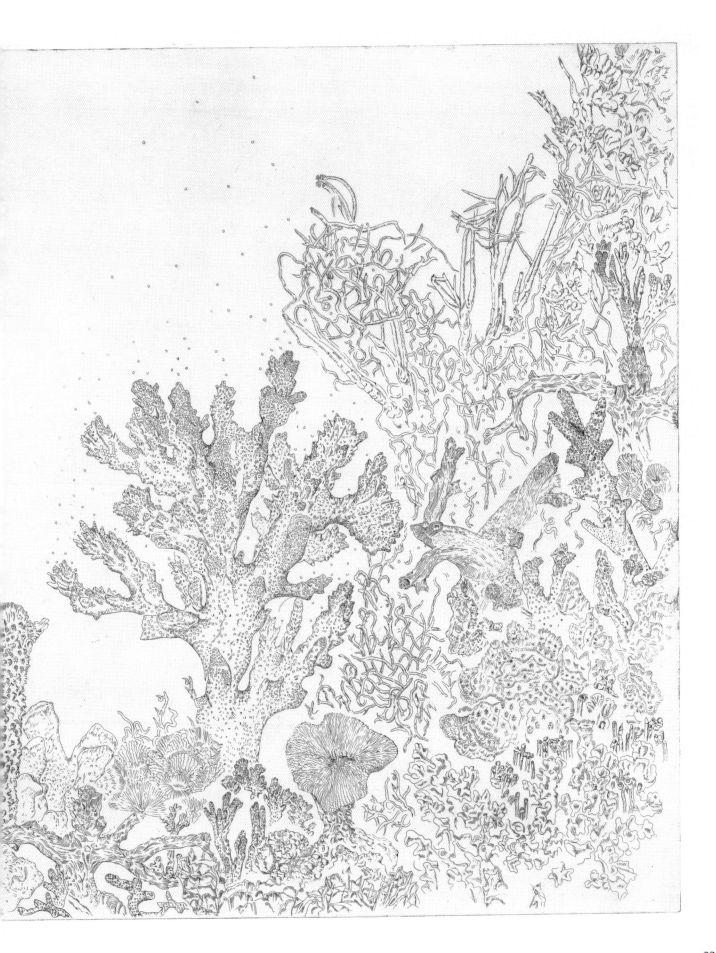

Figure 14: Coral specimens selected for a drawing session at the Natural History Museum, London. Photo: Gemma Anderson.

weeks making this work, researching, selecting specimens, drawing and composing the work (figs 14–16). During the process I learnt about polyps and spawning, and this influenced the work, for example, I drew brain coral as a moon under which the coral specimens spawned. The name of the work 'Aragonite spawning under full moon' implies the aragonite material of coral. I wanted to draw the mineral aragonite, which also branches and resembles coral, so I went through a similar process of sourcing and drawing mineral specimens for this work with NHM mineral curator Peter Tandy. Finally, the work is etched and printed, involving experimentation with the etching and lithographic processes.

MEJ: Coral had been alternately classified as plant and mineral until the eighteenth century, when the French naturalist Jean-André Peyssonnel finally established its animal nature. Are your representations of coral in *Aragonite spawning* recourse to pre-scientific ways of classifying coral, a way of un-learning scientific taxonomy?

GA: Yes, in this work I was interested in drawing aragonite, which is currently classified as both mineral and animal (for example the coral specimens). I have always been fascinated by the 'zoophyte' and the 'chimera', and love tracing

the history of specimens like coral, which have been classified as animal, mineral and vegetable at different points in scientific history. I see coral as a good example of a taxonomic misfit, a problem of classification, reflecting both the evolution of scientific understanding and the ultimate impossibility of the quest of taxonomy. My PhD research interest in re-classifying species through drawing practice based on shared forms provides an alternative – a visual classification.

MEJ: Vernacular names for corals are a great example of the importance of analogy, resemblance and association in making sense of the natural world: broccoli corals, stag horn corals, cauliflower corals, mushroom corals, honeycomb corals, organ-pipe corals, brain corals... What is the role of analogy and resemblance in your approach to organizing animal, mineral and vegetable specimens?

GA: I am drawn to pre-Linnaean systems of classification, which are based on shape and form – as this feels like an instinctive approach. Historically, the Doctrine of Signatures[1] is an example of this, indicating the medicinal virtues of plants based on their resemblance to

1 Giambattista della Porta, *Phytognomonica* (Rothomagi, 1650).

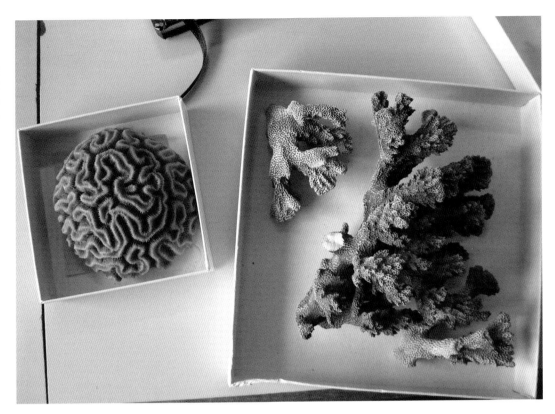

Figure 15: Coral specimens, Natural History Museum, London. Photo: Gemma Anderson.

specific human organs they are believed to be able to cure, thus creating an order for them. For example, the doctrine teaches that aconite will cure eye disease because its shape and symmetry resemble the human eye, and that similarly, ground walnuts mixed with spirits of wine will ease a headache. The origin of these remedies lies within the perception of a resemblance between the forms or 'signatures' of species. Giambattista della Porta's *Phytognomonica* contains a series of drawings of species showing these resemblances. I am interested in how drawing can represent resemblances and contribute to alternative models of classification.

MEJ: The historian of science Chiara Ambrosio has described your work in terms of 'artistic visualisation as critique' – a way of proposing alternatives to scientific taxonomies and methods.[2] But then your practice shares some of these methods – observation, experimentation – and relies to a great extent on collaboration and conversation with scientists. Do you see a conflict?

GA: The work is a critique – I am interested in re-thinking and re-classifying the specimens I

draw. Rather than labelling specimens scientifically, I am interested in knowing them through drawing and direct experience and placing them in relation to other organisms. I share many methods with scientists in this process, but rather than conflicting, I see my study as complementary to their work.

MEJ: Your approach seems to have a lot in common with pre-Enlightenment modes of classification. Do you look to sixteenth- and seventeenth-century cabinets of curiosities and natural history manuals for inspiration?

GA: I have loved natural history museums since I was a child. My grandmother used to take me to the Ulster Museum, which was wonderful and inspiring. Everywhere I go I make sure I visit the museum of natural history. Some of my favourites are the Pitt Rivers Museum and the D'Arcy Thompson Museum of Zoology. Sixteenth- and seventeenth-century natural history manuals have been influential, especially Della Porta's *Phytognomonica* of 1588, which I have mentioned before. Curiosity and wonder are the driving forces of my work. Curiosity drives each experiment and wonder is present in each act of drawing.

MEJ: Another 'role model' that comes to mind is the polymath, striving for universal knowledge and adopting a holistic approach to organizing

2 Chiara Ambrosio, 'An Introduction', in Gemma Anderson (ed.), *Isomorphology* (London: EB & Flow, 2013), pp. 6–7, here p. 7.

Figure 16: Corals and Gemma's copper etching plate. Photo: Gemma Anderson.

the world. Some artists (such as Mark Dion and Cornelia Parker) have invoked the figure of the dilettante in recent years, but it seems that such a characterization would jar with your infinitely careful drawings, which are a demonstration of skill, handicraft and technical mastery (fig. 17). How would you situate yourself as an artist in relation to the polymath, the dilettante and the expert?

GA: I am most inspired by the work of great polymaths – Goethe, d'Arcy Thompson, Leonardo da Vinci – and I feel a great connection to the approach of the polymath. I work in a holistic manner, as studying forms that are shared across the natural world is an interdisciplinary job! This fits the notion of the artist as a universal progressive conception. But working in this way today has a very different meaning to working as a polymath in the nineteenth century. Interestingly, there is a shift towards interdisciplinarity in contemporary culture. I believe there will always be a need for new connections to be found between existing subjects, in order to create new areas of study – and to bring new perspectives. I see this as one of the roles for artists within today's society.

MEJ: You have described the practice of drawing natural specimens as a process of observation, trained judgement and abstraction. Is there a place for imagination, creativity and chance?

GA: Yes, I believe in the practice of observation and drawing as disciplines. Observation, trained judgment and abstraction are the skills I use in the drawing process all the time. I think observation is the foundation, and trained judgment and abstraction grow from practiced observation. For the critic Thierry de Duve, any artwork is nothing other than a 'sum of judgments'[3] historical and aesthetic, stated by the artist in the act of its production, and my own judgments are the result of this rigorous method. The practice generates the skill and the confidence, which in turn gives more freedom. In a way, I believe freedom can be found in restriction, for example, when I am restricted to the etching plate, and the etching tool, I feel total freedom within that space. And yes, imagination, creativity and chance are present throughout the entire process.

MEJ: I'm very interested in the possibilities of drawing as documentation on the one hand and invention on the other – there seems to be

3 Thierry de Duve, *Essais datés I*, 1974–86 (Paris, Editions de la Différence, 1987).

a friction between the literal, factual and the fictive, creative. How do you position yourself between these poles?

GA: Yes, drawing has been my way of getting to know the world, of getting to know objects and people. I believe drawing is a knowledge producing process, as it is within the space of drawing that an understanding and exploration of the subject occurs. I am revealing something that no other technology can reveal; drawing shows me what I understand, and it shows this understanding to others. I see my drawings as making notes from nature, almost like writing the forms, and in this sense they are empirical evidence. But there are also interventions – operations on morphologies and exchanging of parts; the way in which they are composed, the relationships drawn between objects in the work are creative, responding to the particular specimens I work with – sensitively listening to their suggestions and following these intuitively to create the work.

MEJ: New technologies have always played a massive role in how we explore, see and understand the world – the microscope, the telescope, the aqua-lung... What tools are you using and what is your relationship with them?

Figure 17: Gemma Anderson, *Hyperbolic Coral Portal*, drawn from corals and bryozoans at the D'Arcy Thompson Zoology Museum, University of Dundee, copper etching, 2013.

"You are about to come with us into our unfathomable depths, never penetrated by man before. Different races dwell in the country of the ocean. Some are in the abode of the tempests; others swim openly in the transparency of the cold waves, browse like oxen over the coral plains, sniff in with their nostrils the ebbing tide, or carry on their shoulders the weight of the ocean-springs.

Phosphorescences flash from the hairs of the seals and from the scales of the fishes. Sea-hedgehogs turn around like wheels; Ammon's horns unroll themselves like cables; oysters make sounds with the fastenings of their shells; polypi spread out their tentacles; medusæ quiver like crystal balls; sponges float; anemones squirt out water; and mosses and seaweed shoot up.

And all kinds of plants spread out into branches, twist themselves into tendrils, lengthen into points, and grow round like fans. Pumpkins present the appearance of bosoms, and creeping plants entwine themselves like serpents.

The Dedaims of Babylon, which are trees, have as their fruits human heads; mandrakes sing; and the root Baaras runs into the grass.

And now the plants can no longer be distinguished from the animals. Polyparies, which have the appearance of sycamores, carry arms on their branches. Antony fancies he can trace a caterpillar between two leaves; it is a butterfly which flits away. He is on the point of walking over some shingle when up springs a grey grasshopper. Insects, like petals of roses, garnish a bush; the remains of ephemera make a bed of snow upon the soil.

And, next, the plants are indistinguishable from the stones.

Pebbles bear a resemblance to brains, stalactites to udders, and iron-dust to tapestries adorned with figures. In pieces of ice he can trace efflorescences, impressions of bushes and shells – so that one cannot tell whether they are the impressions of those objects or the objects themselves. Diamonds glisten like eyes, and minerals palpitate."

Gustave Flaubert, *The Temptation of Saint Antony or, A Revelation of the Soul*, 1874

GA: I suppose I am mostly interested in the technology of the self: observation, drawing, contemplation and extending these into processes like etching and model making. I have drawn with the aid of microscopes and telescopes, but I prefer direct observation, as there is less mediation between subject and object.

MEJ: The slow, painstaking process of composing a drawing seems to be a quietly subversive, almost obsessive way of engaging with an object – it seems to entail an almost intimate relationship between artist and object. Do you see this special form of devotion to a natural object as a way of making us care more about the environment? What is the potential for using drawing as an educational, or even environmental activist, tool?

GA: Yes – I believe drawing is a meaningful way to engage with the natural world and I hope that through my work I can encourage others to deepen their relationship with natural phenomena. In contemporary culture there is a big disconnect between humans and the environment, and this human-environment relationship needs to be addressed. I believe drawing is one way to approach this problem.

MEJ: Many naturalists and scientists – the French entomologist Jean-Henri Fabre comes to mind, for example – believed in the benefits of studying living animals and plants in their natural environment over observing dead specimens in a museum collection. How do you see the differences between drawing or sketching from nature and drawing from collected, institutionalized nature?

GA: It is a very different experience. I would love to draw each specimen in its natural environment, but the nature of my study means that this is impossible. Although there are perks to drawing in the museum, including working with some very interesting individuals!

MEJ: There seems to be a contradiction between studying and proposing ever-evolving morphologies and classifications and 'capturing' them on a piece of paper, or a copper plate. Are you interested in the concepts of process and metamorphosis?

GA: Yes, and I believe that drawing is a very important method to begin understanding these processes – although the drawing finishes as a static thing. Its process has mimicked many of the processes of formation and growth of the forms it develops as a line in movement – so I don't see a contradiction here, as I feel the drawing process is *as* dynamic and alive as the processes which form the morphologies.

MEJ: The French physiologist Etienne-Jules Marey wrote in 1890 that being immersed in studying the motion of marine creatures had 'led [his] eyes and mind to seeing and thinking under water.'[4] How has all the time spent among the museums' and institutions' 'treasures' influenced your way of thinking and seeing the world?

GA: The forms of isomorphology can be realized in everyday observations. It is possible to observe the forms and symmetries in a garden or in the city – in plant life, examples would be bilateral leaves, branches, or bilateral leaves on branches, and in architecture and design, hexagonal meshes and helical staircases – and to ponder the combinations of such forms and symmetries through drawing.

The interview was conducted by email in June and July 2013.

References

Chiara Ambrosio, 'An Introduction', in Gemma Anderson (ed.), *Isomorphology* (London: EB & Flow, 2013), pp. 6–7.

Thierry de Duve, *Essais datés I*, 1974–86 (Paris, Editions de la Différence, 1987).

Etienne-Jules Marey, 'Locomotion in Water as Studied Through Photochronography' (1890), trans. Hanna Rose Shell, in Bruno Latour and Peter Weibel (eds), *Making Things Public: Atmospheres of Democracy* (Karlsruhe, Germany and Cambridge, Mass.: ZKM and The MIT Press, 2005), pp. 327–31.

Giambattista della Porta, *Phytognomonica* (Rothomagi, 1650).

4 Etienne-Jules Marey, 'Locomotion in Water as Studied Through Photochronography' (1890), trans. Hanna Rose Shell, in Bruno Latour and Peter Weibel (eds), *Making Things Public: Atmospheres of Democracy* (Karlsruhe, Germany and Cambridge, Mass.: ZKM and The MIT Press, 2005), pp. 327–31, here p. 328.

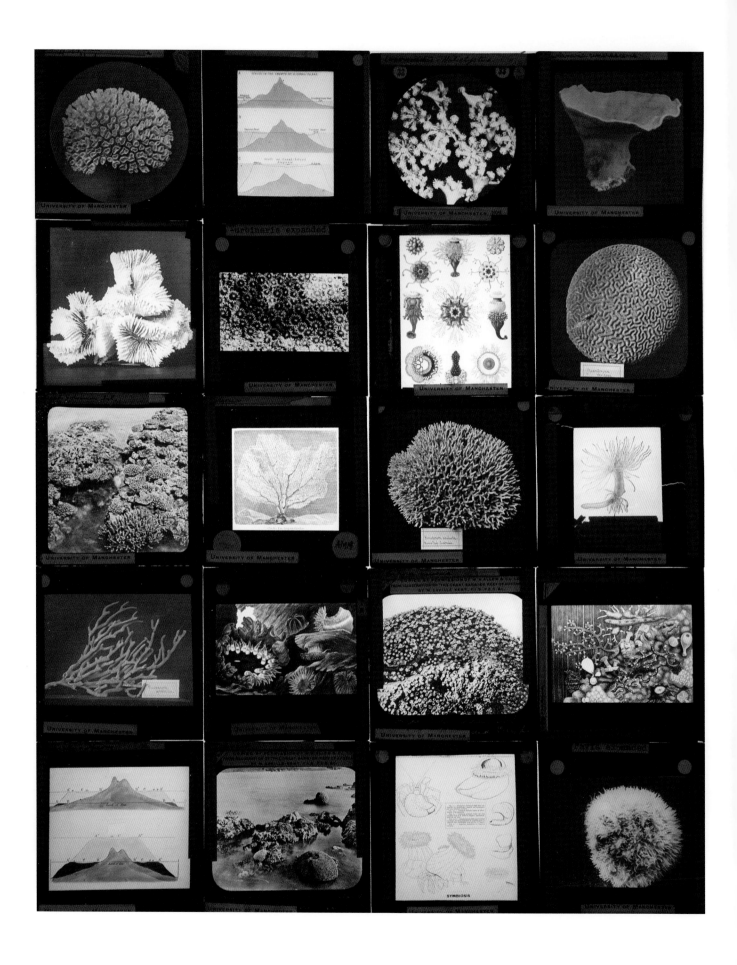

Something Rich and Strange

"Instead of gazing down through water buckets and glass-bottomed boats, in addition to watching the fish milling about in aquariums, get a helmet and make all the shallows of the world your own. Start an exploration which has no superior in jungle or mountain; insure your present life and future memories from any possibility of ennui or boredom, and provide yourself with tales of sights and adventures which no listener will believe – until he too has gone and seen, and in turn has become an active member of the Society of Wonderers under-sea."

William Beebe, *Half Mile Down*, 1934

Figure 18: A selection of coral-related slides from Manchester Museum's collection of over 50,000 glass magic lantern slides dating from the late nineteenth and early twentieth century. Photo: Paul Cliff.

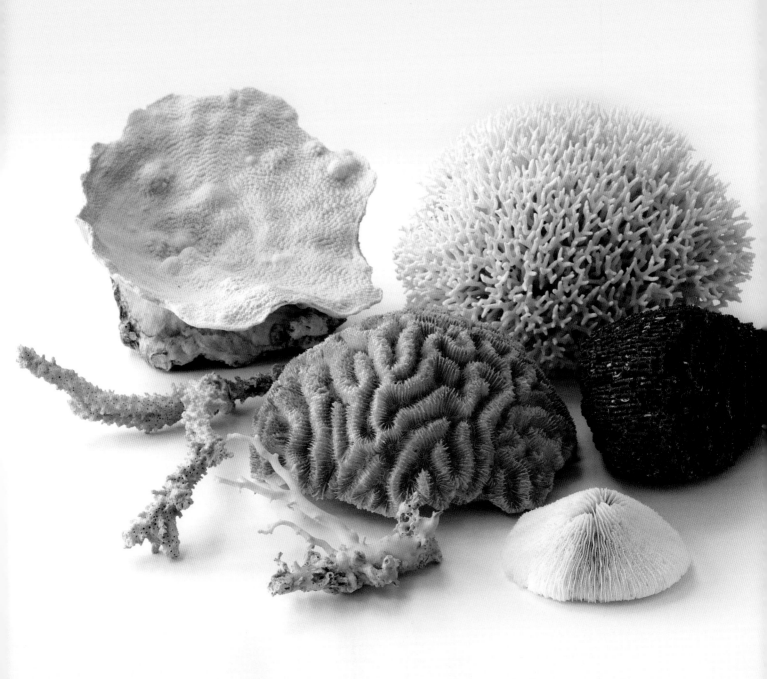

1 What are corals?

Dmitri Logunov

Although the term 'coral' is often used in a general sense, it usually refers to reef or stony corals (phylum Coelenterata, class Anthozoa, order Scleractinia). Despite their superficial similarity to plants, corals are animals. A coral is a colony of myriad tiny (1–3 mm in diameter), sac-like individuals called polyps. Polyps have a simple structure and a flower-like appearance. Each has a ring of tentacles that surround a central mouth opening, through which food is ingested and digested wastes are expelled. The polyps of colonial corals are all interconnected by their body cavities having a kind of united, colonial digestive system that allow significant sharing of nutrients. Corals are predators. They use their outstretched tentacles to capture food ranging from small fishes to zooplankton.

Soft-bodied polyps excrete hard outer skeletons composed of calcium carbonate. The skeleton is actually secreted outside the body, near the base, being attached either to rock or the dead skeletons of other polyps. So the living polyps grow on their skeleton, completely covering it with live tissues. In the case of stony corals, polyp colonies grow and die, giving shape to the familiar calcium carbonate skeletons. The variety of skeletal configurations of corals is determined by the growth patterns of the colony and the mutual arrangement of its polyps. These structures can range from delicate, branching bushes to robust tables (plate corals) or massive boulders in the shape of a human brain (brain corals).

The growth rate of corals varies from 0.2 to 10 mm per year, depending on the species and water temperature. Slowly growing colonies of corals are the main builders of the reef limestone foundation through the accumulation of calcium carbonate, or calcification. However, although such reefs are principally made of calcium carbonate derived from corals, coral skeletons are cemented into a wave-resistant solid rock by microscopic organisms known as coralline algae that reside within the coral's tissues. Corals and algae co-exist in a unique partnership, called symbiosis, from which they both benefit. Algae benefit from living in a sheltered milieu (i.e. inside coral cells) and use the coral's metabolic waste products such as nitrates and phosphates for photosynthesis. In return, the algae produce an extra supply of oxygen for the coral to breathe and some organic products stimulating the calcium metabolism of the coral. The algae give their coral host a yellow-brown to dark brown colour; responsible for the reef's vivid, brilliant colours, ranging from red, pink and purple to yellow, green and blue, are pigment proteins produced by the polyps themselves.

Both corals and algae flourish in shallow, turbulent and well-lit environments, in which coral reefs grow best. However, an important factor in the formation of coral reefs is that the water should be clean, that is, free from suspended waste debris that would hinder their development. Clean water is also important for the survival and proper functioning of coralline algae, and therefore corals rarely develop in depths greater than forty metres. Finally, coral reefs also need warm water (the optimum is around 23–25°C) and therefore are limited to a belt from approximately 30°N to 30°S latitude.

Figure 19: A variety of coral specimens from Manchester Museum's Zoology collection. Photo: Paul Cliff.

33

References

John E.N. Veron, 'Corals: Biology, Skeletal Deposition, and Reef-Building', in David Hopley (ed.), *Encyclopedia of Modern Coral Reefs: Structure, Form and Process* (Dordrecht: Springer, 2011), pp. 275–81.

Mark D. Spalding, Edmund P. Green and Corinna Ravilious, *World Atlas of Coral Reefs* (Berkeley and London: University of California Press, 2001).

Gunnar Thorson, *Life in the Sea* (London: Weidenfeld and Nicolson, 1971).

"We need a whole new vocabulary, new adjectives, adequately to describe the designs and colors of under sea."

William Beebe, *Beneath Tropic Seas: A Record of Diving Among the Coral Reefs of Haiti*, 1928

Figure 20: Illustration of Great Barrier Reef corals, in William Saville-Kent, *The Great Barrier Reef of Australia: Its Products and Potentialities* (London: W.H. Allen, 1893), colour plate VIII.

W. Saville-Kent, del. et pinx. ad nat.　　　　　　　　　　　Riddle & Couchman, imp. London. S.E.

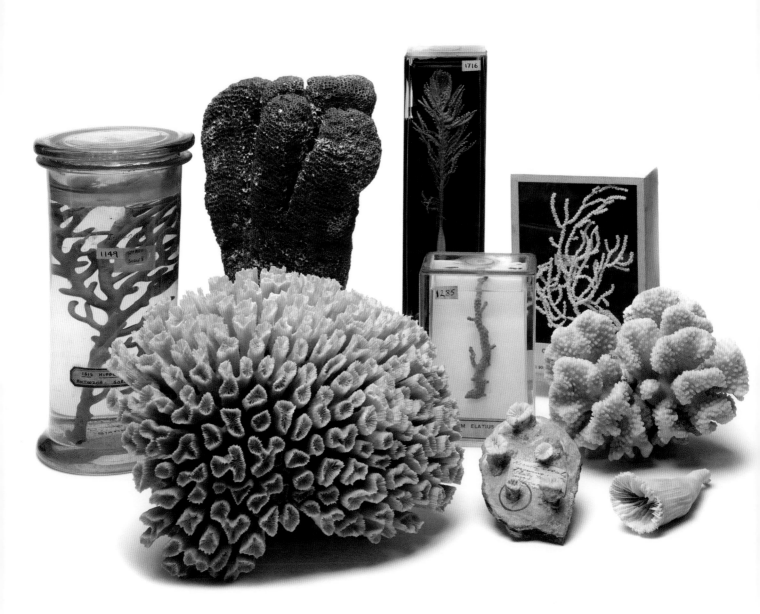

2 Manchester Museum's coral collection

Dmitri Logunov

The corals illustrated opposite and those displayed in the *Coral: Something Rich and Strange* exhibition form a small part of the collections of corals and their allies (from jellyfish to sea anemones) held by the Manchester Museum. Some 90 per cent of these collections are kept in storage behind the scenes and due to the large size of many of them will hardly be displayed in their full diversity. The collection consists of dry and spirit specimens, microscope slides and fossils. In total, it numbers more than 1,600 specimens of the extant corals, i.e. those living today, and some 2,200 fossil specimens belonging to 130 different species.

The collection of dried specimens includes the skeletons of both hard and soft corals, totalling some 724 specimens of an unknown number of species, plus approximately 500 microscopic slides. Hard corals are the architects of coral reefs. Their calcareous skeletons of remarkably diverse shapes are likely to be familiar to everyone. Soft corals, such as seas fans, sea feathers and sea whips, are bendable and often resemble brightly coloured plants or trees. They are found in oceans from the equator to the north and south poles.

The collection of spirit specimens (corals, jellyfish and sea anemones) numbers 351 specimens that are kept in glass jars, fully immersed in 70–80 per cent ethanol. Each sample is kept in a separate jar and provided with a corresponding data label. The main reason for keeping corals in spirit is to preserve the structure of their polyps, which is important for taxonomic research. If the coral dries up, the thin layer of polyps inevitably shrivels or distorts, which will render its identification impossible.

The fossil coral collection contains specimens of different geological ages. Fossil corals can tell us about the past. For instance, fossil corals found in the UK are indicative of a tropical environment, similar to the Caribbean today, that occurred here at certain periods of time.

Regardless of the kind of collection (dried, spirit or fossil), the hundreds of coral specimens are examples of organisms collected in the course of taxonomic or biodiversity research. They are called *voucher specimens*: the physical proof that species have been recorded from the study site or geological deposit, and that they have been identified accurately. Such specimens represent an essential and irreplaceable resource for research aiming to answer three fundamental questions: *what* is the organism under study, *where* is it found in nature and *why* is it found there? Without such reference collections, acting as a 'biological library', most taxonomic, biodiversity or conservation research could not be conducted.

The scientific quality and international reputation of a natural history collection is measured by the number of deposited type specimens. A *type specimen* (or *type*) is a reference specimen selected by a scientist during the description of a new species. The primary purpose of a museum type collection is to serve as a reference tool for taxonomic research. The Manchester Museum's coral collection contains at least 37 coral type specimens (both extant and fossil). Most of the extant species were described by Prof. Sydney Hickson (1859–1940), an eminent explorer of the Indo-Pacific and expert on corals.

References

Peter Davies, *Museums and the Natural Environment: The Role of Natural History Museums in Biological Conservation* (London and New York: Leicester University Press, 1996).

Dmitri V. Logunov and Nicholas Merriman (eds), *The Manchester Museum: Window to the World* (London: Third Millenium Ltd, 2012).

John R. Nudds and Charles W. Pettitt (eds), *The Value and Valuation of Natural Science Collections: Proceedings of the International Conference, Manchester, 1995* (London: Geological Society, 1997).

Figure 21: Variety of dry, spirit and type specimens from Manchester Museum's Zoology collection. Photo: Paul Cliff.

3 Fossil corals in the UK

David Gelsthorpe

Corals have played a key role in the evolution of life on Earth. The earliest corals are over 500 million years old. Fossil corals are quite common, as their hard calcium carbonate skeleton is easily preserved. Corals form an important habitat for other animals and the fossils are often preserved with shellfish, sea urchins and trilobites. The debris from these organisms accumulates to form limestone.

The location and size of coral reefs has varied considerably over time. Changes in sea level, temperature and the amount of food available have all had a large influence on their success. Corals have a different body shape to most organisms. Their shape means they can easily regenerate if damaged, they have the potential for unlimited growth and they can reproduce quickly.

Corals have not escaped the effects of mass extinctions. Changes in sea level and water temperature, massive volcanic eruptions and meteorite impacts have had major consequences for corals. The largest mass extinction occurred 251 million years ago and killed 96 per cent of life in the sea. Some species have always survived and gone on to diversify afterwards.

Fossil corals are relatively easy to find in the UK. There are three main time periods where corals have flourished: the Cretaceous, the Lower Carboniferous and the Silurian. The rocks from each period are found in different parts of Britain and give clues to the reef communities and environmental conditions at the time.

The Cretaceous

The Cretaceous period, 145–65 million years ago, saw an enormous tropical shallow sea cover much of Europe and into southern Russia. Much of the surface of the Earth was under seawater. This was probably because the temperature became high enough to melt the polar icecaps.

The environment in the UK was similar to the Caribbean today. Sharks, sponges and shellfish lived alongside the corals.

Reefs grew quickly in the Cretaceous, but changes in the environment and the amount of sediment that washed in from land meant they came and went. The thin widespread reefs were mostly made from shell debris with the occasional coral. Cretaceous rocks are best seen in Sussex, Kent and East Yorkshire.

The Lower Carboniferous

The Lower Carboniferous, 359–318 million years ago, saw warm shallow seas cover much of Britain. Extensive reefs ran along the ancient coastline in much the same way as the Great Barrier Reef sits off Australia today.

One of the best places to see these reefs is the area around Castleton, Derbyshire. Erosion has revealed the original shape, almost as if the water had just drained away. The edge of the reef falls steeply away into the deep Derbyshire valleys, where the fossils reflect the different depths of water.

The Silurian

The Silurian period, 443–416 million years ago, was dominated by warm shallow seas. The best place to see these reefs today is Wenlock Edge in Shropshire. The fossilized sea floor reveals a warm tropical ocean teeming with life. An abundance of shellfish, trilobites and other animals can be found with some of the best-preserved corals in the UK.

References

Richard Fortey, *Fossils: The Key to the Past*, revised fourth edition (London: Natural History Museum, 2009).

Chris and Helen Pellant, *Fossils: A Photographic Field Guide* (New Holland Publishers Ltd, 2007).

Figure 22: Coral fossils from Manchester Museum's Earth Sciences collection. Photo: Paul Cliff.

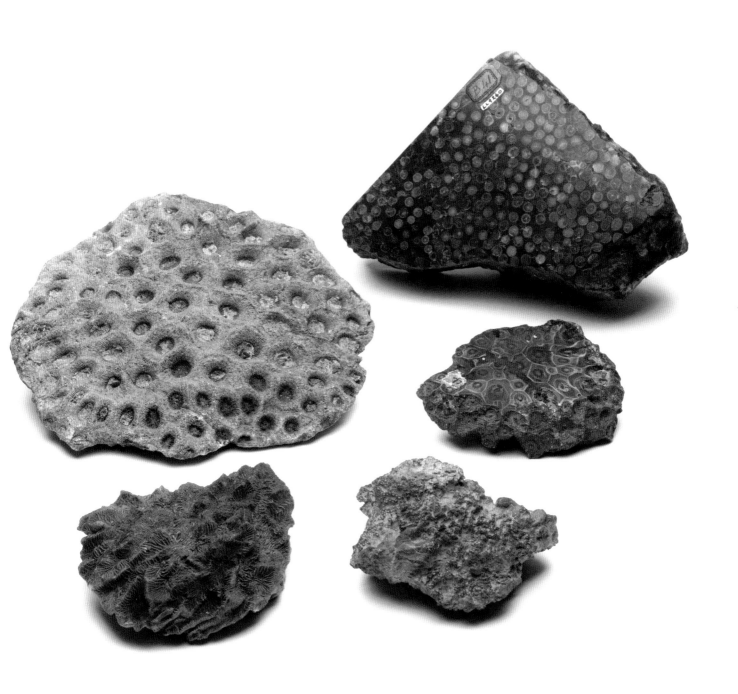

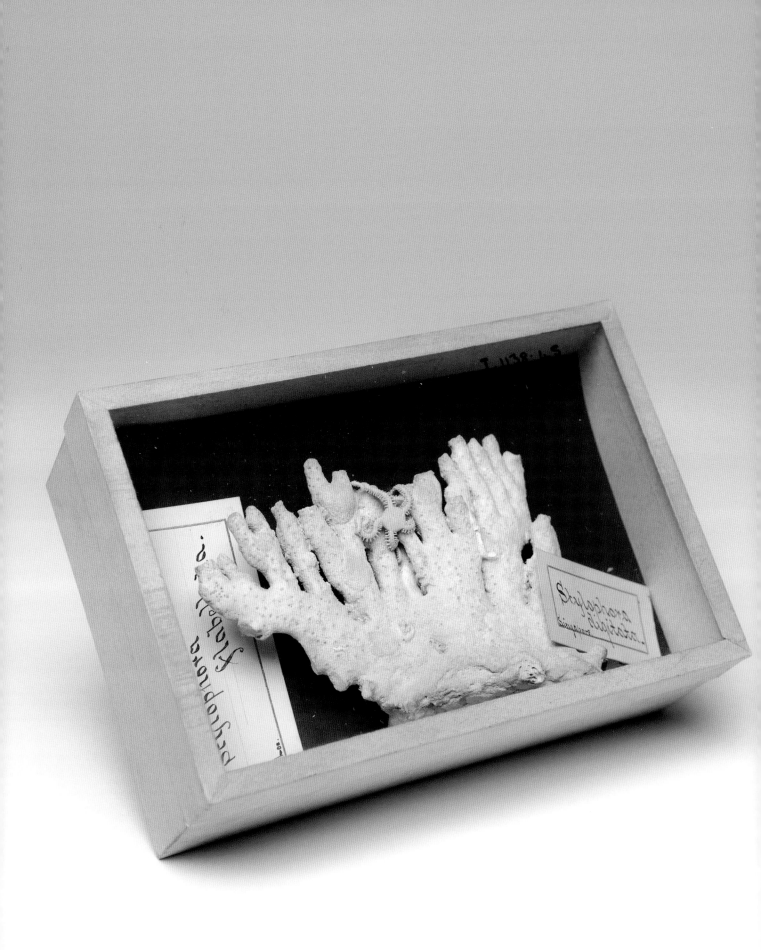

4 Perseus, Medusa and the birth of coral

Bryan Sitch and Keith Sugden

Our source for knowledge and beliefs about many different aspects of the natural world during the Roman period is Pliny the Elder's encyclopaedic *Natural History*, published in large part in AD 77. His description of coral is in Book 32.21–24, and contains information about the provenance, harvesting, decorative and medical uses of coral.[1] Pliny's account is very detailed, but does not include the myth about Medusa and coral: he is content to note merely that 'men say that live coral petrifies at a touch' (32.22). The myth about coral and Medusa's head is found in Ovid's *Metamorphoses* (4.782–86), published some 70 years earlier. Here, the petrifying powers of the monstrous Gorgon Medusa were held responsible for the formation of coral.[2] The Greek hero, Perseus, having succeeded in destroying the snake-headed Medusa, who turned all who looked on her to stone, went on to free Andromeda and slay the sea monster that threatened her. After rescuing Andromeda and claiming her hand in marriage, he washed in the sea, accidentally causing the birth of coral by setting down the Gorgon's head on the seashore: the seaweed petrified on contact with the Gorgon's blood and turned into coral.[3]

Perseus, the legendary founder of Mycenae, was raised on the Cycladic island of Seriphos. When the island's king, Polydectes, developed a passion for Perseus's mother, Danae, he was unable to force his attentions on her because her son had become a formidable protector. In order to get him away from her, the king hatched a plot to send him as far away as possible from the island. This involved his invitation to a large

banquet, to which each guest was expected to bring a gift, on this occasion a horse. As a poor fisherman's protégé, Perseus had no horse to give to Polydectes, and foolishly asked the king to name any other gift. What he was asked for was the head of Medusa.

Perseus accomplished this task with the help of Hermes, who supplied him with the means to get close enough to Medusa to chop off her head and escape: a cap that made him invisible; a magical sickle-shaped sword ('harpe'); a special satchel to hold her head safely; and winged shoes. When Perseus eventually returned to Seriphos, he used the Gorgon's head to turn the king and his followers into stone for persecuting his mother, before presenting it to Athena, who put the so-called *gorgoneion*, an image of the severed head of Medusa, in the centre of her shield. Athena had played an important role in the Gorgon's death: she had stood behind Perseus, holding a mirror, so that he would not have to look directly at Medusa as he cut off her head.

A number of objects in the Manchester Museum's archaeology and numismatic collections relate to the myth of Perseus, Medusa and the *gorgoneion*.

The image of Perseus appears on the obverse of a silver tetradrachm of Philip V of Macedon (220–178 BC; fig. 24, left). The Hellenistic coin shows the hero with the harpe, the sickle-shaped sword used to chop off the Gorgon's head, and the wings that helped him to escape (here on his helmet, rather than his sandals). A club and legend within a wreath appear on the reverse (acc. no. SNG 740, Raby colln).

A copper alloy figurine in the archaeology collection, apparently depicting the god Mercury, shows the god wearing a winged helmet and sandals, and carrying a bag or purse (acc. no. 1986.13; fig. 25, right). Wilk reproduces a drawing of an illustration on a Red Figure amphora

Figure 23: Stony coral (*Stylophora flabellata*) with brittle star attached, Manchester Museum, Zoology collection. Photo: Paul Cliff.

1 Pers. comm. Dr Mary Beagon, Department of Classics & Ancient History, University of Manchester.
2 See Marion Endt-Jones, *Coral: A Cultural History* (London: Reaktion Books, forthcoming).
3 Michael Cole, 'Cellini's Blood', *The Art Bulletin*, 81.2 (1999), pp. 215–35, here p. 228.

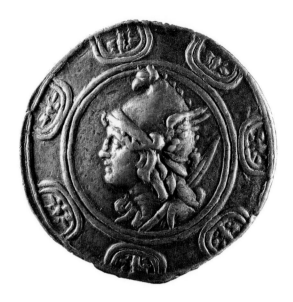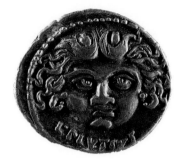

Figure 24: Coins from Manchester Museum's Numismatics collection showing Perseus (left) and the *gorgoneion* (centre and right). Photo: Phillip Rispin.

depicting Perseus wearing a winged helmet and sandals.[4] As the Manchester Museum figurine is not holding the satchel or *kibisis* it may be safer to identify the figurine as Hermes.

As mentioned above, the *gorgoneion* is an image of the Gorgon Medusa's severed head that Athena put on her shield to both terrify and impress her opponents in battle, and which became a regular feature on the shields of Greek soldiers. A tiny gold piece of Syracuse, Sicily, struck in the late fifth to early fourth century BC is a tribute to the ancient die engraver's skills (acc. no. SNG 474, Güterbock colln; fig. 24, right). The obverse shows Athena wearing an Attic helmet; the reverse shows the *gorgoneion* on the aegis.

A Roman Republican denarius issued by the moneyer L. Plautius Plancus in 47 BC is justly regarded as a *chef d'oeuvre* of ancient glyptic art. It shows the facing head of Medusa on the obverse: the wide, staring eyes, together with hair in the form of wriggling snakes, provides the most dramatic image of the monster on a coin (fig. 24, centre). The reverse shows the goddess Victory conducting four rearing horses (Sharp-Ogden colln).

An ancient Greek terracotta on display in the Ancient Worlds gallery at the Manchester Museum also depicts the Medusa with staring eyes and protruding tongue (acc. no. 1983.335; fig. 25, centre back). It is a fragment of a terracotta revetment from roof decoration with floral ornament and a *gorgoneion* in high relief. The slab is pierced with a hole beneath the Gorgon's chin. It is made of light orange clay, and still bears traces of white plaster and yellow and blue paint. It dates from the late sixth century BC and is thought to have been found in Campania in Italy. Building roofs were often dressed with terracotta antefixes for both protection and decoration.

A copper alloy escutcheon, or decoration for a bucket or *situla* of the Roman period, depicts Medusa's head (acc. no. 1981.935; fig. 25, left). The open ring behind her head shows this is the attachment for the handle of the *situla*. Medusa has wings in her hair and two snakes' heads, one on either side of her temples, issuing from the hair on either side of her forehead. The piece is about 10 cm tall. It came from the Wellcome Collection. It may be noted in passing that Medusa heads are often at or near the handles of vases, jugs, tripods and other vessels, where they serve an apotropaic function.[5]

References

Michael Cole, 'Cellini's Blood', *The Art Bulletin*, 81.2 (1999), pp. 215–35.

Marion Endt-Jones, *Coral: A Cultural History* (London: Reaktion Books, forthcoming).

Stephen R. Wilk, *Medusa: Solving the Mystery of the Gorgon* (Oxford: Oxford University Press, 2000).

Figure 25: Objects related to the myth of Perseus and Medusa, from Manchester Museum's Archaeology collection. Photo: Paul Cliff.

4 Stephen R. Wilk, *Medusa: Solving the Mystery of the Gorgon* (Oxford: Oxford University Press, 2000), p. 139.

5 Wilk, *Medusa*, p. 40.

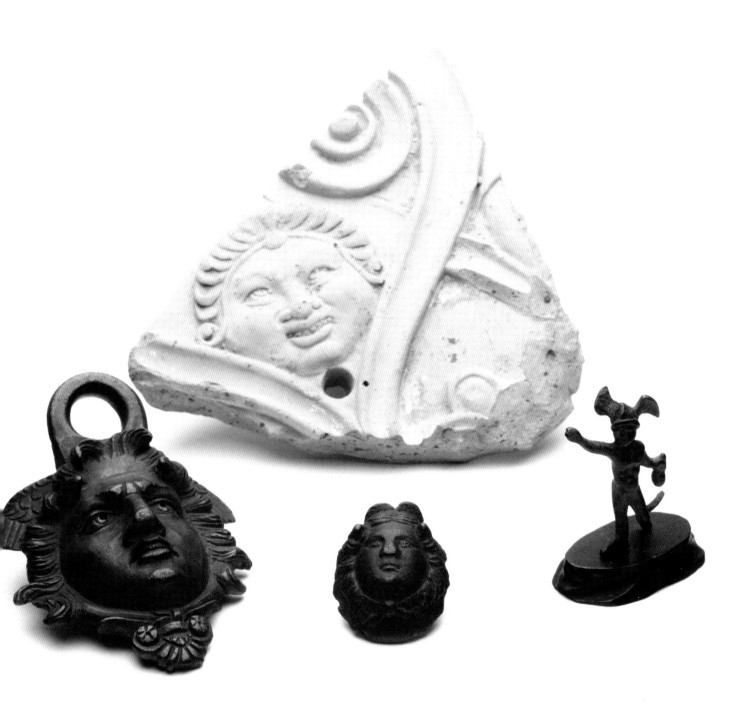

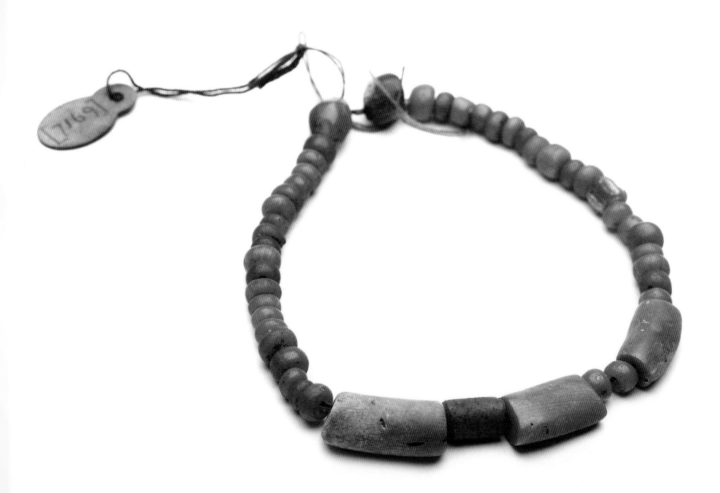

5 Coral jewellery from Egypt

Campbell Price

Use of coral in ancient Egypt was very limited. This is reflected by the fact that in the Manchester Museum's collection of over 16,000 artefacts from ancient Egypt and Sudan only two items have elements that are made from coral.

This string of beads (acc. no. 7169) comes from a grave excavated by the British School of Archaeology in Egypt at the site of Qau el-Kebir. The string may have formed a bracelet, an anklet or part of a larger necklace. It consists of 41 green glass beads, two of carnelian, one of gilt glass, and three long coral beads. Glass beads imitating gold and pearl provide a useful dating criterion as they seem to be an innovation of the Ptolemaic Period (332–330 BC) and continue to be used into Christian times (fourth century AD).[1] Our string is most likely to date to between 30 BC and 394 AD, when Egypt was a province of the Roman Empire.

For the Egyptians, the nearest source of coral lay in the reefs of the Red Sea to the east of the Nile Valley. Red Sea coral (*Tubipora musica*) is attested in small numbers of grave goods from the Predynastic Period (*c.* 5000–3100 BC) onwards, chiefly in the form of beads. Trade between the Nile Valley and the Red Sea coast is well-attested, and several areas of Egyptian occupation are known throughout the Pharaonic Period and later.[2] Items arriving in Egypt through this route included a range of shells, sea urchins, coral and other materials.

Due to its comparative rarity, coral is likely to have been prized by the ancient Egyptians as *exotica*, a material particularly suitable for use in small amounts in jewellery. The ownership of such items also implied wealth and status for the wearer.

It is unclear what, if any, special properties or associations coral had for the ancient Egyptians, but colour symbolism was important in Pharaonic art. While blues and greens represented fresh growth, new life and rebirth after death, red stones such as carnelian and jasper were often used to represent solar elements in jewellery. Red also represented blood, and in Chapter 156 from the Book of the Dead, known as the 'Chapter for a Knot-amulet of Red Jasper', protection is sought through the blood of the goddess Isis:

> You have your blood, O Isis; you have your power, O Isis; you have your magic, O Isis. The amulet is a protection for this Great One which will drive away whoever would commit a crime against him.

It may be assumed that these associations also applied to coral. As so often in Egyptian jewellery, colour was primarily symbolic rather than simply decorative.

References

Guy Brunton, *Qau and Badari III* (London: Quaritch, 1930).

Gregory Mumford, 'Ras Budran and the Old Kingdom trade in Red Sea shells and other exotica', *British Museum Studies in Ancient Egypt and Sudan*, 18 (2012), pp. 107–45.

Roberta Tomber, 'From the Roman Red Sea to beyond the Empire: Egyptian ports and their trading partners', *British Museum Studies in Ancient Egypt and Sudan*, 18 (2012), pp. 201–15.

Figure 26: String of beads containing 41 green glass, two carnelian, one gilt glass and three coral beads, Manchester Museum Egyptology collection.
Photo: Paul Cliff.

1 Guy Brunton, *Qau and Badari III* (London: Quaritch, 1930), p. 27.
2 See for example Gregory Mumford, 'Ras Budran and the Old Kingdom trade in Red Sea shells and other exotica', *British Museum Studies in Ancient Egypt and Sudan*, 18 (2012), pp. 107–45, and Roberta Tomber, 'From the Roman Red Sea to beyond the Empire: Egyptian ports and their trading partners', *British Museum Studies in Ancient Egypt and Sudan*, 18 (2012), pp. 201–15.

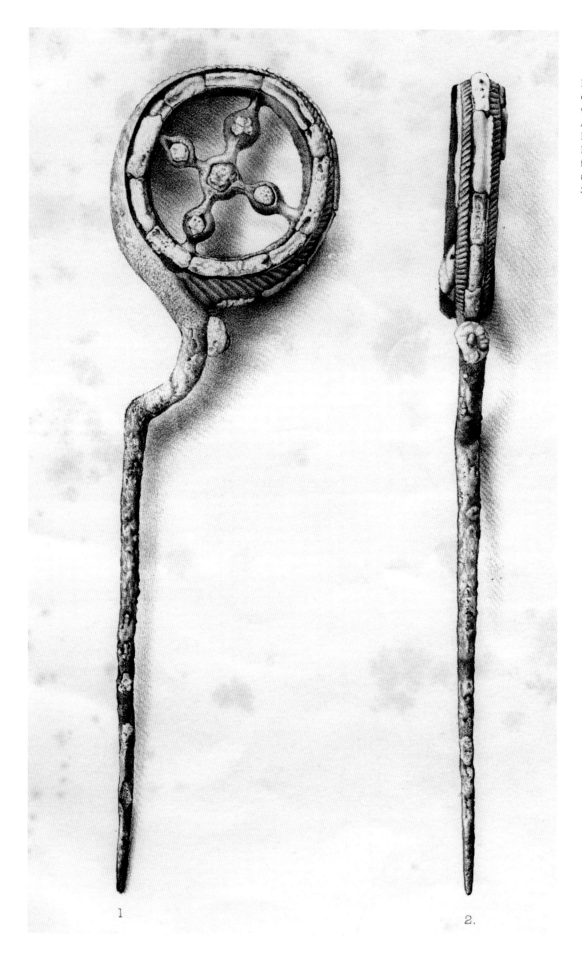

Figure 27: Pencil drawing of the Danes Graves wheel-headed pin by Agnes Mortimer, in John Robert Mortimer, 'The Danes Graves', reprint from the *Annual Report of the Yorkshire Philosophical Society* (1897), plate III.

6 The Danes Graves wheel-headed pin (The Yorkshire Museum)

Melanie Giles

This elegant swan's necked ring-headed pin is made of copper alloy, inset with beads of coral, which would once have been the colour of flesh. It was found behind the head of a skeleton in an Iron Age square barrow at the cemetery of Danes Graves, East Yorkshire.[1] This burial probably dates to the late third to second century BC.[2] The antiquarian excavator, John Mortimer, interpreted the remains as that of a 'strong boned person – probably a female.'[3] The pin may have been used to hold back her hair, or even secure a shroud, as the body was crouched on its side in the grave with its legs at right angles – as if wrapped and concealed for burial. The pencil drawing shown here (fig. 27) was made by Mortimer's accomplished teenage daughter, Agnes, as part of a portfolio of archaeological illustrations for her father (1905).

The coral that decorates the pin came from the Mediterranean, travelling to Britain in the form of perforated cylinder beads, which were then cut and reset by a local bronze smith.[4] This gives the beads an interesting biography, telling us of travel or exchange between Britain and the near Continent. The choice of design is important: the cross-quartered head resembles a wheel, with its 'spokes' and axle 'hub' decorated with further knobs of coral. The 'rim' of the wheel is ribbed (or 'corded')[5] with incised lines, giving the finished artefact a dynamic sense of movement. Wheels held great meaning for these communities, since their most elaborate burials include the disassembled remains of chariots: taken apart and laid around the body.[6] The horse-fittings for these vehicles are sometimes decorated with beads of coral, alongside many brooches, and rare shield ornaments and scabbard fittings for swords.

Such beads or knobs of decoration are small yet they were selected to adorn important items of jewellery or weaponry. Although its colour was symbolically significant, the attraction of this easily carved substance also lay in its apotropaic properties.[7] Writing about the Iron Age Gauls, Pliny records that they decorated swords, shields and helmets with coral, hung it around the necks of infants, or used it as a medicine (powdered and ingested) for eye complaints, ulcerous wounds and scars.[8] Coral seems to have been thought of as analogous to flesh and a good healing agent, but it also had amuletic power for vulnerable bodies. Its inclusion in martial objects may have helped make these

1. Mound 11; see John Robert Mortimer, 'Danes Graves', *Transactions of the East Riding Antiquarian Society*, 18 (1911), pp. 30–52.

2. Ian M. Stead, *The Arras Culture* (York: The Yorkshire Philosophical Society, 1979), p. 77.

3. John Robert Mortimer, 'The Danes Graves', reprint from the *Annual Report of the Yorkshire Philosophical Society* (1897), pp. 1–10, plates I–III, p. 2.

4. Stead, *The Arras Culture*, p. 77.

5. William Greenwell, 'Early Iron Age Burials in Yorkshire', *Archaeologia*, LX (1906), pp. 251–324, here p. 270.

6. Melanie Giles, *A forged glamour: landscape, identity and material culture in the Iron Age* (Oxford: Windgather Press, 2012).

7. Melanie Giles, '"Seeing red": the aesthetics of martial objects in the Iron Age of East Yorkshire', in Duncan Garrow, Chris Gosden and J.D. Hill (eds), *Rethinking Celtic Art* (Oxford: Oxbow, 2008), pp. 59–77.

8. Pliny the Elder, *The Natural History, Book XXXII: Remedies derived from aquatic animals*, trans. J. Healey (London: Penguin, 2005).

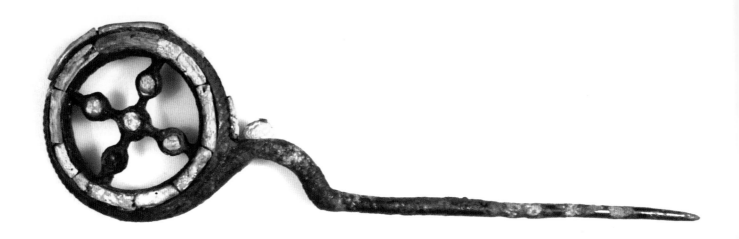

Figure 28: Danes Graves wheel-headed pin (Burial DG42, YORYM: 1948.930.1). Courtesy York Museums Trust (Yorkshire Museum).

weapons more effective: possessing a supernatural power to ward off violence, whilst its inclusion on more decorative items like the pin may have helped protect this powerful woman's body from malign intent. The exotic origin of this substance also conferred power upon those who wielded it, demonstrating their connections with distant lands through long-distance journeying or exchange.[9]

Coral caught the eye: adorning, protecting and empowering its Iron Age wearers.

References

Melanie Giles, '"Seeing red": the aesthetics of martial objects in the Iron Age of East Yorkshire', in Duncan Garrow, Chris Gosden and J.D. Hill (eds), *Rethinking Celtic Art* (Oxford: Oxbow, 2008), pp. 59–77.

Melanie Giles, *A forged glamour: landscape, identity and material culture in the Iron Age* (Oxford: Windgather Press, 2012).

William Greenwell, 'Early Iron Age Burials in Yorkshire', *Archaeologia*, LX (1906), pp. 251–324.

John Robert Mortimer, 'The Danes Graves', reprint from the *Annual Report of the Yorkshire Philosophical Society* (1897), pp. 1–10, plates I–III.

John Robert Mortimer, *Forty Years Researches in British and Saxon Burial Mounds of East Yorkshire* (London: Dent, 1905).

John Robert Mortimer, 'Danes Graves', *Transactions of the East Riding Antiquarian Society*, 18 (1911), pp. 30–52.

Pliny the Elder, *The Natural History, Book XXXII: Remedies derived from aquatic animals*, trans. J. Healey (London: Penguin, 2005).

Ian M. Stead, *The Arras Culture* (York: The Yorkshire Philosophical Society, 1979).

9 Giles, *A forged glamour*.

7 Red coral beads, Benin City (nineteenth century)

Stephen Terence Welsh

Manchester Museum acquired a set of eight red coral beads from Benin City, in south-west Nigeria, in 1956 (acc. no. W.A.55A; fig. 29, centre back, and fig. 30). The beads were part of a much larger consignment of approximately 3,000 ethnographic objects transferred from Halifax Museum. Henry Ling Roth (1855–1925), a widely published and experienced anthropologist, donated the beads to Halifax Museum in 1901. At the time of donation Ling Roth was part-time curator at Halifax Museum, and had been since 1890. In his alarmingly titled book *Great Benin: Its Customs, Art and Horrors* (1903), he explicitly referenced the beads and wrote at length about the significance of coral to the Edo people and their king, the Oba (fig. 31).

The early twentieth century witnessed a marked increase in publications concerning Benin City, such as Ling Roth's aforementioned text. The stimulus was the destruction of the city during the British-led Benin Expedition of 1897. In retaliation for an attack on a British delegation, a heavily armed punitive expedition force of 1,200 devastated and looted the city. The British protectorate of Southern Nigeria was established and hundreds of culturally significant objects were sold to recoup expedition costs. Oba Ovonramwen, the reigning king at the time, was exiled and his precious red coral bead regalia taken.

For centuries red coral beads have signified the powerful political status of the Oba and of their royal officials and chiefs. This exotic and rare commodity was initially imported from the Mediterranean by Portuguese merchants in the late fifteenth century. Trade with Europe increased the wealth of Benin City, and coral became indelibly linked with prosperity. It also represented the Oba's expert ability to administer foreign trade relations. Thus only the Oba is permitted to wear entire costumes and associated regalia made from woven red coral beads. His royal officials and chiefs are only allowed to wear coral necklaces in order to signify rank.

Beyond secular authority red coral beads also have a cosmological and mystical importance to the Oba and the Edo people. Edo oral tradition recounts how during his reign in the fifteenth century Oba Ewuare adeptly stole coral beads from Olokun, the god of waters, from a river at Ughoton village. Once in his possession the beads signified his right to rule over dry land, while Olokun would continue to govern the waters. This divine right was further strengthened by the power of *ase*. Both coral and stone red beads are imbued with this power which when held by the Oba ensures that his proclamations will happen with complete certainty.

The years following the Benin Expedition were entirely uncertain for Benin City and the Edo people. It was not until 1914 that the monarchy was re-established, albeit a curbed version, but the coral regalia remained abroad. By 1938 the British agreed to return pieces of the regalia to Oba Akenzua II (1933–78), grandson of Ovonramwen. With the regalia back in Benin City, the traditional rites of kingship could be exercised. Oba Erediauwa, the current king, continues to practice these customs including the use of coral beads.

References

Margret Carey, *Beads and Beadwork of West and Central Africa* (Oxford: Shire Publications Ltd, 1991).

Paula Girshick Ben-Amos, *The Art of Benin* (London: British Museum Press, 1995).

Helga M. Griffin, 'Roth, Henry Ling (1855–1925)', *Australian Dictionary of Biography*, vol. 11 (Carlton, Vic.: Melbourne University Publishing, 1988), pp. 461–2.

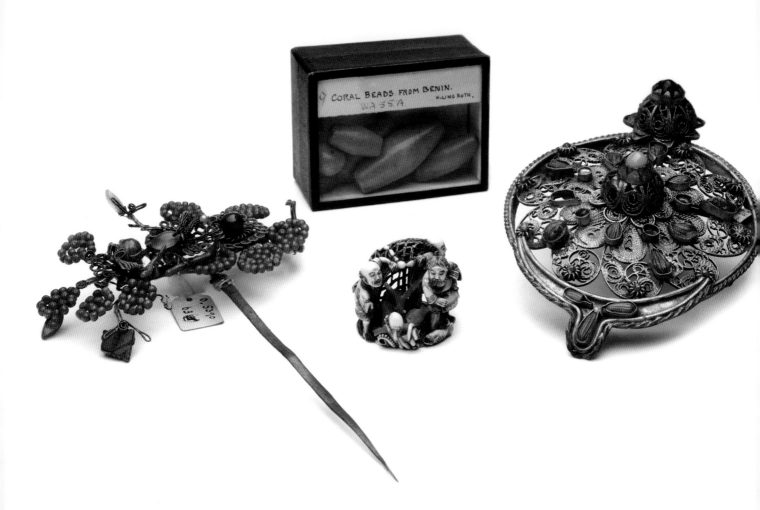

Figure 29: Objects from Manchester Museum's Living Cultures collection: hair pin from China (left), netsuke from Japan (front, centre); beads from Benin (back, centre); and belt buckle from India (right). Photo: Paul Cliff.

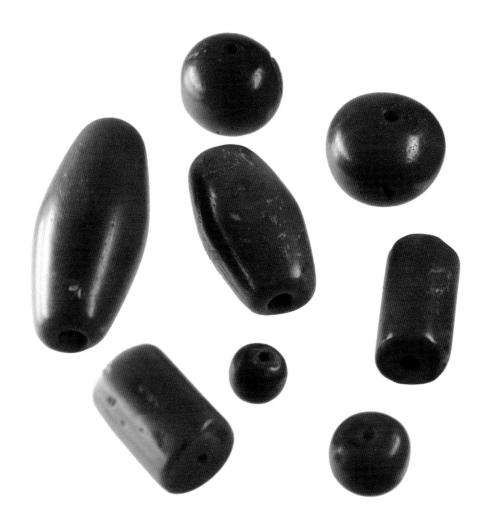

Figure 30: Eight red coral
beads from Benin City,
Living Cultures collection,
Manchester Museum.
Photo: Phillip Rispin.

Figure 31: Henry Ling
Roth, illustration of coral
beads, in *Great Benin: Its
Customs, Art and Horrors*
(Halifax, L. King & Sons
Ltd, 1903), p. 19.

Fig. 9.—1. Coral bead, 1¼in. (380 mm. long.
 2. Agate bead, 1¼in. (380 „) „
 3. Coral bead, ⅜in. (95 „) „
 4. Coral bead, ¹⁄₁₆in. (63 „) „
 5. Coral bead, ⅝in. (160 „) „
 6. Coral bead, 1¼in. (318 „) „
Bankfield Museum, Halifax.

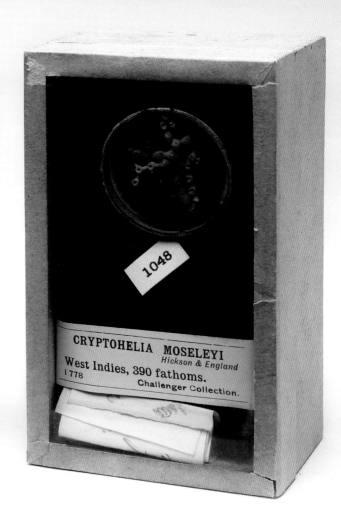

I. 632
Alcyonar
Chall:
H.M.S. Porcupine

CRYPTOHELIA MOSELEYI
Hickson & England
West Indies, 390 fathoms.
1778 Challenger Collection.

1048

8 The Challenger expedition

Henry McGhie

The expedition of HMS Challenger, which took place during the years 1872–76, was the first scientific expedition of the deep oceans. It transformed the way in which people thought about and understood the life of the depths of the sea. The expedition measured the weather, currents, temperature, sea floor conditions and marine life at 362 places around the world, sailing 127,580 km in total.

A variety of equipment was used, including dredges, nets and measuring devices. Samples were collected by slowly winding cables thousands of metres down to the sea floor – a process taking ponderous lengths of time and causing great boredom to the ship's crew. Thousands of animals and plants were collected and preserved. These were studied by experts after the expedition returned to Britain; the results were published in 83 *Challenger Reports* in 32 volumes. Specimens were given to a small number of museums, including Manchester Museum. About 4,700 new species were discovered; specimens of these new species are still important as 'type specimens', which define scientific names. Corals, jellyfish, sea anemones and Portuguese men o' war (a type of siphonophores) were described in 11 reports, with two of these written by the famous zoologist Ernst Haeckel. Of the 293 species of stony corals collected, a quarter belonged to new species.

Two members of Manchester Museum staff are associated with the Challenger expedition. Frederick Pearcey (1855–1927) was a member of the naval crew of the Challenger expedition. He assisted the scientists by preserving specimens and became an expert on microscopic animals. He helped to write the official reports about the expedition. Pearcey worked in the Museum from 1889 to 1898 as a zoologist. He gave his collection of microscope slides, including many specimens collected on the Challenger expedition, to the Museum. William Hoyle (1855–1926) was the first Director of the Museum from 1899 to 1909. He wrote the volume of the Challenger reports on cephalopods (squid, octopus and nautilus).

References

Richard M. Corfield, *The Silent Landscape: The Scientific Voyage of HMS Challenger* (Washington, D.C.: Joseph Henry Press, 2003).

Eric Linklater, *The Voyage of the Challenger* (London: George Rainbird Cardinal, 1974).

Helen M. Rozwadowski, *Fathoming the Ocean: The Discovery and Exploration of the Deep Sea* (Cambridge, Mass. and London: Harvard University Press, 2005).

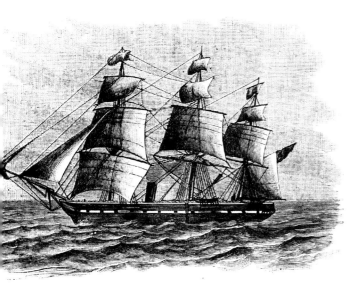

9 Sydney Hickson (1859–1940)

Henry McGhie

Sydney Hickson was one of the most eminent zoologists of the late nineteenth and early twentieth centuries. He studied the distribution, classification, taxonomy, embryology and development of corals – especially soft-bodied corals – and published many articles and books on them.

Hickson was the son of a wealthy London shoemaker and disgusted his family with the variety of living things he took home from the open country around his home in Hampstead. As a young man, he listened to lectures by Thomas Huxley, better known as 'Darwin's Bulldog', since he was a fierce supporter of evolution by natural selection. Hickson entered Downing College, Cambridge, in 1877 and by the time he graduated in 1881 he had already published an article on the eyes of the scallop. He became a demonstrator to Henry Moseley, recently returned from the Challenger expedition, in Oxford. From this time on Hickson studied the anatomy of soft-bodied (as opposed to reef-forming) corals. His interest in animals' eyes continued and he studied a variety of animals in this respect, producing an important paper on the insect eye in 1885.

In 1885–86 he travelled around the Makassar district of Celebes (now Sulawesi), described in *A Naturalist in North Celebes* of 1889. He was fascinated by the coral reefs of Talisse: 'a tremendous interchange of goodwill between the different kinds of animals getting their living on a coral reef...the greatest struggle for existence that there was anywhere in the world.' After this expedition he returned to Cambridge and to University College London. He spent 1889 in Canada with his uncle, Sir Sydney Waterlow (retiring Lord Mayor of London), returning the following year to Cambridge as a lecturer, and studied the embryology and development of soft-bodied corals.

He became the Beyer Professor of Zoology at Owens College (now the University of Manchester) in 1894. His predecessor had also been a devotee of soft-bodied corals. Hickson became a leading educational reformer, promoting the teaching of natural history in Lancashire schools, and he wrote two successful popular books on marine life to encourage interest in marine science. Hickson committed himself to the reorganization of the University and the expansion of teaching. He supported educational equality for women and was a Governor of the Manchester High School for Girls. He was especially heavily involved with the Manchester Museum, giving many public lectures and publishing a number of articles in the series of Museum publications. He acted as the Museum's Director for six months in 1909. Hickson was also widely consulted on matters relating to public health, such as animal pests in slums and parks and in the water supply. He was a leading figure in the Manchester Literary and Philosophical Society and of the Microscopical Society, serving as President of the latter for most of his time in Manchester.

In the early twentieth century he studied the coral collections of the Siboga expedition, more substantial even than those of the Challenger expedition. He published *An Introduction to the Study of Recent Corals* in 1924, describing reefs as 'a huge, living, pulsating organism slowly stretching out an arm here and withdrawing one there, in some places showing youth and vigour, in others disease and death.' He returned to Cambridge in 1926, lecturing on corals and jellyfish. Later research was based on collections from Panama, the Great Barrier Reef, the Society Islands and the Red Sea.

Most of Hickson's collection of corals was given to the British Museum (Natural History), now known as the Natural History Museum. Some specimens, including type specimens and specimens from Sulawesi, were given to the Manchester Museum during his time at the University there and are still found in the collections. One colleague described Hickson as having 'the old fashioned naturalists' great interest in animal life, the anatomists' interest in structure, and the endless patience of the good systematist.'

Figure 35: Two coral specimens collected by Sydney Hickson, Manchester Museum Zoology collection. Photo: Paul Cliff.

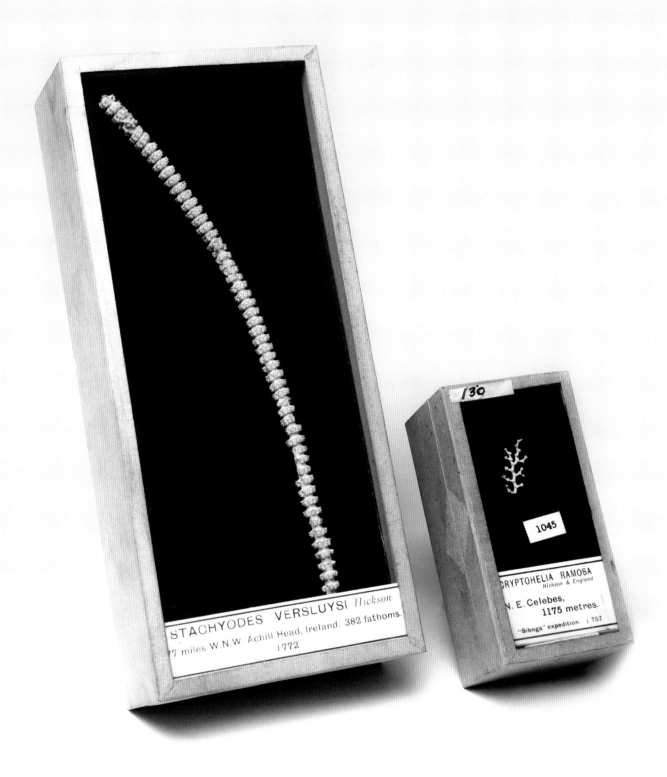

STACHYODES VERSLUYSI *Hickson*

77 miles W.N.W. Achill Head, Ireland. 382 fathoms.

1772

130

1045

CRYPTOHELIA RAMOSA
Hickson & England

N. E. Celebes,
1175 metres.

"Siboga" expedition. 1 752

References

Stanley J. Gardiner, 'Sydney John Hickson, 1859–1940', *Obituary Notices of the Fellows of the Royal Society*, 3.9 (January 1941), pp. 383–94.

Sydney J. Hickson, *The Fauna of the Deep Sea* (London: Kegan Paul, Trench, Trübner & Co., 1894).

Sydney J. Hickson, *An Introduction to the Study of Recent Corals* (Manchester: University Press, 1924).

Sydney J. Hickson, *A Naturalist in North Celebes* (London: John Murray, 1889).

Sydney J. Hickson, *The Story of Life in the Seas* (London: George Newnes, 1897).

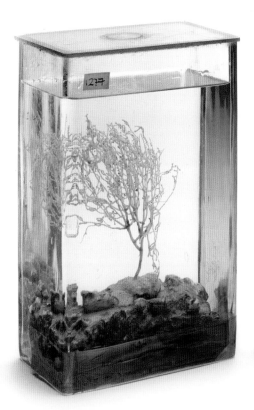
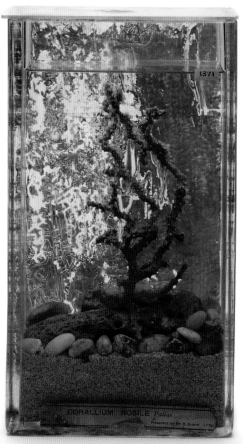
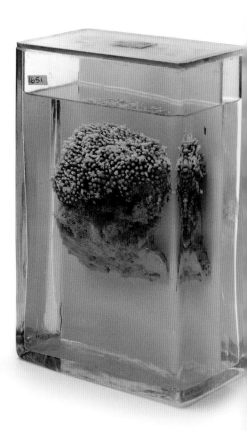

Figure 36: Selection of
spirit specimens from
Manchester Museum's
Zoology collection:
Deep-water bamboo coral
(*Acanella arbuscula*, left);
Red coral (*Corallium nobile*,
centre); Red organ pipe
coral (*Tubipora musica*,
right). Photo: Paul Cliff.

Figure 37: Cover of Matthias Jacob Schleiden's popular book on the life of the sea, *Das Meer* (Berlin: Sacco, 1867). Courtesy NOAA Photo Library.

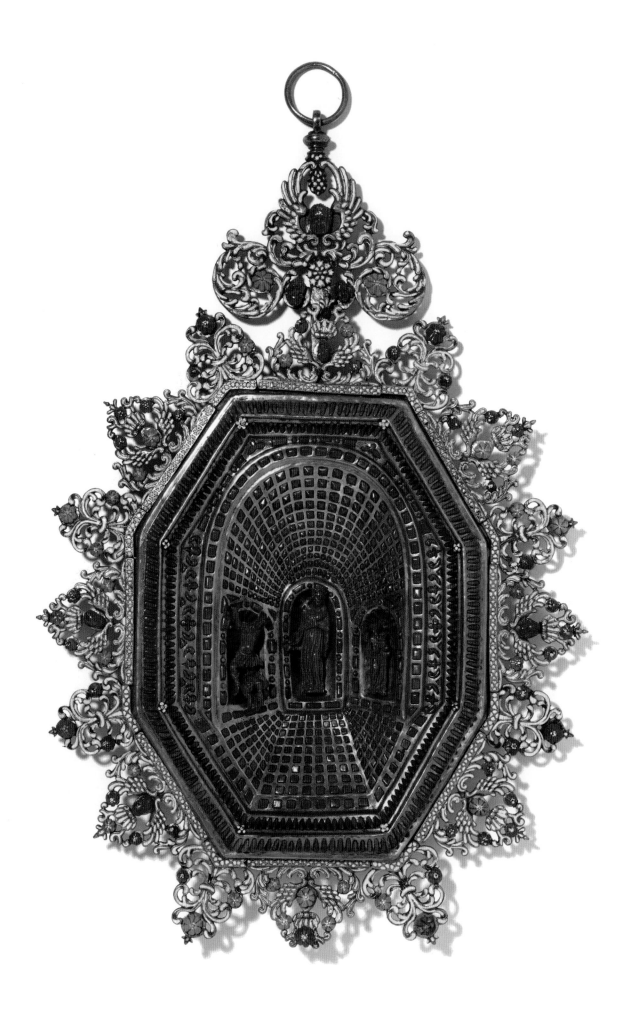

10 Coral shrine from Trapani (*c.* 1650)

Marion Endt-Jones

Figure 38: Shrine made in Trapani, Sicily, *c.* 1650, copper-gilt set with enamel and coral, h.: 50 cm, w.: 32 cm, d.: 4.5 cm. Courtesy V&A, London.

Decorative and devotional objects crafted from gilt metal and carved coral are a speciality of Trapani on the West coast of Sicily. This small shrine, which would have been used as an aid to prayer at home and in the church, probably shows Saint Rosalia, a medieval hermit and the patron saint of nearby Palermo, flanked by Saint Anthony of Padua and a female martyr.

During the eleventh and twelfth centuries, Mediterranean coral fishing, workshops and trade were centred around Marseille and Genoa, but when Jewish merchants and artisans settled in coastal towns like Trapani, Torre del Greco (near Naples), Livorno and Alghero (Sardinia), they began to dominate commercial activities. A veritable 'coral boom' took place in Trapani from the sixteenth to the eighteenth century. In 1698, more than 40 coral workshops operated in via dei Corallari – all of them renowned for their superior craftsmanship.

Coral fishermen set out in small boats to harvest the prized red coral (*corallium rubrum*) from the depths, using a cross-shaped wooden device, the 'ingegno', which had fishing nets dangling from its four ends, to pluck the coral branches from the rocks on which they grew. Then the precious catch was processed: the branches were dried, cut, polished, perforated and shaped into small figures, jewellery, cameos and talismans, as well as devotional objects like rosaries, crucifixes, monstrances, holy water stoups, cups and shrines, and decorative vessels exported to courts all over Europe. The technique of 'retroincastro', or inlay, characteristic of the shrine of Saint Rosalia, was developed in the seventeenth century. It involved setting small coral 'droplets' into gilded copper, bronze or silver, and fixing them with wax and pitch.

With the near-exhaustion of the majority of the coral banks off the coast of Trapani in the nineteenth century, Sicilian coral fishing, craftsmanship and trade fell into decline. Today coral survives as one of Sicily's main tourist attractions: souvenir and jewellery shops selling coral ornaments and trinkets can be found all along its coasts. At the moment, the trade in some coral species is regulated, but not banned, by CITES (the Convention on International Trade in Endangered Species of Wild Fauna and Flora). In 2010, however, CITES failed to approve a proposal jointly put forward by the United States and the European Union to list 32 species of red and pink coral in Appendix II of the Convention. This would have prompted countries to ensure international trade in all of these corals is sustainable and regulated. As it stands, efforts to increase Marine Protected Areas in the Mediterranean – in order to prevent *corallium rubrum* and other marine life from depletion and, eventually, extinction – are under discussion.

References

Vincenzo Abbate (ed.), *Wunderkammer siciliana: alle origini del museo perduto* (Naples: Electa Napoli, 2001).

Antonio Daneu, *L'arte trapanese del corallo* (Palermo: Banco di Sicilia, Fondazione Ignazio Mormino, 1964).

Cristina Del Mare and Maria Concetta Di Natale, *Mirabilia corallii: Baroque masterpieces in coral by Jewish and Sicilian craftsmen in Trapani* (Naples: Arte'M, 2009).

Maria Concetta Di Natale, *Splendori di Sicilia: Arti decorative dal Rinascimento al Barocco* (Milan: Edizioni Charta, 2001).

Basilico Liverino, *Il corallo dalle origini ai nostri giorni* (Naples: Edizioni dell'arte Tipografica, 1998).

Valeria Patrizia Li Vigni, Maria Concetta Di Natale and Vincenzo Abbate (eds), *I grandi capolavori del corallo: I coralli di Trapani del XVII e XVIII secolo* (Milan: Silvana Editoriale, 2013).

Leonardo Pisciotta, 'Rosso di mare', *MCM*, 64 (June 2004), pp. 33–36.

Figure 39: *The Archangel Michael*, coral brooch, Italy, seventeenth or eighteenth century, h.: 13.5 cm. © The Fitzwilliam Museum, Cambridge.

11 Mark Dion, *Blood-Coral* (2011)

The experiment: a recollection

Gerhard Theewen

Full of anticipation for a festive dinner with Mark Dion – one of my very favourite artists – I arrived at his house much too early. I decided to pass the time until the entrance of other guests by browsing his library and examining the table decoration.

Since both the artist and I share a famous fascination with the *Kunst-* and *Wunderkammer*, my eyes were immediately drawn to the *Natternzungenkredenz*, which formed the centrepiece of the lavishly decorated table. Suspended from a blood red, unusually large and intricately branching coral twig, mounted on a gold-coloured, metal stand, were numerous fossilized shark teeth slotted in metal holders; during the Renaissance and Baroque periods these shark teeth were believed to be the tongues of vipers or dragons. Kings, dukes and members of the high clergy would use such tabletop ornaments as indicators of poisons that might have been slipped into the food and drink being served. Having removed the 'viper's tongue' from the coral branch, lunch or dinner guests would dip it into their cup and hold it above their plate – a procedure called 'dare la credenza'. After subjecting this strangely beautiful object to close scrutiny, however, I began to doubt its age. Could it by chance be a replica, made in recent times with extra special care? I decided to broach the question with the artist – not without the necessary restraint – in the course of the evening.

Since I still had some time left before the other guests arrived, I studied the rows and rows of shelves, which, reaching from the floor to the high ceiling, were overflowing with books on every imaginable subject – especially that of *naturalia, scientifica, artificialia, rara* and *curiosa*. Letting my gaze wander across the spines, I noticed, not without satisfaction, that many titles matched those in my own library.

While I was still admiring and contemplating, time seemed to stretch out; I turned back to the table and carefully lifted one of the teeth out of its place. In front of me stood a glass of wine, handed to me upon entering the house, and out of pure mischief, I plunged the shark tooth into it. To my utter amazement, the colour of both tooth and wine changed immediately; the tooth took on an unsightly discolouration, while the wine turned a sulphurous yellow. I quickly returned the tooth to the coral branch and cast a searching glance around the room – I was still on my own.

As the wine in my glass had since returned to its pleasant golden colour, I overcame my initial hesitation and took a sip; it was 2011, after all, not the sixteenth century! In terms of taste, absolutely nothing seemed to be wrong with the wine – a full-bodied white Burgundy with an interesting touch of brass, stone and resin on finish. The alcohol level it contained was equally impressive. Therefore, when a waiter approached with the bottle, I was happy to have my glass refilled. This must have been repeated a few times, for suddenly the room around me began to spin and shake in uncontrollable circle- and wave-like movements. I sank to the floor... On the verge of losing consciousness, I thought: 'So it *is* poisoned after all!' Then suddenly – as if in a great distance – the door opened and the artist rushed over and said, bending down to me: 'My dear friend, I hope you haven't been bored! Why don't we make the magnificent blood-coral into an exquisite limited edition?'

Translated from the German
by Marion Endt-Jones.

Figure 40: Mark Dion, *Blood-Coral*, 2011, limited edition. Photo: Jean Vong.

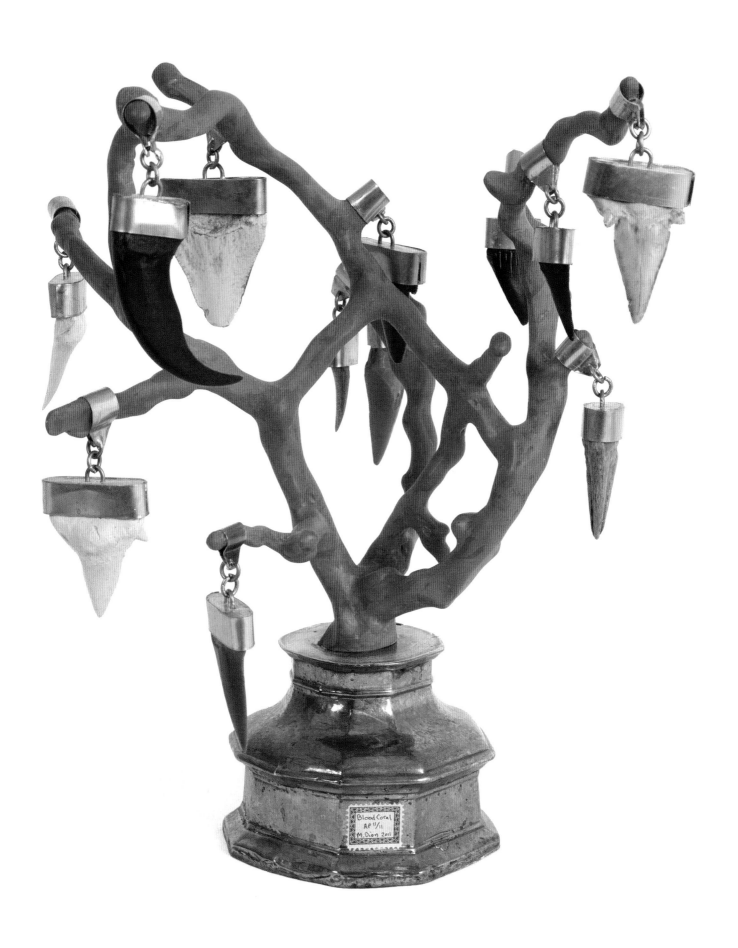

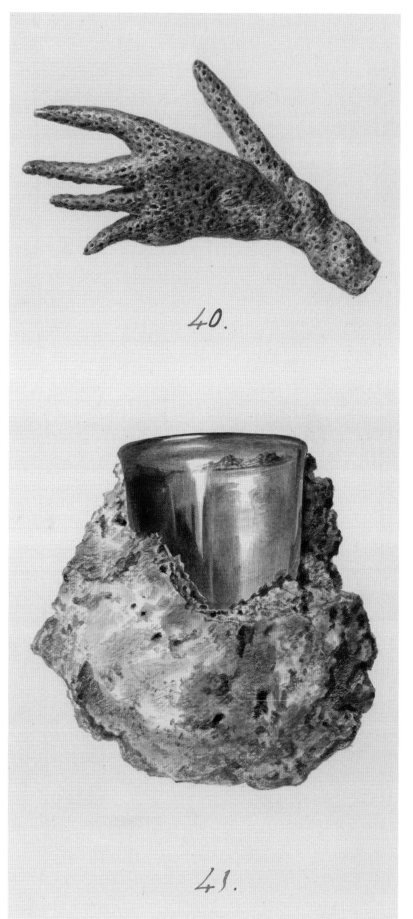

40.

43.

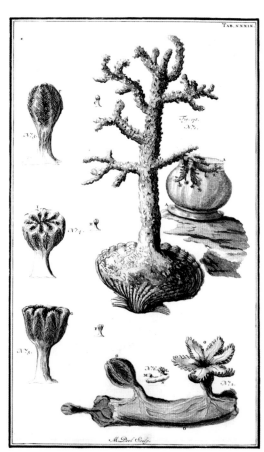

Figure 41: A coral shaped as a hand and a glass incrustated in stone, preparatory drawings for plate XX in Jan and Andreas van Rymsdyk's *Museum Britannicum*, 1778, watercolour on paper.
© Trustees of the
British Museum.

This 'coral hand' was once held in the collections of the British Museum. The true nature of coral was still disputed in the eighteenth century – was coral a vegetable, a mineral, or an animal? This rock-like object shaped like a human hand added further fuel to the debate.

Figure 42: Illustrations of 'flowering' coral, in Louis Ferdinand Comte de Marsilli, *Histoire physique de la mer*, 1725, plate XXXIX.

12 Living rocks: the mystery of coral in the eighteenth century

Susannah Gibson

Deep. Sixty feet below the surface. The pressure on your lungs almost unbearable. Sunlight flutters down. The rope tied beneath your arms cutting into your skin. The stone you carry feeling heavier with each passing second. A fish dazzles past. Then you spot it. The red of fresh blood. The trails of worms in sand. A coral. You pull the rope and are returned to the alien world of air and sky. Your prize is a good one, but it is not for you to keep. You place it in a rough sack with the others. Fifteen minutes to breathe freely, twenty if you are lucky. Then down again to the silent sea bed while your newly captured coral begins a different journey.

Corals from the Caribbean (often collected by slaves) were in high demand in eighteenth-century Europe. There, these strange objects were much sought after for display and jewellery, for medical purposes, or as objects for scientific study. Coral had long been a valuable commodity in the Old World but, even in the eighteenth century, little was known about it. The most basic question remained unanswered: was a coral an animal, a vegetable or a mineral? For thousands of years, the most common answers were vegetable and mineral, or perhaps a hybrid of the two (fig. 41). But in the eighteenth century, as corals were studied more and more closely, a new answer began to emerge.

In 1706, the famous Italian naturalist Count Luigi Ferdinando Marsigli spent some months in Marseille where he befriended a group of coral fishermen who brought him fresh specimens. Convinced that he could see flowers blooming from the branches of corals, Marsigli believed that corals were plants (fig. 42). He showed these so-called flowers to the young son of his host in Marseille. This boy, Jean-André Peyssonnel, fascinated by what the great Marsigli showed him, began his own life-long passion for these mysterious objects. Twenty years later, when he had qualified as a doctor and accepted a post in Guadeloupe, Peyssonnel could continue his study in a new world filled with new corals.

Peyssonnel's first observation was that touching or pouring acid on a coral caused its 'flowers' to retract. Sense of touch is a property usually associated with animals, and Peyssonnel began to doubt that corals were plants. Investigating further, he found that the 'flowers' were really the tentacles of tiny animals that lived within a coral. He showed that each of these animals built itself a hard cell in which to live, just as an oyster forms a shell for protection, and that hundreds or thousands of these cells grew together to form the hundreds of peculiar shapes of corals. The mystery of the corals' origin was solved. But they retained a different kind of mystery – of the deep, of the exotic, of new worlds – and, for decades to come, the fashions of Europe would continue to impel young men on a dangerous journey to the bottom of the sea.

References

James Delbourgo, 'Divers Things: Collecting the World Under Water', *History of Science*, 49 (June 2011), pp. 149–85.

Steve Jones, *Coral: A Pessimist in Paradise* (London: Abacus, 2008).

Herbert S. Klein, *The Atlantic Slave Trade* (Cambridge: Cambridge University Press, 1999).

Jean-André Peyssonnel, 'Traité du corail, contenant les nouvelles découvertes...', *Philosophical Transactions of the Royal Society*, 47 (1751), pp. 445–69.

Figure 43: Sarah Stone, *Study of Shells and Coral*, eighteenth century, pencil, watercolour and bodycolour (heightened with white) on paper, 395 × 543 mm. © Whitworth Art Gallery, The University of Manchester.

The natural history illustrator Sarah Stone was employed by Sir Ashton Lever (1729–1788) to record his vast collection of 'objects of curiosity'. The collection contained a number of objects collected on Captain Cook's second and third voyages. Stone embarked on an extensive illustration project, producing more than a thousand watercolours of various specimens from Lever's museum in Leicester House, London (also known as *Holophusicon*) from the late 1770s until the sale of his collection in 1786. This watercolour is an example of Stone's record of a collection that included 'Corals, Corallines, Sea plants, Sea Weeds and Spunges'.

Figure 44: Coral attached to a bivalve shell, Manchester Museum, Zoology collection. Photo: Paul Cliff.

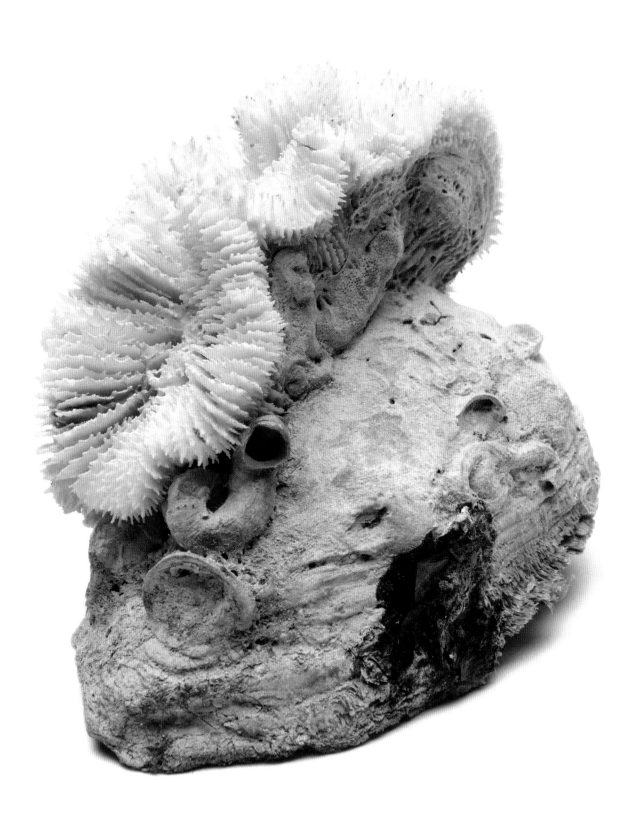

IIII

Fig. 2 Nummus argenteus Hispanicus, cuj Lapis astroites innascitur, ab eodem naufragio expiscatus.

Fig. 2.

Fig. 3. Nummus argenteus Hispanicus, substantia Lapidea incrustatus, ab eodem naufragio expis-_____catus.

Fig. 3.

Fig. 1.

Fig. 5. Urtica marina solu_____ longissimis.

Fig. 4. Nummi Hispanici argentei quin-_____que æruginosi, & inter se _____cohærentes, ab eodem _____naufragio expiscati.

Fig. 4.

Fig. 1. Navis, prope Hispaniolam ann. Dom. 1659. Naufragium passæ, asser, a clavo ferreo transfixus, e corallio aspero candicante I.B. Obsitus, & a fundo Maris anno 1687. expiscatus.

M.V. Gucht Sculp

"Sunken treasures, the once-buoyant nautical crafts are now anchored to the bottom of the ocean as fantastic sculptures in a vast underwater garden. Here, these humbled navigators commence a new, sedentary existence: their whole physiognomy starts to metamorphose, camouflaging into the hues and textures of the marine scenario, in the same way that loose memories and idle fantasies slowly conform to the irregular panorama of our psyche. Contraband fixtures of the undulatory ocean desert, these capsized vessels develop and unfold, like madrepores, from the abandoned carcasses of transient creatures, one corpse piling upon another as in the mineral chimneys of coral reefs, which grow taller with each discarded life."

Celeste Olalquiaga, *The Artificial Kingdom*, 2002

13 *Expiscatus*!

James Delbourgo

If you're a collector of curiosities in the seventeenth or eighteenth century, there's a good chance your cabinet is stocked with delicate branches of coral, artfully arranged to dart from its apex, or perhaps tucked neatly into little drawers. Red coral is particularly prized. It's beautiful. It's curiously intricate. And coral's a puzzle of natural history: how does it form? Is it vegetable or animal? Mysteries of creation! Puzzles of the deep!

But how do you procure this coral? Do you collect it yourself? Do you even know how to swim, or know anyone who can? Highly unlikely: swimming only becomes fashionable among Europeans in the nineteenth century, and really, it's not very gentlemanly. Maybe you bought it at auction or from some trafficker in rarities? Fair enough. But how did they get it? If you've managed to lay your hands on some of the exotic stuff, say some Ceylon or Caribbean coral, you must be well connected. But connected to whom or what?

The image opposite isn't pretty coral. It's a coral-encrusted *thing*. It's not cleaned up, carved out or polished off – and that's the point, that's why it's curious. It's from the collections of Hans Sloane (1660–1753), founder of the British Museum, who spends fifteen months in Jamaica as the governor's physician during 1687–89. A coral-encrusted spar from a sunken Spanish galleon, accompanied by encrusted silver coins, fished – *expiscatus!* – from a wreck off the island of Hispaniola several fathoms below the surface of the Caribbean Sea.

This corkscrew of art and nature is twisted Baroque beauty: its misshapenness embodies the curiosity that lies in not knowing where nature ends and art begins. Human machinery of navigation and commerce, transfigured by the chemistry of brine and the encasing embrace of coral.

Sloane's coral is a curiosity that follows, not leads: that rides waves of treasure into the coffers of ambitious salvage men, trickling into the cabinets of the curious. In Sloane's Jamaica, salvage dives are a going concern for the English as they struggle against Spain's American supremacy. The best they can do for decades is an ingenious parasitism: stealing in the depths when Spanish treasure fleets flounder on Caribbean shoals, suddenly dragging their slave-mined bullion into the abyss.

This helps explain what the future founder of the British Museum is doing in Jamaica in the first place. The small fortune his patron, the Duke of Albemarle, has already made in London as a salvage investor persuades his dissolute lordship to accept the island's governorship. Water, not land, holds the key to his torrid zone power-grab: less England's rising sugar colony

Figure 45: Coral-encrusted spar and coins from the Caribbean Sea, engraving from Hans Sloane, *A Voyage to the Islands*, vol. I (1707), detail. Photo: James Delbourgo.

and slave island than what sinks below the surface – if it can be freed from the coral that encloses it.

Rudimentary tubs are already in use as diving bells, but these are only the darkest glimmers of the submarine dream of Captain Nemo's *Nautilus*. Fortunes like Albemarle's are made, rather, by enslaved divers: probably Native Americans from Florida, and likely Africans too. These people can swim and dive in a way Europeans cannot comprehend, fishing the deep for bullion and trawling curiosities up with them. Forty-five minutes under water, it's said, with only an oil-soaked sponge as a breathing apparatus.

Packed into row-boats that make for the site of the wreck, they're chucked into the deep, with a stone tied to their ankle, and when far enough down, hack their way with crow-bars through the coral as well as they can. The treasure-laden *Golden Lion*, for example, says the Jamaica traveller John Taylor, lay womb-like in 'a perfect rock'. 'Being beaten to pieces, there have bin severall thousand dollars and other plat found to be intombed within the bowells of this gro-weing stonny sea tree called the whitcorall'.

Coral, not as a curiosity, but a barrier: an object not of beauty but violence. An obstacle to be hacked through by a slave diver working for a pittance in the depths, under threat of violence when they come up for air. Followed in time by a certain coral corollary, in metropolitan portraits like Pierre Mignard's *Louise de Kéroualle, Duchess of Portsmouth* (1682; fig. 46), where an African girl presents underwater tribute to her mistress: red coral and pearls flowing from a cornucopian nautilus shell. The wet dream of empire: treasure, beauty, slavery.

Though early modern folk might not agree, Sloane's coral-encrusted spar is in fact more valuable than all the pretty coral of the finest cabinets put together. Because in not releasing its quarry, this coral asks the viewer, *what am I? How did I get this way?*

Capital and labour, beauty and curiosity, art and nature: histories fused in the abyss – *corallium encrustatus*.

Expiscatus!

References

James Delbourgo, 'Divers Things: Collecting the World Under Water', *History of Science*, 49 (2011), pp. 149–85.

Peter Earle, *The Wreck of the Almiranta: Sir William Phips and the Search for the Hispaniola Treasure* (London: Macmillan, 1979).

"I rushed to the window and saw crusts of coral: fungus coral, siphonula coral, alcyon coral, sea anemone from the genus *Caryophylia*, plus myriads of charming fish including greenfish, damselfish, sweepers, snappers, and squirrelfish; underneath this coral covering I detected some rubble the old dredges hadn't been able to tear free – Iron stirrups, anchors, cannons, shells, tackle from a capstan, a stempost, all objects hailing from the wrecked ships and now carpeted in moving flowers."

Jules Verne, *Twenty-Thousand Leagues Under the Sea*, 1870

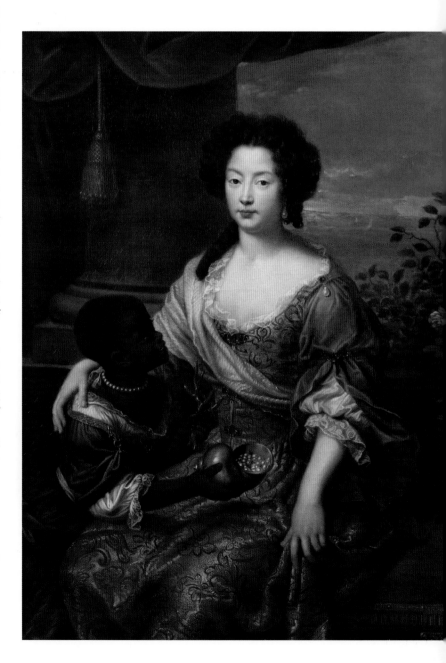

Figure 46: Pierre Mignard, *Louise de Kéroualle, Duchess of Portsmouth*, 1682, oil on canvas, 207 × 953 mm. © National Portrait Gallery, London.

Figure 47: Female deity figure carved from pink coral, China, 1850–1899, h.: 22 cm. Photo: Alan Seabright. © Manchester City Galleries.

14 Darwin's theory of coral reef formation

Alistair Sponsel

Twenty years before Charles Darwin published his evolutionary theory he was already renowned for the elegant theory of coral reef formation he developed during his five-year voyage around the world (1831–36) on the British naval surveying ship HMS *Beagle*. This theory offered a new answer to a pair of well-known questions of the day: what was the origin of the low, ring-shaped reefs that we now call atolls, and why did they possess their characteristic form of a narrow reef encircling a shallow lagoon? Standing in the deepest parts of the ocean, hundreds or thousands of miles from high land, these reefs posed a great threat to navigation in the Pacific. Knowing why and how they formed where they did was a question of great practical significance for navigators, for it would aid in predicting their location and in gauging how quickly new reefs might form in areas that had already been charted.

The notion that the phenomena we call 'coral reefs' were created by coral animals dates to the late eighteenth century. Johann Reinhold Forster, the naturalist on James Cook's second Pacific voyage (1772–75), argued that these 'animalcules' possessed an instinct to erect structures from the floor of the ocean and to protect within them a calm inner lagoon where juvenile corals might flourish. Although Forster's claim that reefs were built by corals has been embraced ever since then, naturalists from the 1820s onward have doubted that reef-building corals could inhabit the deep waters of the ocean's floor. By 1831, the year Darwin departed England on the *Beagle*, a new theory had emerged to explain how shallow-water organisms could form a ring-shaped structure near the surface of oceans so deep as to be literally unfathomable using the lengths of rope most navigators carried on their ships. Indeed, the *Beagle*'s Captain

FitzRoy was instructed by the British Admiralty to spend time during the voyage evaluating this 'modern and very plausible theory', which argued that atolls must be formed atop submarine volcano craters whose rims lay at the shallow depths in which corals could flourish.

Darwin joined the voyage as a twenty-two year old enthusiast of marine zoology, and he spent a great deal of his time in the first three years of the voyage studying the various plant-like colonial organisms then classed as 'zoophytes', including the non-reef-forming corals of the Atlantic. In the final year of the voyage, when the *Beagle* passed rapidly through the Pacific and Indian Oceans and encountered several atolls as well as reefs encircling the shoreline of high islands such as Mauritius, Darwin was struck by a new explanation for how and why atolls were formed. He claimed that ring-shaped reefs encircling a shallow lagoon were caused by sinking of the ocean floor in an area where an island like Mauritius had reefs growing around it. As long as this subsidence proceeded slowly or intermittently, so that the living corals were never drawn below the depths at which they could flourish, the tops of the reefs would remain near sea level while the island they surrounded eventually disappeared beneath the surface of the lagoon. At an intermediate stage in this process, reefs would parallel a coast at some distance, just as they did in encircling the island of Tahiti and forming a barrier to the tropical coast of northeast Australia. Darwin called upon his knowledge of geology to argue that such subsidence was likely in the Pacific. He used his experience in marine zoology to determine that different types of corals inhabited the inner and outer parts of a reef, arguing that an atoll continued to have the shape of the sunken island's coastline rather

Figure 48: Josiah Wood Whymper, *Coral Reefs*, 1843, wood-engraving with hand-colouring and letterpress, published by the Society for Promoting Christian Knowledge, London. Courtesy V&A, London.

CORAL-REEFS.

SOME parts of the ocean are studded with a peculiar kind of rock, very narrow, but stretched out to a considerable length. It is called a *Coral-reef*, and is produced by innumerable small zoophytes popularly called *Coral-insects*. The Coral-insect consists of a little oblong bag of jelly closed at one end, but having the other extremity open, and surrounded by tentacles or feelers, usually six or eight in number, set like the rays of a star. Multitudes of these minute animals unite to form a common stony skeleton called *Coral*, or *Madrepore*, in the minute openings of which they live, protruding their mouths and tentacles when under water, but suddenly drawing them into their holes when danger approaches. These animals cannot exist at a greater depth in the sea than about ten fathoms, and as the Coral islands often rise with great steepness from a sea more than three hundred fathoms deep, it would seem that a great alteration must have taken place in the depth of the ocean since the time when the little architects commenced their labours. Their mode of working is, to build up pile upon pile of their rocky habitations, until at length the work rises to such a height that it remains almost dry at low water. A solid rocky base being thus formed, sea-shells, fragments of coral, sea-hedge-hog-shells, and prickles, are united by the burning sun and the cementing calcareous sand into a solid stone, which gradually increases in thickness, till it becomes so high that it is covered only by the spring tides. The heat of the sun so penetrates the mass of stone when it is dry, that it splits in many places, and breaks off in flakes. These flakes are raised by the active surf, and thrown, with sand and shells of marine animals, between and upon the foundation stones, where they offer to the seeds of trees and plants, cast up by the waves, a soil upon which they rapidly grow, overshadowing the dazzling white surface. Trunks of trees, carried by rivers from other countries and islands, find here, at length, a resting-place; with these come small animals, such as lizards and insects, as the first inhabitants; sea-birds nestle there; strayed land-birds take refuge in the bushes; and at a much later period man also appears, and builds his hut on the fruitful soil.

Reefs are of various forms. In some places they occur at a great distance from the land, and run nearly parallel with it: these are called *barrier-reefs*, and are often of enormous dimensions. Usually a snow-white line of great breakers, with here and there an islet crowned by cocoa-nut trees, separates a broad channel of smooth water from the waves of the open sea. In other places Coral-reefs *fringe* the shore, and are separated from it by a narrow channel of moderate depth: these are called *fringing* or *shore-reefs*.

But perhaps the most remarkable form of reef is that to which the term *Lagoon-Island* has been applied. In this case the reef approaches the form of a circle; and, surrounding a part of the sea, produces a sheet of smooth water called a *lagoon*, or *lake*, within which are usually several smaller islands. From this circumstance the word *island*, as applied to the whole, has been objected to, and the term *atoll* substituted, which is the name given to these circular groups of Coral islets by the inhabitants of the Indian Ocean.

"Every one," says Mr. Darwin, "must be struck with astonishment when he first beholds one of these vast rings of Coral rock, often many leagues in diameter, here and there surmounted by a low verdant island with dazzling white shores, bathed on the outside by the foaming breakers of the ocean, and on the inside surrounding a calm expanse of water, which, from reflection, is of a bright but pale green colour. The naturalist will feel this astonishment more deeply after having examined the soft and almost gelatinous bodies of these apparently insignificant creatures, and when he knows that the solid reef increases only on the outer edge, which, day and night, is lashed by the breakers of an ocean never at rest."

PUBLISHED UNDER THE DIRECTION OF THE COMMITTEE OF GENERAL LITERATURE AND EDUCATION, APPOINTED BY THE
SOCIETY FOR PROMOTING CHRISTIAN KNOWLEDGE.

No. 12.]　　　　　　　　　　　Price ¾d. PLAIN; 2d. COLOURED.　　　　　　　S. BENTLEY AND CO., PRINTERS, BANGOR HOUSE, SHOE LANE.

PARACYATHUS CAVATUS Alcock.
with Pyrgoma stokesii.
Telegraph Cable. 30 fms. 60 Miles.
S. W. of Bushire. Persian Gulf.
A. Prygoma Stokesii. B. Vertical section of a
specimen.
E coll. Townsend.

Figure 49: Coral
(*Paracyathus cavatus*) with
coral-inhabiting barnacle
(*Pyrgoma stokesii*),
Manchester Museum,
Zoology collection.
Photo: Paul Cliff.

These corals –
encrustations encasing
the Persian Gulf
Telegraphic Cable laid
between Britain and
Karachi – were collected
in the 1860s by F.W.
Townsend, Chief of the
Telegraph Staff of the
Indo-European Telegraph
Company and later
Commander of a ship
repairing the telegraph
cable in the Persian Gulf
and Gulf of Oman.

"The island [Haiti] is completely encircled by a reef, with the exception of one small gateway; at this distance a narrow but well defined line of brilliant white where the waves first encountered the wall of coral, was alone visible; Within this line was included the smooth glassy water of the lagoon, out of which the mountains rose abruptly. The effect was very pleasing & might be aptly compared to a framed engraving, where the frame represents the breakers, the marginal paper the lagoon, & the drawing the Island itself."

Charles Darwin, *Journal of Researches* (*Voyage of the Beagle*), 1839

than becoming filled in because lagoon corals were not robust enough to form solid reef rock.

This theory of reef formation was one of Darwin's chief achievements during the voyage and it contributed to his meteoric rise in scientific circles after returning to England in 1836. He described the theory in his extremely popular travel narrative, the 1839 *Journal of Researches* (now often published under the title *Voyage of the Beagle*), and he made it the topic of his first scholarly book, the 1842 *Structure and Distribution of Coral Reefs*. As Darwin worked on his evolutionary theory from the late 1830s to the late 1850s before publishing it in the 1859 book *On the Origin of Species*, his ideas of how to frame a theory and when to publish it were shaped by the experience of producing his first great theory, that of coral reefs.

References

Charles Darwin, *The Structure and Distribution of Coral Reefs: Being the First Part of the Geology of the Voyage of the Beagle, Under the Command of Capt. Fitzroy, R.N. During the Years 1832 to 1836* (London: Smith, Elder and Co., 1842).

Brian Roy Rosen, 'Darwin, coral reefs, and global geology', *BioScience*, 32.6 (1982), pp. 519–25.

David R. Stoddart, '"This Coral Episode": Darwin, Dana, and the Coral Reefs of the Pacific', in Roy M. MacLeod and Philip F. Rehbock (eds), *Darwin's Laboratory: Evolutionary Theory and Natural History in the Pacific* (Honolulu: University of Hawaii Press, 1994), pp. 24–48.

David R. Stoddart, 'Darwin, Lyell, and the Geological Significance of Coral Reefs', *British Journal for the History of Science*, 9 (1976), pp. 199–218.

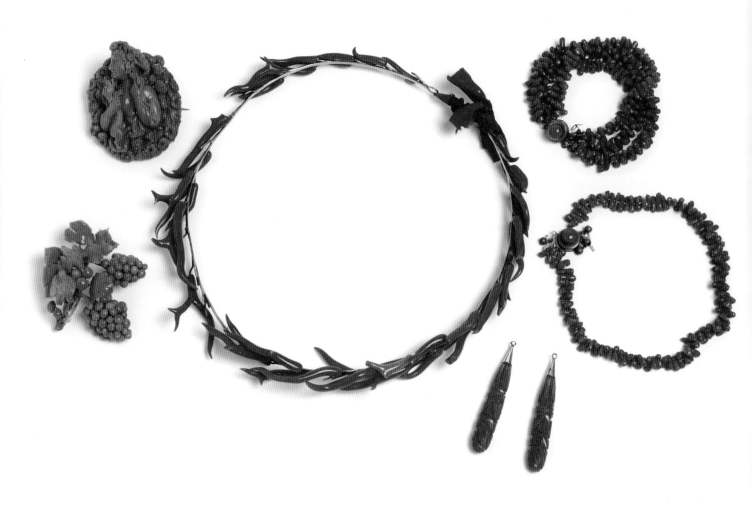

Figure 50: Victorian coral jewellery from the collections of the Gallery of Costume, Platt Hall. Photo: Alan Seabright. © Manchester City Galleries.

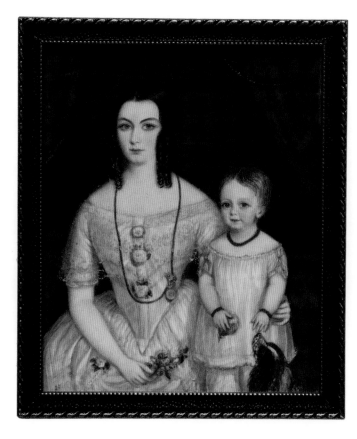

Figure 51: English School, Matilda Gibbon with Daughter, 1848–1850, watercolour paint, gilt, plaster, 12.7 cm × 14 cm. Photo: Alan Seabright. © Manchester City Galleries.

Coral jewellery was popular in the nineteenth century because it was seen as flattering to the wearer's skin colour, but the material also retained its protective, apotropaic connotations, especially for children.

15 Victorian coral jewellery

Katharine Anderson

Coral jewellery, from elaborate tiaras to the vivid strings of beads that feature in the work of Pre-Raphaelite artists like Dante Gabriel Rossetti and Edward Burne-Jones, was an intense though relatively short-lived fashion of the mid-Victorian period. The Mediterranean coral fishing industry, centred in Naples, supplied several colours, ranging from the inferior white and a rare black to several shades of red and pink. The most valuable was the pale pink coral. In 1867, reviewing the award-winning work of the leading London designer Robert Phillips (1810–81), *The Times* noted its versatility:

> Sometimes [coral] is cut into the shape of a flower, sometimes into that of a mask, sometimes it is left in the form of a branch. It is cut into cylinders, into balls, into chains; and all these varying shapes are grouped into masses – coronets, necklaces, bracelets – that call forth the exercise of no small ingenuity and taste.[1]

At the same time, another commentator wrote in relief that the craze for the most naturalistic forms – 'twisted sticks of seeming red sealing-wax' – had already passed.[2]

The fashion for coral seems to have several possible explanations. It can be related to the revival of ancient Italian styles of jewellery, associated particularly with the work of the Castellani family, notable nineteenth-century goldsmiths from Rome. Beyond its antiquarian appeal, coral jewellery also drew on the Victorian interest in decorative naturalism, such as the use of insects, feathers, shells and even whole aquaria for design and display. Here coral as one of nature's beauties possessed an added exotic or even uncanny edge. Victorian popular natural history portrayed coral as a liminal form of life, subject to transformation from animal to mineral. The word 'coral' evoked not just Mediterranean sea and civilizations, but the coral reef islands of the Pacific, whose other-worldly gardens of fantastic shapes and colours had captured the Victorian imagination. As a wonder of nature, coral carried religious significance as well – the tropical coral island came to symbolize evangelical ideas of transformation and renewal through influential works like James Montgomery's *Pelican Island* (1827) and Robert Ballantyne's *Coral Island: A Tale of the Pacific Ocean* (1858). Pulled from under the surface and shaped into an object of personal decoration, then, coral evoked a rich set of ideas. Simultaneously exotic and traditional, the coral ornament appealed equally to the vernacular aesthetic of ancient Greek and Rome and to modern understandings of nature and change.

References

Shirley Bury, *Jewellery 1789–1910: The International Era*, 2 vols (Woodbridge, Suffolk: Antique Collectors Club, 1991).

Margaret Flower, *Victorian Jewellery*, 2nd ed. (New York: Barnes, 1973).

Charlotte Gere and Judy Rudoe, *Jewellery in the Age of Queen Victoria: A Mirror to the World* (London: British Museum Press, 2010).

Susan Weber Soros, '"Under the Great Canopies of Civilization": Castellani Jewelry and Metalwork at International Exhibitions', in Soros and Stefanie Walker, *Castellani and Italian Archaeological Jewelry* (New Haven, London and New York: Yale University Press in association with Bard Graduate Center for Studies in the Decorative Arts, Design, and Culture, 2004), pp. 229–84.

1 *The Times*, 16 September 1867, p. 10.
2 Margaret Flower, *Victorian Jewellery*, 2nd ed. (New York: Barnes, 1973), p. 18.

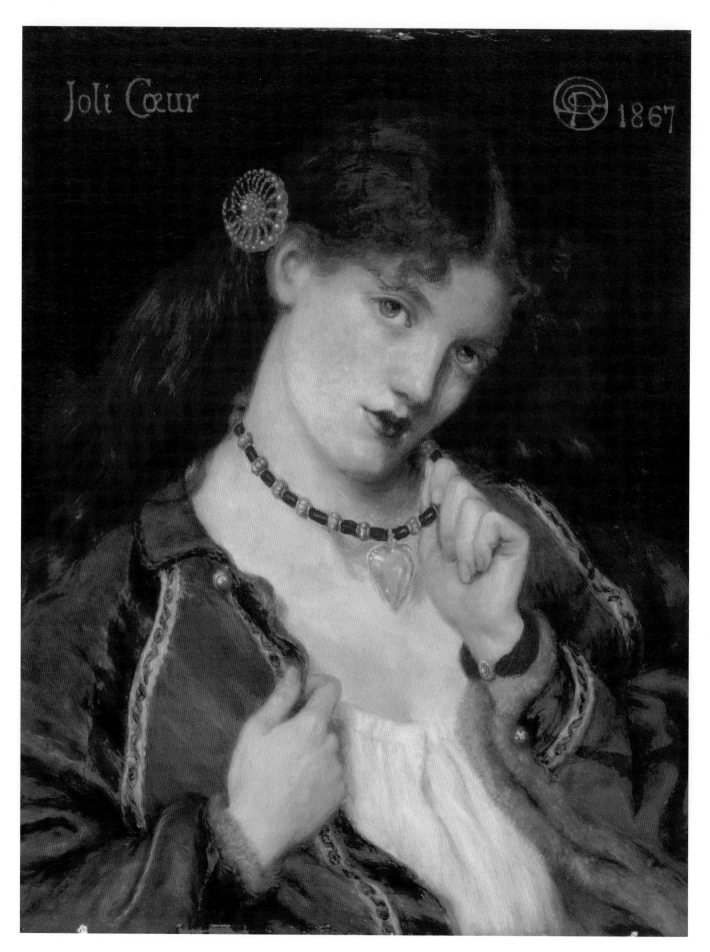

"–Madame, why is it that you prefer this tree of a dubious red, to all the precious stones?

–Monsieur, it suits my complexion. Rubies are too vivid, they make me look pale, while this, somewhat duller, rather more favorably contrasts fairness.

The lady is quite right; the coral and the lady are related. In the coral, as in the lip and the cheek of the lady, it is iron, according to Voyel, which makes the one red and the others roseate.

–But, Madame, these brilliant stones have an incomparable polish, and dazzling lustre.

–Yes, but the coral has something of the softness and even the warmth of the skin. As soon as I put it on, it seems to become a part of myself.

–But Madame, there are much finer reds than that of your coral necklace.

–Doctor, leave me this, I love it. Why? That I know not; or if there is a reason, that which will do as well as any, is that its Eastern and true name is 'the Blood-Flower.'"

Jules Michelet, *The Sea*, 1861

Figure 52: Dante Gabriel Rossetti, *Joli Cœur*, 1867, oil on panel, 38.1 × 30.2 cm. © Manchester City Galleries.

In this Pre-Raphaelite painting, the blood red colour of the jewellery and coral's association with the monstrous Gorgon Medusa make it a suggestive attribute of the seductress, or *femme fatale*.

Figure 53: *Painting a Submarine Scene at First Hand*, cover of *Scientific American*, May 1922. Courtesy NOAA Photo Library.

Figure 54: Illustration of sea anemones, in Wilhelm Rapp, *Ueber die Polypen und die Actinien* (Weimar: Verlag des Großherzogl. Sächs. privileg. Landes-Industrie-Comptoirs, 1829), plate I.

Figure 55: Leopold and Rudolf Blaschka, Glass models of sea anemones, late nineteenth century, Manchester Museum Zoology collection. Photo: Paul Cliff.

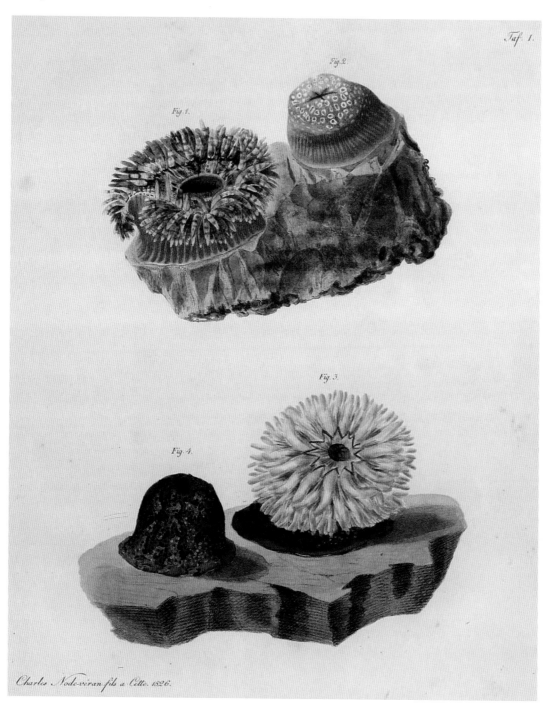

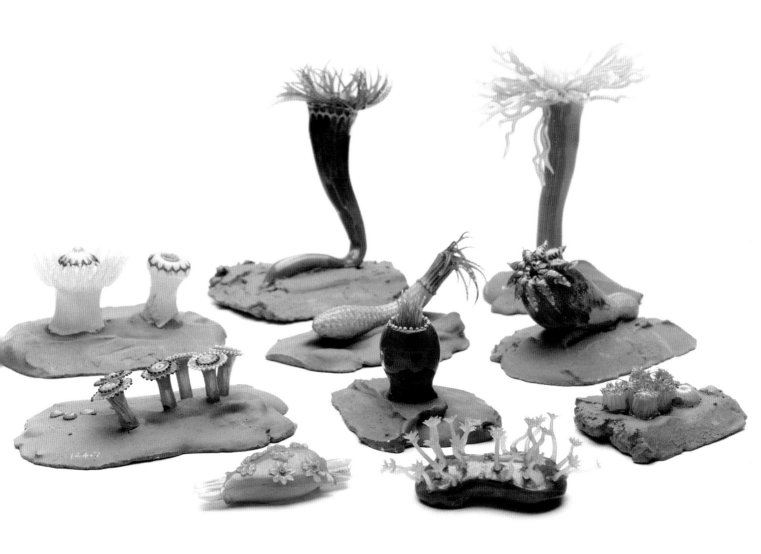

Figure 56: Philip Henry Gosse, Different species of sea anemones, illustration from *Actinologia Britannica: A History of the British Sea-Anemones and Corals* (1860), plate I.

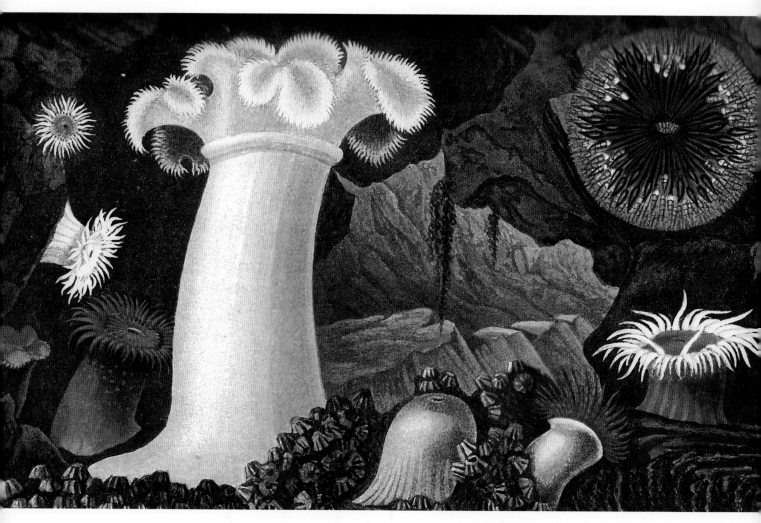

Figure 57: Leopold and Rudolf Blaschka, Glass models of sea anemones, late nineteenth century, Manchester Museum Zoology collection. Photo: Paul Cliff.

The Blaschkas often used natural history illustrations such as Philip Henry Gosse's drawings of sea anemones to make their models more accurate. The white Frilled, or Plumose, Sea Anemone at the centre of the group was almost certainly crafted using Gosse's illustration in fig. 56 as a template. Later on, inspired by Gosse's books and the aquarium craze of the second half of the nineteenth century, the Blaschkas installed an aquarium in their studio.

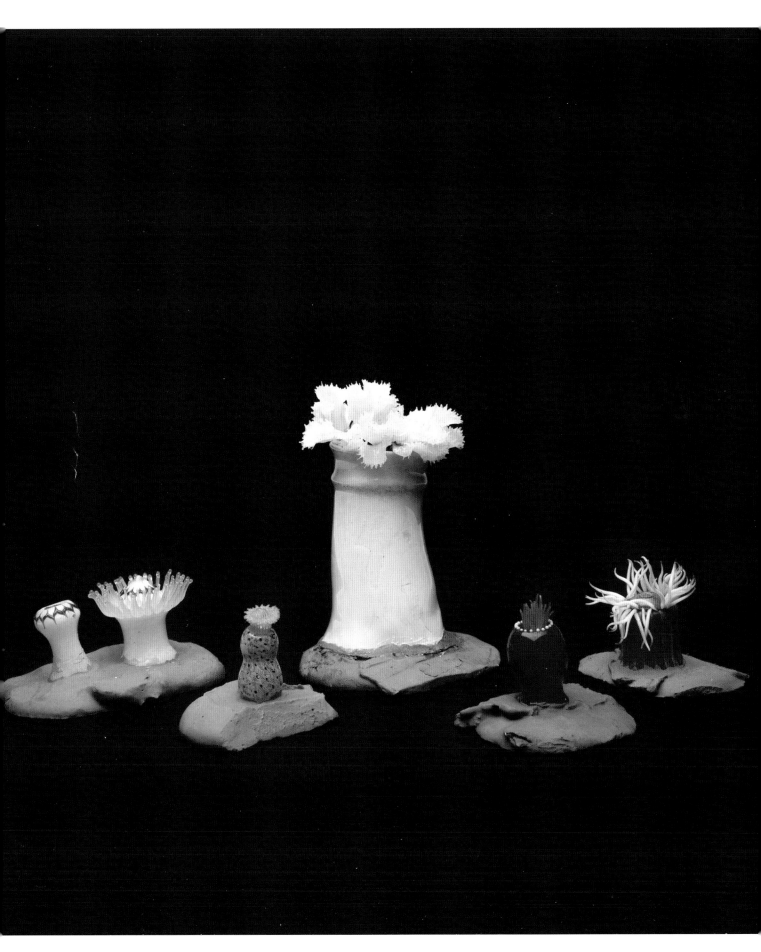

16 The Blaschka glass models of marine invertebrates (*c.* 1860–1890)

Pandora Syperek

The Blaschka glass models of marine invertebrates are disorienting objects. They are uncannily realistic, creating the impression of live aquatic animals in the dry air of the museum. Looking closely, however, one sees their fine craft. They appear like abstract ornaments (made using traditional jewellers' techniques) or delicious confections (the naturalist Philip Henry Gosse wrote extensively about his culinary experiments with sea anemones).[1] The creatures they simulate are perplexing in and of themselves: gelatinous, in between plant and animal, eyeless, with hermaphroditic and asexual reproductive habits. Of transparent delicacy and liquid origin, but also hard and brittle, glass is both intuitive and contradictory. The effect is of the life of the sea frozen forever (though this is an illusion – the models are so fragile they present a conservational nightmare). Glass suggests purity, transparency, the 'naked truth'. However, the models are not just glass: they incorporate painted glazes, fine wires, glue, speckled pigment and grainy powders...[2]

A fair bit of myth encircles the models. Produced by the father and son team Leopold and Rudolf Blaschka, they were made in isolation with methods tracing back to Bohemian glassmaking traditions. The sheer number and range of models combined with the prestige of their patrons is reminiscent of fairytale. One pictures two Geppetto-like figures, producing not wooden boys, but even more fantastic: glass marine creatures, which bring sparkling, eternal life to the notoriously dusty, death-filled shelves of the natural history museum. The models are deemed singular in their manufacture, with Leopold and Rudolf's techniques never passed down for lack of heirs, and an output unparalleled in its volume and intricacy. They are prized at once for their uniqueness and for their amazing reproducibility within the Blaschkas' hands.

Beginning with Leopold's experiments with sea anemone models in the early 1860s, the family business expanding once Rudolf joined in 1876, the Dresden-based glassmakers produced thousands of anemones, jellyfish, snails, starfish, sea cucumbers, crustaceans, siphonophores, squid, octopi, sea slugs, radiolaria and eventually enlarged anatomical dissections. In 1890, the Blaschkas ceased to produce marine invertebrates upon signing an exclusive contract with Harvard University to produce its collection of glass flowers. The original purpose of the marine models is ambiguous – some claim they had an educational function,[3] but they were largely destined to fill in gaps in collections, making up for the difficulty of exhibiting marine invertebrates, whose delicate tissues contract and discolour when exposed

1 Philip Henry Gosse, *A Naturalist's Rambles on the Devonshire Coast* (London: Van Voorst, 1853), p. 152.

2 Chris Meechan and Henri Reiling, 'Leopold and Rudolf Blaschka and Natural History in the Nineteenth Century', in James Peto and Angie Hudson (eds), *Leopold and Rudolf Blaschka* (London: Design Museum, 2002), pp. 21–22.

3 Ruthanna Dyer, 'Learning Through Glass: The Blaschka Marine Models in North American Post Secondary Education', in *Historical Biology*, 20.1 (2008), pp. 29–37.

"All these things which come and go in the troubled atmosphere of sleep, and to which men give the name of dreams, are, in truth, only realities invisible to those who walk about the daylight world. The dream-world is the Aquarium of Night."

Victor Hugo, *The Toilers of the Sea*, 1866

to preserving fluids. At one point the Blaschka models were even intended as decorations for elegant living rooms![4]

The models straddled the aquarium craze of the 1850s and the new biology of the deep sea that developed over the following decades. Over time, the Blaschkas' sources ranged from Philip Henry Gosse, a religious writer of popular guides to ocean life and inventor of the term 'aquarium', to Ernst Haeckel, pioneer of modern marine biology and the major popularizer of Darwinian evolution in the German language. Yet, the models demonstrate the remarkable level of overlap between traditional binaries of religion and science, amateur and professional. The 'beautiful objects' of the sea were fetishized in scientific literature as in art.[5]

Leopold's initial inspiration, so the story goes, came during a sea voyage following the deaths of his first wife and father in 1853. Becalmed for several weeks, he drew jellyfish found in the surrounding waters.[6] This melancholic legend signals the evocative nature of creatures that captured the nineteenth-century imagination. Jules Michelet wrote that 'the noble and beautiful medusas...reveal a sentiment and an undefinable mystery. One would say it is the spirit of the abyss meditating over its secrets.'[7] This enigmatic beauty is at the heart of the glass models' appeal.

References

Philip Henry Gosse, *Life In Its Lower, Intermediate, and Higher Forms: Or, Manifestations of the Divine Wisdom in the Natural History of Animals* (London: Van Voorst, 1857).

Philip Henry Gosse, *A Naturalist's Rambles on the Devonshire Coast* (London: Van Voorst, 1853).

Historical Biology: An International Journal of Paleobiology, 20.1 (2008), Special Issue: Proceedings of the Dublin Blaschka Congress.

Heidi and Hans-Jürgen Koch, *Blaschka: Gläserne Geschöpfe des Meeres* (Hamburg: Dölling & Galitz, 2007).

Jules Michelet, *The Sea* (1861), trans. W.H. Davenport Adams (London: T. Nelson & Sons, 1875).

James Peto and Angie Hudson (eds), *Leopold and Rudolf Blaschka* (London: Design Museum, 2002).

Henri Reiling, 'The Blaschkas' Glass Animal Models: Origins of Design', *Journal of Glass Studies*, 40 (1998), pp. 105–26.

4 *Blaschka Catalogue* (*c.* 1870), enclosed in Leopold Blaschka, Letter to Albert Günther (11 Nov 1875), Natural History Museum archives.

5 Philip Henry Gosse, *Life In Its Lower, Intermediate, and Higher Forms: Or, Manifestations of the Divine Wisdom in the Natural History of Animals* (London: Van Voorst, 1857), p. 89.

6 Meechan and Reiling, 'Leopold and Rudolf Blaschka', p. 13.

7 Jules Michelet, *The Sea* (1861), trans. W.H. Davenport Adams (London: T. Nelson & Sons, 1875), p. 136.

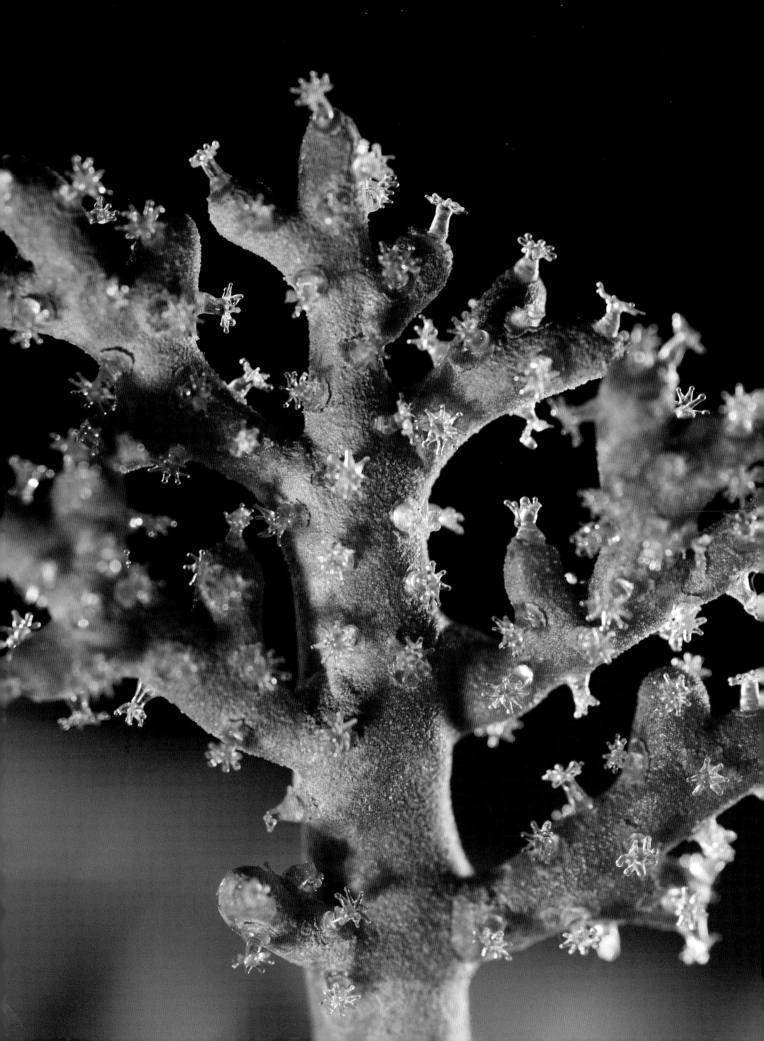

17 The ceaseless seas of magical, miraculous, marvellous coral

Carol Mavor

'Far out at sea the water is as blue as the petals of the loveliest cornflower and as clear as the purest *glass*, but it's very deep, deeper than any anchor line can reach…At the very deepest spot stands the sea king's castle. The walls are made of *coral* and the tall arched windows are of the clearest amber', so begins the magical world of Hans Christian Andersen's 'The Little Mermaid'.[1] Andersen's fairy tale is an enchanted place, inhabited by mermen and mermaids who live for three-hundred years, sing with unearthly beautiful voices, and have their dreams come true, like trading in your fish tail for legs, thanks to the sea witch's magical potion.

The Little Mermaid lives in a sea castle, where the walls are made of coral.

Coral, like the fairy tale itself, is magical.

Changing from animal to stone and vice versa: coral is *possessed* by the magic of animation and so is the fairy tale. Tales by the Brothers Grimm, Lewis Carroll and the 'huge narrative wheel of the *Arabian Nights*'[2] all turn round and round on magic. There is an animation of things. Things talk. Dolls come alive. Humans fly, before aeroplanes: Aladdin on his magic carpet; Peter Pan on his magic dust. Underwater, the Little Mermaid soars through the blue sea, wary of the 'polyps'[3] that might grab her as she flies through the sea witch's forest. Captain Nemo flies through the seven seas in an imagined,

but not-yet invented, magic-carpet submarine named the *Nautilus,* where the ship and its crew encounter *barely imagined beings*:[4] a gigantic sea monster (a narwhal); flowers that turn to stone (coral).

Verne's fantasy story of mermen is science fiction and is not exactly a fairy tale; yet, it is dependent on imagination, on magical thinking. Verne's narrative is akin to a scientific 'hypothesis' (which comes from the Greek, 'to put under' or 'to suppose'). In her *Stranger Magic: Charmed States and the Arabian Nights,* Marina Warner philosophically touches upon the usually opposing poles of the fairy tale and science.[5] On one pole, the magic of the fairy tale propels poetic truths; on the other, science (through its own imaginative enquiry and speculation) propels physical truths. *Imagining science* leads up to *real* technical ingenuity and discovery. For example, Verne's fantasy of the submarine before its invention becomes prophecy.

Verne's sea is a magical place where technicolour coral flourishes under the surreal, fairy-tale, Baudelairish names of the 'Flower of Blood' and the 'Froth of Blood'.[6] These 'living flowers' do not sing songs or dance, but they do perform *real* magical transformations, turning themselves into stone, as if their own tubular, snaky branches held the desire of Narcissus

1 Hans Christian Andersen, 'The Little Mermaid', in *Hans Christian Andersen, Fairy Tales,* trans. Tiina Nunnally, ed. Jackie Wullschläger (New York: Viking, 2005), p. 67. Emphasis is the author's.

2 Marina Warner, *Stranger Magic: Charmed States and the Arabian Nights* (London: Chatto & Windus, 2011), p. 9.

3 Andersen, 'The Little Mermaid', p. 80.

4 See Caspar Henderson's fine book *The Book of Barely Imagined Beings: A 21ˢᵗ Century Bestiary* (London: Granta, 2012). As Henderson writes: 'I woke with the thought that many real animals are stranger than imaginary ones, and it is our knowledge and understanding that are too cramped and fragmentary to accommodate them: we have *barely imagined* them' (p. x).

5 Warner, *Stranger Magic*, p. 23.

6 Jules Verne, *20,000 Leagues Under the Sea* (New York: Sterling, 2006), p. 148.

Figure 58: Leopold and Rudolf Blaschka, Glass model of *Corallium rubrum*, 1879. Photo: Stuart Humphreys. Courtesy Australian Museum – AMS582/MA00777.

and the power of Medusa.[7] As Verne writes (of what must be *Corallium rubrum*): 'I seemed to see the membranous and cylindrical tubes tremble beneath the undulation of the waters. I was tempted to gather their fresh petals, ornamented with delicate tentacles, some just blown, the others budding...But if my hand approached these living flowers, these *animated* sensitive plants, the whole colony took alarm. The white petals re-entered their red cases, the flowers faded as I looked and the bush changed into a block of stony knobs'.[8]

The German father and son model makers, Leopold (1822–95) and Rudolf Blaschka (1857–1939), made glass models of flowers and ocean life for scientific study, including their fiery *Corallium*

rubrum, the colour and texture of Italian oranges, speckled with icy snowflakes (its retractable white polyps; fig. 58). Glass is the favoured material of science (from beakers to Petri dishes to microscopes and telescopes). Likewise, its delicate transparency and fragility (both real and metaphorical) provides much of the enchantment of Charles Perrault's 'Cinderella'.

Turning sand into glass has a fairy-tale quality, akin to coral's ability to metamorphosize into a stony knob and reanimate back into life. Likewise, the story of Cinderella turns on repeated magical transformations: a pumpkin turns into a 'beautiful golden coach'; six live mice become 'a team of six horses' and so on.

Through the mouth of Perrault and the Blaschkas 'glass is dead matter transformed by human labour and by breath',[9] like the miracle of coral out of seaweed under the gaze of Medusa.

Magical coral is particularly *fitting* as a subject to be blown into glass.

7 *Corallium rubrum* was once called *Gorgonia nobilis* in reference to Medusa, the most famous of the gorgons. In Ovid's *Metamorphoses,* her head turns seaweed into coral. 'The fronds which were fresh and still abundant in spongy pith/ absorbed the force of the Gorgon and hardened under her touch', Ovid, *Metamorphoses,* trans. David Raeburn (London: Penguin, 2004), p. 168.

8 Verne, *20,000 Leagues Under the Sea,* p. 148. Emphasis is the author's.

9 Isobel Armstrong, *Victorian Glassworlds: Glass Culture and the Imagination, 1830–1880* (Oxford: Oxford University Press, 2008), p. 207.

Figure 59: *Underwater Landscape of Crespo Island*, detail, illustration from Jules Verne's popular science fiction novel *Twenty Thousand Leagues Under the Sea* (1871).

In the spirit of the Little Mermaid's coral palace, Verne's 'Coral Kingdom' and the Blaschkas' glass *Corallium rubrum*, the folk artist and amateur scientist Edward Leedskalnin made his own real, if landlocked, Coral Castle. The Latvian emigrant (who was obsessed with theories of magnetism) built his castle in Florida between the years of 1923 and 1951, after being spurned by a sixteen-year old girl the night before he was to marry her. He made this castle, where everything consists of huge, massively heavy, pieces of coral (oolitic limestone), in honour of this unnamed girl whom the Latvian referred to always and only as 'Sweet Sixteen'. There is a throne room with a gigantic heart shaped table with benches all around; beds with coral pillows; chairs, including a rocking chair for rocking into fairy-tale sleep; even a coral telescope. With your head on a coral pillow, you can look up to see a coral Mars, a coral Saturn, a single six-pointed Latvian star made of coral and a coral crescent moon held still by monolithic time, so that it never grows full. The castle is walled in but always open to the blue above. The most magical part of the Coral Castle is the mysterious gate that can be easily moved by the touch of a child's finger, even though it weighs nine tons.[10] It feels miraculous.

Leedskalnin worked secretly at night.

How did this tiny, J.M. Barrie-sized man (five feet tall, 100 pounds), single-handedly build his coral Stonehenge? We know that he borrowed a friend's truck, but that hardly solves the mystery. He claimed to have discovered the secret of levitation used when building the pyramids. 'He clearly used his brain to move the coral'.[11] The 'coral of eons ago' becomes a bed of limestone, which in the hands of Leedskalnin become literal beds.[12] In the words of the British art critic, modern painter and poet Adrian Stokes, although in a rather different context, we discover that 'ceaseless seas of experience construct the coral mind'.[13]

Leedskalnin's monolithic castle carries the heft of deathbeds and tombstones, summoning Verne's 'coral cemetery', where Captain Nemo laid to rest the man who died on board the *Nautilus*. A cross of red coral, like 'petrified blood' could be found at the gravesite, where 'the polypi undertake to seal' the 'dead for eternity'.[14] If Verne's tale was a fairy tale and not science fiction, this man, who died on the *Nautilus* and was buried at the bottom of the ocean, might be magically awakened (like Briar-Rose from her brambles and thickets) emerging from his own 100-year sleep, out of the Coral Kingdom's 'real petrified thickets'.[15]

There is perhaps the real point where life rises obscurely from the sleep of a stone, without detaching itself from the rough point of departure.

Jules Verne, 'The Coral Kingdom'

References

Hans Christian Andersen, 'The Little Mermaid', in *Hans Christian Andersen, Fairy Tales,* trans. Tiina Nunnally, ed. Jackie Wullschläger (New York: Viking, 2005).

Isobel Armstrong, *Victorian Glassworlds: Glass Culture and the Imagination, 1830–1880* (Oxford: Oxford University Press, 2008).

Stephen Bann (ed.), *The Coral Mind: Adrian Stokes's Engagement with Architecture, Art History, Criticism, and Psychoanalysis* (University Park: Pennsylvania State University Press, 2007).

Kristin G. Congdon and Kara Kelley Hallmark, *American Folk Art: A Regional Reference* (Santa Barbara, California: ABC-CLIO, 2012).

Caspar Henderson, *The Book of Barely Imagined Beings: A 21st Century Bestiary* (London: Granta, 2012).

Ovid, *Metamorphoses,* trans. David Raeburn (London: Penguin, 2004).

Jules Verne, *20,000 Leagues Under the Sea* (New York: Sterling, 2006).

Marina Warner, *Stranger Magic: Charmed States and the Arabian Nights* (London: Chatto & Windus, 2011).

10 Description of Edward Leedskalnin's Coral Castle (1923–51), which still exists in Florida today, is based on the work of Kristin G. Congdon and Kara Kelley Hallmark, *American Folk Art: A Regional Reference* (Santa Barbara, California: ABC-CLIO, 2012), p. 227.

11 Congdon and Hallmark, *American Folk Art*, p. 228.

12 As Daniel Moore writes in his review of Stephen Bann's *The Coral Mind*: 'Coral is the best symbol for a method of study based on the organic accretion of material which contributes to a flowering whole, the corals of eons ago turn into those beds of limestone that Stokes spends so much time discussing in *The Stones of Rimini*', *The Birmingham Journal of Literature and Language,* 1.2 (2008), p. 59.

13 Adrian Stokes, *Smooth and Rough* (1951), as quoted in Stephen Bann's 'Introduction' to *The Coral Mind:*

Adrian Stokes's Engagement with Architecture, Art History, Criticism, and Psychoanalysis, ed. Bann (University Park: Pennsylvania State University Press, 2007), pp. 1 and 11.

14 Verne, *20,000 Leagues Under the Sea*, p. 150.

15 Verne, *20,000 Leagues Under the Sea*, p. 149.

Figure 60: Leo Stein, Brooch worn by Gertrude Stein in Picasso's portrait of 1906 (fig. 61), *c.* 1900, silver set with coral, 3.8×3 cm.
© The Fitzwilliam Museum, Cambridge.

Figure 61: Pablo Picasso, *Gertrude Stein*, 1906, oil on canvas, 100×81.3 cm. © The Metropolitan Museum of Art, New York; Photo SCALA, Florence; and Succession Picasso/ DACS, London 2013.

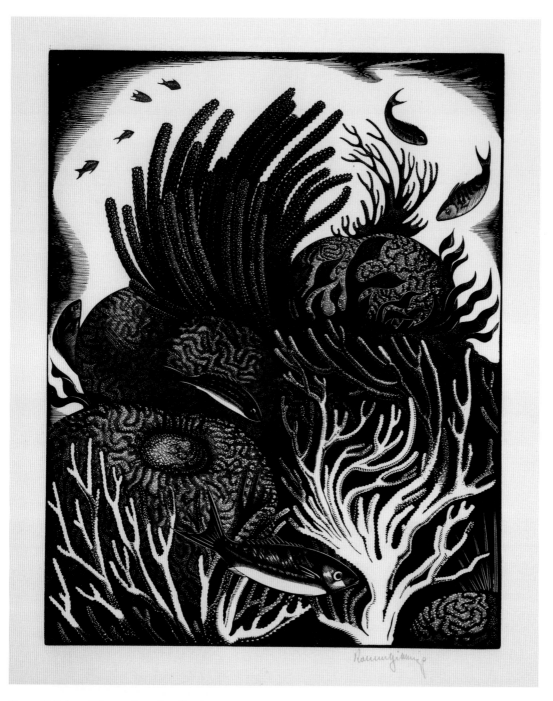

Figure 62: Robert Gibbings, *Ground Swell on the Reef*,
c. 1930, wood engraving, 35.6 × 26.8 cm. Photo: Alan
Seabright. © Manchester City Galleries.

The Irish author and wood-engraver Robert Gibbings
wrote about the coral reefs of Tahiti, Bermuda and the Red
Sea in his book *Blue Angels and Whales: A Record of Personal
Experiences Below and Above Water* (1938). He used special
diving apparatus to sketch the marine life with pencil on
sheets of xylonite under water.

Figure 63: Devonshire cup-corals (*Caryophyllia smithii*,
left) and Scarlet and gold star coral (*Balanophyllia regia*)
and Devonshire cup-corals (*Caryophyllia smithii*, right),
Manchester Museum, Zoology collection. Photo: Paul Cliff.

These golden star, scarlet and Devonshire cup corals are
native to the seas around the British Isles.

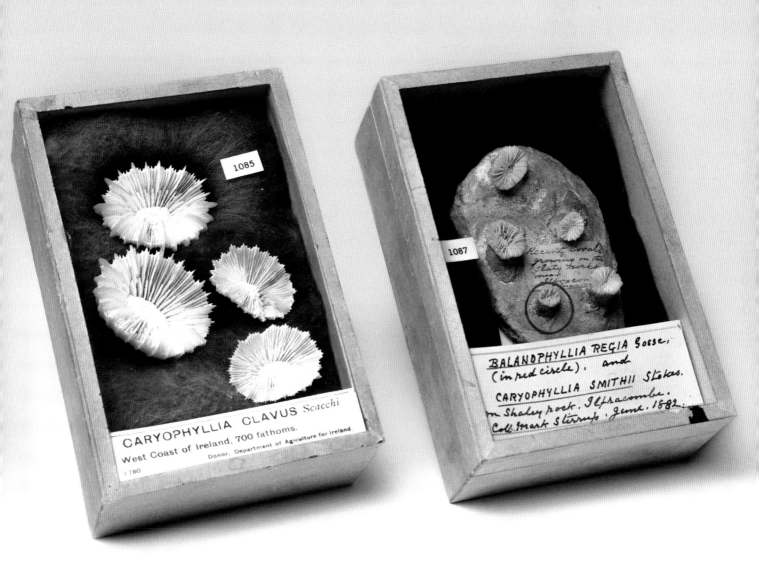

1085

CARYOPHYLLIA CLAVUS Scacchi
West Coast of Ireland, 700 fathoms.
Donor, Department of Agiculture for Ireland.
I 780

1087

BALANOPHYLLIA REGIA Gosse,
(in red circle), and
CARYOPHYLLIA SMITHII Stokes.
on Shaley rock. Ilfracombe.
Coll. Mark Stirrup. June. 1882.

"I want the irrational to be continuously overdetermined, like the structure of coral; it must combine into one single system everything that until now has been systematically excluded by a mode of reason that is still incomplete."

Roger Caillois, *Letter to André Breton*, 1934

18 Eileen Agar, *Coral, Seahorse* (1935)

Patricia Allmer

Coral fulfils a synecdochal function in Eileen Agar's *Coral, Seahorse* (1935). Its ability to 'build new connections across [its] network of branches' and to 'grow into different directions'[1] embodies this artwork's variousness, its multiple challenges to linearity (and lineage), to singularity and hierarchy. In turn this synecdoche connects the work to Surrealist strategies and juxtapositional practices, revealing unexpected new encounters and realities, asserting multiplicities over singularities.

This is already evident in Agar's Surrealist practice of assembling objects found (as she noted) at 'the behest of chance,'[2] such as the marine ones she probably collected during her beachcombings. The coral itself holds the key to the manifold networks of meaning in this work. Previous descriptions of *Coral, Seahorse* identify the various marine objects simply as 'coral'. The work however comprises many different types of coral along with other marine species. On closer inspection these objects subvert the singularity of the word 'coral', linking instead to a proliferating spread of varieties of species and sub-species, and different species altogether; from sea fans and sea anemones, to sponges.

The English names for these marine organisms, such as cup, black, and bubblegum corals, contrast with their Latin names *Antipatharian* (the tall thin tree-like structure left back), *Desmophyllum dianthus* (the small white clusters in the foreground left and mid right), and

Paragorgia arborea (the coral in the upper right corner). These in turn form poetic constellations with the seahorse and the Eye of Horus. The Latin scientific/classificatory names bond and clash with the Egyptian connotations of Horus, pointing to Agar's ongoing interest in palimpsestic representations of cultures, as well as to the breakdown of classifications through the intermingling of the magical with the scientific.

The seahorse itself continues this fanning out of meanings, drawing together distinct realities. It presents a delicate head suggesting a horse, and a rear seemingly stemming from a dolphin evoking the Surrealist concept of the exquisite corpse – a being constructed by chance out of different bodies, an evocation also fostered by its Latin name, *Hippocampus*, which connects the ancient Greek *hippo* (horse) and *kampos* (sea monster), signifying not only the sea creature, but also an anatomical term, referring to a part of the brain.

While the sponges and corals here are cold-water, deep-sea species, occurring in the Atlantic, around the British Isles and in the North Sea, the seahorse would live in warm shallow waters and 'never encounter these corals,'[3] summoning Surrealist notions of what Max Ernst described as '*fortuitous encounter upon a non-suitable plane of two mutually distant realities* (this being a paraphrase of the celebrated Lautréamont quotation, "Beautiful as the chance meeting upon a dissecting table of

1 Marion Endt, *Reopening the Cabinet of Curiosities: Nature and the Marvellous in Surrealism and Contemporary Art*, PhD Dissertation (2008), p. 103.

2 Eileen Agar, *A Look at My Life* (London: Methuen, 1988), p. 140.

3 Dr John Turner, Bangor University, School of Ocean Sciences, email 'Coral query', 5 June 2013.

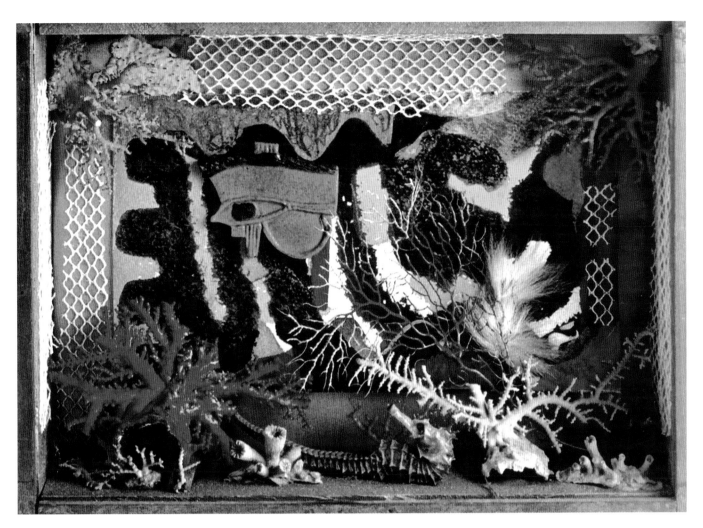

Figure 64: Eileen Agar,
Coral, Seahorse, 1935,
private collection.
Photo: Chris Harrison. ©
The Estate of Eileen Agar.

a sewing-machine with an umbrella")[4]. Such a fortuitous encounter is already implied in the title of the piece, *Coral, Seahorse*.

Finally, coral in this assemblage allows the fortuitous encounter of distant realities to grow still further. It evokes sixteenth- and seventeenth-century cabinets of curiosities adopted by the Surrealists as a strategy of collecting and exhibiting, in which coral was a significant collector's item. In these cabinets, as in Agar's, the artificial and the natural, art, science and mysticism, all co-exist, mixing and mingling in the pursuit of polyhistoric knowledge.

References

Eileen Agar, *A Look at My Life* (London: Methuen, 1988).

Marion Endt, *Reopening the Cabinet of Curiosities: Nature and the Marvellous in Surrealism and Contemporary Art*, unpublished PhD Dissertation (University of Manchester, 2008).

Max Ernst, 'Inspiration to Order', in Max Ernst, *Beyond Painting* (New York: Wittenborn, Schultz, Inc., 1948), pp. 20–25.

4 Max Ernst, 'Inspiration to Order' (1937), *Beyond Painting* (New York: Wittenborn, Schultz, Inc., 1948), p. 21.

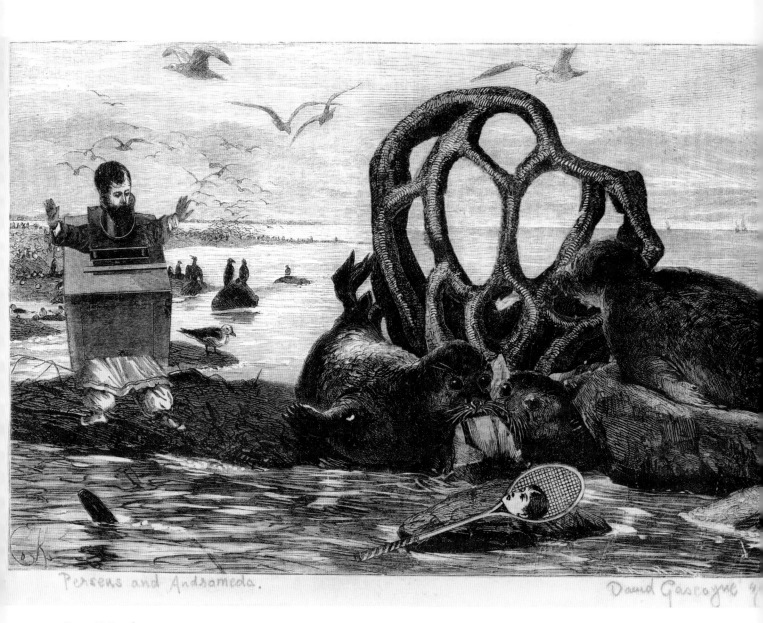

Perseus and Andromeda.

David Gascoyne

Figure 65: David
Gascoyne, *Perseus
and Andromeda*, 1936,
printed papers on paper,
178×248 mm. © Tate,
London 2013 and The
Literary Estate of David
Gascoyne, Enitharmon
Press.

"This dominion of the senses which stretches over all the domains of my mind, residing in a sheaf of light rays within reach, is, I think, fully shared from time to time only by those absolute bouquets formed in the depths by the alcyonaria, the madrepores. Here the inanimate is so close to the animate that the imagination is free to play infinitely with these apparently mineral forms, reproducing their procedure of recognizing a nest, a cluster drawn from a petrifying fountain…Life, in its constant formation and destruction, seems to me never better framed for the human eye than between the hedges of blue titmouses of aragonite and the treasure bridge of Australia's Great Barrier Reef."

André Breton, *Mad Love*, 1937

19 David Gascoyne, *Perseus and Andromeda* (1936)

Donna Roberts

David Gascoyne (1916–2001) was a significant participant in Surrealist activity in England in the 1930s. In 1935 he published *A Short Survey of Surrealism*, the first notable English language study of the movement. Although Gascoyne was primarily a poet, *Perseus and Andromeda* is one of three collages he exhibited at the 1936 International Surrealist Exhibition in London. Influenced by the collage novels of Max Ernst, this collage was made from late Victorian illustrations found in second hand bookstores in London. Gascoyne was attracted to Surrealist collage as a means of uniting the poetic and the pictorial. He also saw it as a creative medium available to everyone, writing in the afore-mentioned publication: 'All that is needed to produce a Surrealist picture is an unshackled imagination and a few materials: paper or cardboard, pencil, scissors, paste, and an illustrated magazine, a catalogue or a newspaper. The marvellous is within everyone's reach.'[1]

The collage takes its title from the Greek myth of Perseus, who, on his return from slaying the snake-headed Gorgon Medusa, encounters the beautiful Andromeda chained to a rock and awaiting her fate in the jaws of the sea monster, Cetus. The sacrifice was ordered by Poseidon in order to punish the hubris of Andromeda's mother, Cassiopeia, for boasting that her daughter was more beautiful than his female cohorts, the Nereids. According to some accounts, Perseus used the decapitated head of Medusa to turn the monster into stone, then placed it on a mound of seaweed as he unchained Andromeda, on the condition that she marry him. In his *Metamorphoses* the Roman poet Ovid tells of how the blood dripping from the Medusa's head caused the seaweed to transform marvellously from soft drab plant into bright red coral. Numerous Old Masters included pieces of coral in their depictions of the myth, including Titian and Giorgio Vasari in their paintings *Perseus and Andromeda* (c. 1555 and 1572 respectively), and Claude Lorrain in his *The Origin of Coral, or, Perseus with the Head of Medusa* (1674).

In the manner of Ernst's collages, Gascoyne reduces the mythical pathos of the scene to a curious, comic melodrama, resonant of the absurdist imagination of his fellow Englishmen,

1 David Gascoyne, *A Short Survey of Surrealism* (Abingdon: Routledge, 1970), p. 106.

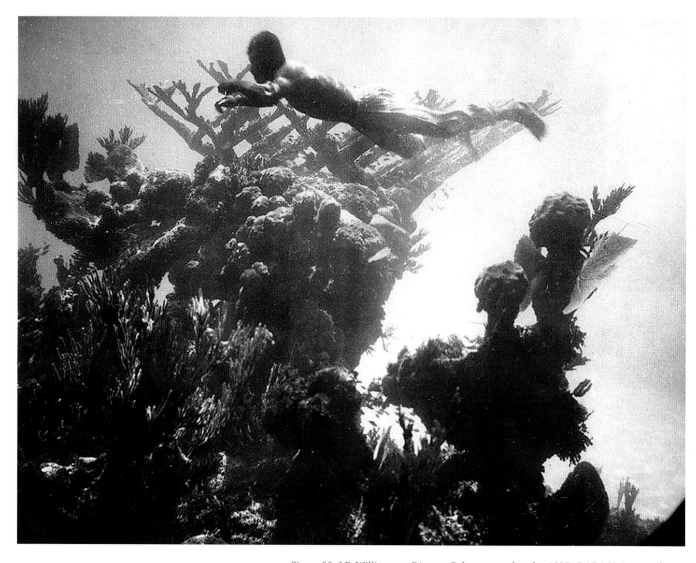

Figure 66: J.E. Williamson, Diver on Bahamas coral reef, *c.* 1935. © ADAGP, Paris and DACS, London 2013.

This photograph is part of a portfolio of eight photographs of crystals, minerals and corals owned by André Breton. The leader of the Surrealist group in France used some of the photographs to illustrate his article 'La beauté sera convulsive' in the journal *Minotaure* (5, 1934). Taped to the back of this photograph is a typewritten note: 'Unexpected vision: a human form within the alluring underwater coralline depths'.

Edward Lear and Lewis Carroll. Perseus appears on the left as a clownish figure bounding over a very un-mythical looking rock pool, encased not in armour but a wooden box. The three nymphs who marvel over the *mirabile* of coral in Vasari's work are here depicted as enormous seals. Above them looms a large coral structure representing the petrified sea monster, and below, the disembodied head and tennis racquet can be seen as a condensed image of Andromeda and the Medusa's head.

The leader of the Surrealist group, André Breton, granted coral a particular significance in his 1937 text, *Mad Love*. Commensurate with the Baroque tradition of natural philosophy, Breton valued coral as a poetic natural phenomenon that blurred the distinction between animate and inanimate.

References

André Breton, *Mad Love*, trans. Mary Ann Caws (Lincoln and London: University of Nebraska Press, 1987).

David Gascoyne, *A Short Survey of Surrealism* (Abingdon: Routledge, 1970).

Werner Spies, *Max Ernst Collages: The Invention of the Surrealist Universe* (London: Thames & Hudson, 1991).

20 Max Ernst, *Antediluvian Landscape* (1967)

David Lomas

Antediluvian Landscape (1967) relates to a series of landscapes of Sedona in Arizona where the Surrealist artist Max Ernst bought a house and took up residence with Dorothea Tanning in 1946. In this later reprise, there is a decided visual ambiguity. Is this an ancient eroded mountainous landscape with deep gullies carved out by water over time as the title implies, or is it not rather a marine seascape? It seems to hover between these two possibilities. The branched and convoluted polyp-like patterns are like a coral reef seen close-up.

This small but exquisite work is an example of Ernst's refined application of the technique of decalcomania, which was introduced to the Surrealist group by Oscar Dominguez in 1936. As described in the *Dictionnaire abrégé du surréalisme* (1938), it consisted of smearing black gouache across shiny white paper. A second sheet is laid over the first, a degree of pressure is applied and then it is lifted off. The shapes and patterns produced by the viscous paint were found to offer surprising chance visual resemblances. Decalcomania was one of several automatic techniques pioneered in that decade that seemed to be less concerned with laying bare the unconscious than with acting as a stimulus to the imagination of the artist or beholder. In this respect, it was similar to Ernst's use of frottage (rubbings obtained by placing a sheet of paper over a variety of textured surfaces) as – he claimed – an aid to his visionary and hallucinatory faculties.

One of Ernst's more elaborate pictures using the decalcomania technique is a work titled *Temptation of Saint Anthony* (1943). It is highly likely that he knew of Gustave Flaubert's novel of the same name that contains a memorable description of Saint Anthony's visions whilst in a state of near delirium. One section in particular evokes a seething profusion of marine life in the ocean where animals 'graze like oxen on coral plains':

> A phosphorescence gleams around the whiskers of seals and the scales of fish. Urchins revolve like wheels, horns of Ammon uncoil like cables, oysters set their hinges creaking, polyps deploy their tentacles, jellyfish resemble balls of quivering crystal, sponges float, anemones spew water; mosses and sea-wrack have spouted.

In Ernst's hands, decalcomania is conducive to a similar kind of 'delirious' visual ambiguity and metamorphic propensity.

Coral speaks to Ernst's longstanding preoccupations with themes of myth and natural history. He frequently made use of encyclopaedia illustrations as source material for collage. A series of frottages was titled *Histoire Naturelle* (1926). The multiplicity of references to the natural world is poetically conveyed by André Breton, the Surrealist leader, in an essay on Ernst where he writes (possibly with decalcomania in mind): 'there clashed and blended together the shapes of the sidereal bestiary, of germination, of mechanical traction, of blossoming crystals.' Ernst's embrace of ambiguity contains an implicit critique of Enlightenment taxonomies where everything is expected to occupy its proper place. Flaubert touches upon this in the same passage as above: 'Vegetable and animal can now no longer be distinguished.

Figure 67: Max Ernst, *Antediluvian Landscape*, 1967, oil on board, 15 × 20.5 cm. Courtesy The University of Edinburgh Art Collection. © ADAGP, Paris and DACS, London 2013.

Figure 68: Brain coral (*Diploria strigosa*), Manchester Museum, Zoology collection. Photo: Paul Cliff.

Brain corals are named for the system of grooves and ridges on their outer surface, which resembles the brain of higher animals. They live in shallow, tropical waters and, if undisturbed, grow very large and old.

Polyparies looking like sycamores have arms on their boughs.' Coral may have appealed to Ernst partly on this account; another factor is the centrality of myth in late Surrealism. Ovid told of how blood spilt from the Gorgon's decapitated head drenched seaweed, which was metamorphosed into stony red coral. *Antediluvian Landscape*, saturated with watery, blood red paint, recalls this gory tale.

References

Gustave Flaubert, *The Temptation of Saint Anthony*, trans. Kitty Mrosovsky (Harmondsworth: Penguin, 1983).

Ovid, *Metamorphoses*, trans. Mary Innes (Harmondsworth: Penguin, 1955).

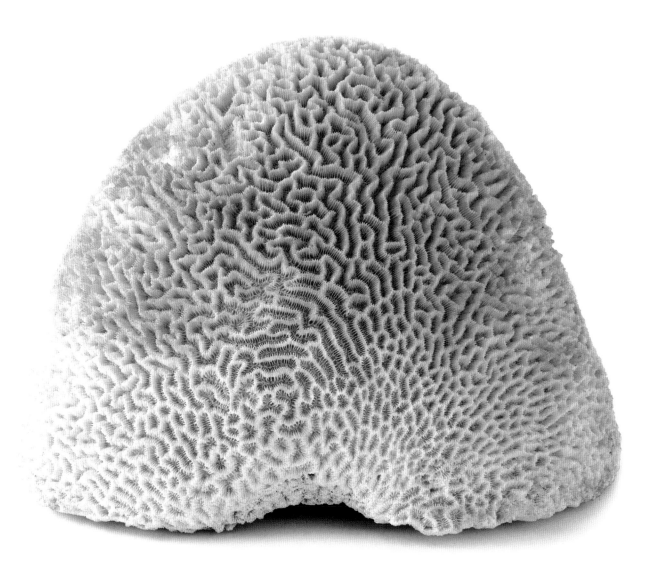

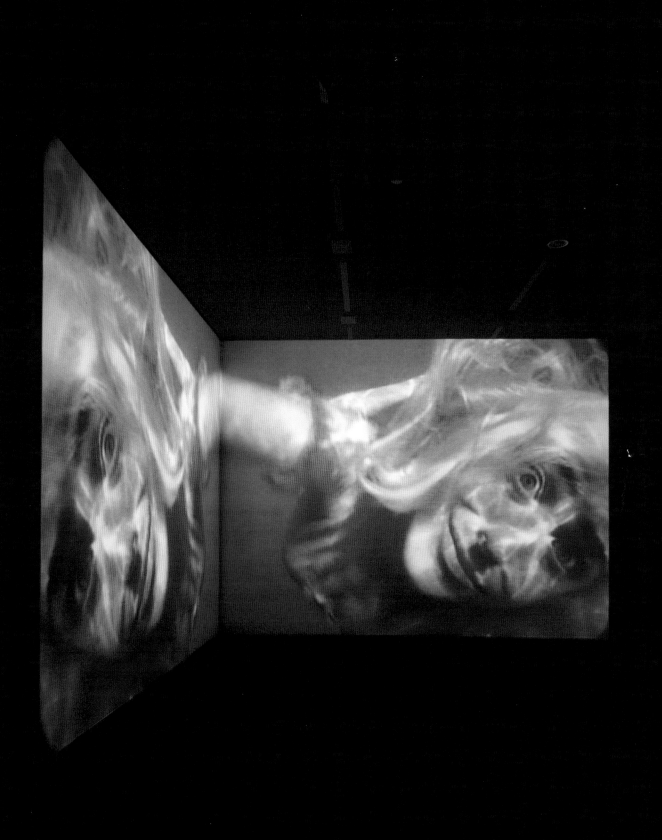

"All men have an indelible mark that reveals their origin in the sea. Just look at their skin with the help of one of those recently invented microscopes, which can enlarge a grain of sand so that it becomes as big as an ostrich egg: you will see how the skin is covered with little scales, just like that of a carp."

Benoît de Maillet, *Telliamed ou Entretiens d'un philosophe Indien avec un missionaire Francois sur la diminution de la mer...*, 1745

21 Pipilotti Rist, *Sip My Ocean* (1996)

David Lomas

Sip My Ocean (1996) is a seminal work in the development of Swiss video artist Pipilotti Rist. The entire film was shot underwater at the Egyptian beach resort of Sharm el Sheikh and includes footage of coral reef interspersed with close-ups of Rist's own bikini-clad body. Projected in duplicate as mirrored reflections on two adjoining walls within an enclosed viewing space, the dwarfed spectator is drawn in to an immersive experience that resonates with the seductive aquatic spectacle on screen.

The artist's body viewed close-up, distorted or fused with its reflected double like Siamese twins, recalls the experiments of Surrealist photographers. André Kertész employed a fairground mirror to produce stretched and distorted anatomies. Less well known is a device invented by the Surrealist Léo Malet for creating images that he claimed reveal a pan-eroticism lurking within the visible world. The apparatus consisted of a mirror that is placed perpendicular to the plane of a randomly selected image. As the mirror is swivelled, the intersection of the image with its reflection creates forms that are suggestively vaginal or phallic. A similar effect obtains at the cusp between the two screens of *Sip My Ocean* where images fuse and separate in a syncopating rhythm in time with the soundtrack. Another Surrealist precedent is a photograph of Jacqueline Lamba, wife of the Surrealist leader André Breton, in an aquarium in 1934. To support her studies, Lamba worked as a dancer at the Coliseum, a nightclub in Pigalle that staged aquatic spectacles. The photograph was published by Breton as one of the illustrations in his book *Mad Love* (1937). Surrealist photography was brought to the attention of a new generation of artists such as Rist by several major exhibitions that have taken place since the mid-1980s.

The philosopher, Gaston Bachelard, in *L'Eau et les rêves* (*Water and Dreams*) (1942) describes the rise of a new cultural imaginary that saw eighteenth-century visions of shipwrecks replaced by a more comforting fantasy of the sea as a nurturing maternal realm. Jules Michelet's *La Mer* (1861) is the epitome of a trend to conflate the sea ('la mer') with the maternal body ('la mère') and to think of seawater as akin to milk or amniotic fluid. Experienced in a darkened, enclosed space, the dreamy, slowed-down imagery and lush colours of *Sip My Ocean* induce a pleasurable satiety that is distinctly regressive in character. Of relevance to the work's effect, Freud described an 'oceanic' feeling that he understood as harking back to an infantile or even prenatal state of the ego. 'Our present ego-feeling is', Freud conjectures, 'a shrunken residue of a much more inclusive – indeed, an all-embracing – feeling which corresponded to a more intimate bond between the ego and the world about it.' *Sip My Ocean* offers this enticement to the beholder. The recent video *Lugenflügel* (*Lobe of the Lung*) (2009) has a sequence in which silhouettes of branching coral in vivid psychedelic hues are superimposed upon Rist's body as it floats across the screen.

References

Gaston Bachelard, *Water and Dreams: An Essay on the Imagination of Matter*, trans. Edith R. Farrell (Dallas, 1994 [1942]).

La Subversion des images: Surréalisme, photographie, film (Paris: Musée national d'art moderne, Centre Georges Pompidou, 2009).

Figure 69: Pipilotti Rist, *Sip My Ocean*, 1996, single-channel video installation, shown using two projectors, with sound, 8 min., edition 3/3, dimensions variable. Courtesy Solomon R. Guggenheim Museum, New York; the artist; Luhring Augustine, New York; and Hauser & Wirth.

22 Mike Nelson, *The Coral Reef* (2000)

Clare O'Dowd

These fragile, complex structures, struggling for a foothold beneath the surface…

Mike Nelson's vast, labyrinthine installation work, which was first displayed at East London's Matt's Gallery, used the idea of the coral reef as a metaphor. Each of the installation's fifteen rooms was meticulously constructed to suggest a different set of characters, drawn from the margins of society: biker gangs, black magicians, conspiracy theorists, drug addicts, Marxist revolutionaries. Their different belief systems and ways of living represented the 'fragile and complex structures' described by Nelson as struggling for existence beneath the oceanic social and economic systems that submerged them.

Carefully chosen objects gave each space a distinct identity. The bric-a-brac was not left there by chance. A worn out sofa, a peculiar picture on the wall, a book, or a strategically placed tear in the wallpaper all furnished viewers with clues. Like amateur detectives, viewers pieced together the story from fragments left by these persons unknown, as Nelson invited us to lose ourselves, in a lost world full of lost people. Suddenly, in the dim light, assailed by musty smells and surrounded by potentially threatening paraphernalia, there was no way of knowing what was real any more.

Walking through *The Coral Reef* is like reading a book: entering a fictional world in which we agree to suspend our disbelief, but in which we ourselves create the narrative. We are aware that we are in a space that has been constructed by someone, an artist, and that it is fake. But those objects are real. Everything in the installation once belonged to someone; each object was made, used, collected, played with, prayed with, communicated through by someone before it ended up here, and each object can tell a story.

The way in which each visitor entering the installation interprets the stories is different, depending on what Nelson describes as each person's own 'ghosts'. It is these ghosts, our own fears, prejudices and beliefs, that inform the way we see the installation, and who we think the characters might be. While it might seem that we are being asked to figure out who *they* are, we are also being asked who we think *we* are. It is our ghosts who really occupy the space.

The Coral Reef suggests that existence is precarious, that the way we see ourselves and others is part of a large and complicated system, and that we are all struggling for a foothold. At any moment, we might sink.

References

Claire Bishop, *Installation Art: A Critical History* (London: Tate, 2005).

Mike Nelson, *Between a Formula and a Code* (London: Koenig Books, 2005).

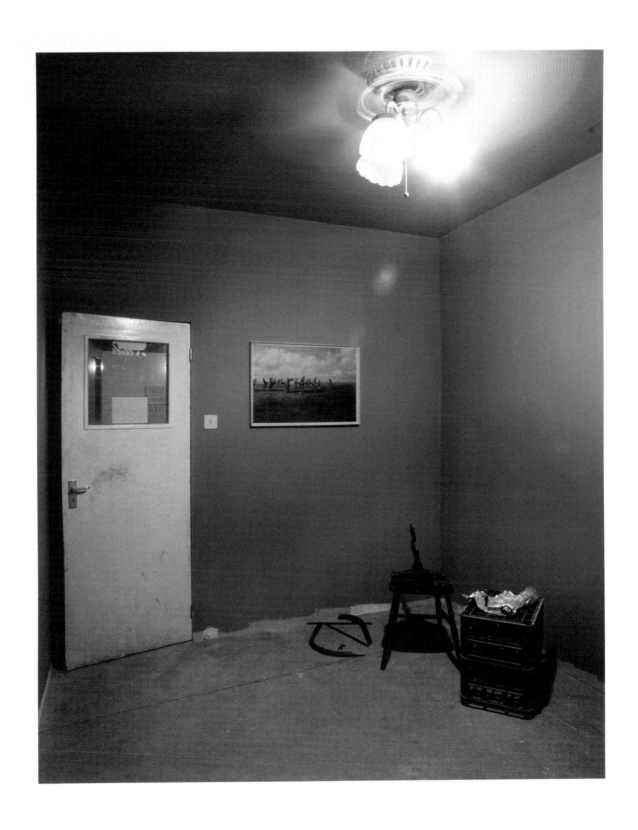

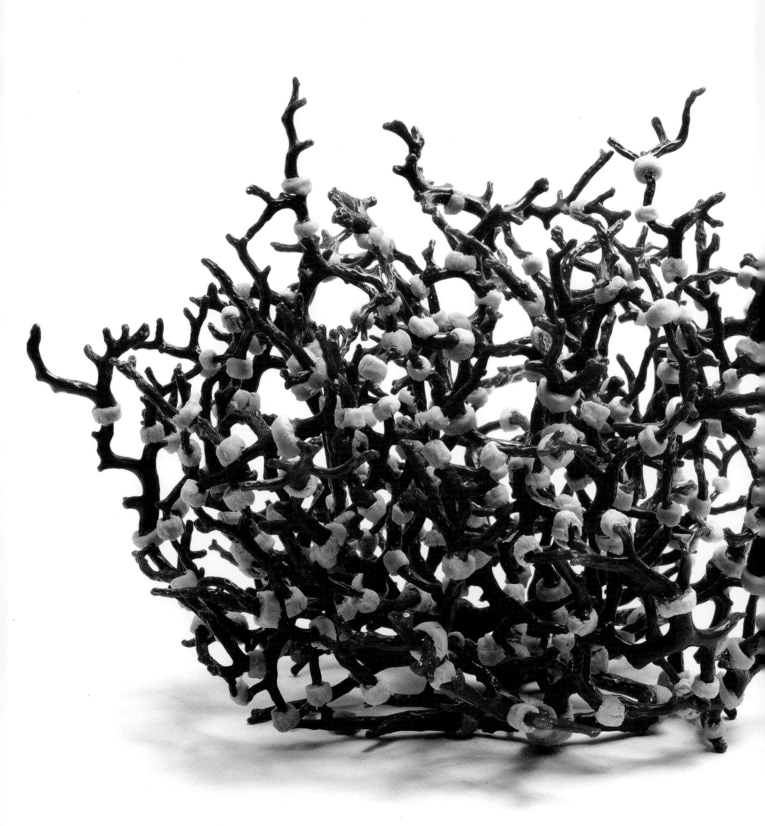

Figure 71: Hubert
Duprat, *Costa Brava Coral*,
1994–1998, coral and
breadcrumbs, average
diameter 25 cm, Frac
Franche-Comté, Besançon.
Photo: Frédéric Delpech. ©
ADAGP, Paris and DACS,
London 2013.

23 Hubert Duprat, *Costa Brava Coral* (1994–1998)

Marion Endt-Jones

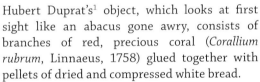

Hubert Duprat's[1] object, which looks at first sight like an abacus gone awry, consists of branches of red, precious coral (*Corallium rubrum*, Linnaeus, 1758) glued together with pellets of dried and compressed white bread.

Duprat, who is perhaps best known for his work with caddis flies (*Trichopterae*, 1980–2011), has been characterized as an artist and sculptor, but his practice also lends itself to comparisons with the naturalist, alchemist, architect, goldsmith and artisan. His interest in concepts of materiality, form, space and trace have placed him – in the eyes of some critics – in proximity to minimalism, while his concern with the relationship between nature and culture has earned him the labels Arte Povera and Land Art.

Collaboration and chance play a major role in the artist's creative process. Rather than creating the object with his own hands, Duprat enlisted the help of skilled expert craftsmen to assemble the pieces into the intricately branching structure, which, in keeping with the *fin-de-siècle* notion of art's superiority over nature, surpasses any coral formation existing in the natural world. Having stumbled upon the coral twigs originating from the Costa Brava at a maker of marquetry and cabinet maker's in Toulouse, he sent them to a coral workshop in Torre del Greco near Naples to have them polished and manufactured into the finished piece.[2] While such an emphasis on coincidence (the quasi-Surrealist chance encounter with the found material), research and collaboration has implications for authorship and authenticity, Duprat's tongue-in-cheek comment, 'If I touch it, I break everything!'[3] also highlights his kinship with the historical figures of the amateur, dilettante and polymath: his encyclopaedic mindset and erudite, larger-than-life library take precedence over concrete spaces of artistic production, such as the studio.[4]

To complicate categorizing the work further,

1 A version of this text first appeared on *Preserved!*, the online archive of the AHRC Research Network *The Cultures of Preservation*, in 2012 (http://www.preservedproject.co.uk/).

2 See Christian Besson, *Hubert Duprat Theatrum: Guide imaginaire des collections* (Paris: Réunion des musées nationaux, 2002), p. 52.

3 Quoted in Frédéric Paul, 'La bibliothèque de l'instituteur: Hubert Durpat, archéologie et macération', *Les Cahiers du Musée national d'art moderne*, 72 (summer 2000), pp. 56–79, here p. 67.

4 'I think that, in a sense, I have a fantasy of totality and maximum density. The desire for an encyclopaedic way of working, for cutting across different fields.' Hubert Duprat, 'Entretien avec Éric Audinet', *Magazine no. 2* (Bordeaux: Galerie Jean-François Dumont, February 1986), sp. For a description of the copious contents of Duprat's library, see Besson, *Hubert Duprat Theatrum*, pp. 5–6, 12–14 and 31, and Paul, 'La bibliothèque de l'instituteur', p 65.

Costa Brava Coral could be described as specimen, art, decorative art, collage or assemblage. It is both natural and artificial (organic materials are transformed by human craftsmanship); it is animal, mineral and vegetable (true to the metamorphic, unsettled and unsettling status of coral); it is one and many (the singularity of the object is challenged by the multitude of the materials and elements it is made of as well as the plurality of coral as a colony of polyps and of bread as a conglomerate of ingredients); it is precious and banal (what is more valuable, we may ask, the costly, endangered coral pieces or the bread, which is a staple of our diet, and how does this relate to consumption and the distribution and depletion of resources?); it is both useless and potentially useful (bread crust plaster, a poultice made from bread crusts soaked in vinegar and mixed with red coral powder, was applied hot to the body to alleviate stomach pain and help keep food down);[5] it is rigid and soft; smooth and rough; polished and porous; it is both surface and interior; voluminous and void; simple and complex; grown and made; alive and dead. Suspended between these binary opposites, and held together by the most brittle and fragile of materials, the object seems to exist in a state of impending collapse.

In light of such an obvious resistance to labelling and classification, Duprat's practice has been situated within a return of certain postmodern artists to the sixteenth- and seventeenth-century epistemic reign of curiosity.[6] *Costa Brava Coral* can certainly be seen as echoing the narcissistic, self-contained nature of the cabinet of curiosities on the one hand and its programme of displaying a totality of knowledge, a microcosmic version of the world through juxtaposition, analogy and affinity on the other. Such a link is also encouraged by its exhibition context at the Musée Gassendi

in Digne-les-Bains, a museum of art, science, natural history, geology and archaeology that has invited collaborative projects from contemporary artists such as Andy Goldsworthy, herman de vries and Mark Dion. In contrast to its sister object at frac Franche-Comté, a 'classic' white-cube museum of contemporary art, at Digne, *Costa Brava Coral* has been displayed in the *Old Masters Gallery (Salle d'art ancien)* alongside historical and religious Baroque paintings. But it would not look entirely out of place in a natural history or anatomy museum either.

What makes the act of tracing historical trajectories so apposite is the object's rhizomatic configuration that can be compared to dendrites, neural networks and resin models of cerebral blood vessels. Our thoughts can either permeate the object and linger in the hollow spaces between its branches, or we can choose to explore its many meandering pathways. But ultimately, although *Costa Brava Coral* is seductive and seems to invite an intimate relationship, it remains elusive, undermining our tendency to read things into it. Rather than us interrogating the object, it is the object interrogating us, opening up gaps in our knowledge and perception and keeping our definitions, descriptions and categories in suspension.

References

Stephen Bann, *Ways Around Modernism* (New York and London: Routledge, 2007).

Christian Besson, *Hubert Duprat Theatrum: Guide imaginaire des collections* (Paris: Réunion des musées nationaux, 2002).

Rudolph E.A. Drey, *Apothecary Jars: Pharmaceutical Pottery and Porcelain in Europe and the East 1150–1850* (London: Faber & Faber, 1978).

Hubert Duprat, 'Entretien avec Éric Audinet', *Magazine no. 2* (Bordeaux: Galerie Jean-François Dumont, February 1986), sp.

Frédéric Paul, 'La bibliothèque de l'instituteur: Hubert Durpat, archéologie et macération', *Les Cahiers du Musée national d'art moderne*, 72 (summer 2000), pp. 56–79.

5 Rudolph E.A. Drey, *Apothecary Jars: Pharmaceutical Pottery and Porcelain in Europe and the East 1150–1850* (London: Faber & Faber, 1978), p. 197.

6 See Stephen Bann, *Ways Around Modernism* (New York and London: Routledge, 2007), pp. 103–72.

24 Mark Dion, *Bone Coral (Phantom Museum)* (2011)

Marion Endt-Jones

The American artist Mark Dion's installations and collaborations with museums, universities and scientific institutions share with Hubert Duprat's works an interest in decoding representations of nature as culturally constructed. Like Captain Nemo, the hero of Jules Verne's science fiction novel *Twenty Thousand Leagues Under the Sea* (first published in English in 1873), Dion and Duprat act as encyclopaedic 'minds rebelling against any manner of imposed culture and social systems.'[1] Following a similar de-classificatory impulse, Gemma Anderson (*Portraits: Patients and Psychiatrists*, 2009–10; *Isomorphology,* 2011–13) and the French artist Laure Tixier (*Siphonophores*, 2002–03) use coral and other polymorphous natural objects in their drawings and watercolours in order to explore questions of taxonomy, analogy and hybrid morphologies.

In recent years, Dion's projects have taken more and more decidedly an oceanographic turn. Thus he organized *Oceanomania*, a major exhibition celebrating the human exploration of and fascination with the sea in collaboration with the Nouveau Musée National de Monaco and the Musée Océanographique de Monaco in 2011, and created *Encrustations*, an installation commemorating the 75th anniversary of the Golden Gate Bridge with his wife, the artist Dana Sherwood in 2012 (*International Orange*, curated by FOR-SITE Foundation at Fort Point,

San Francisco). In 2013 and 2014, he is participating in *Gyre: An Expedition and Exhibition with Marine Debris as Material and Message*, organized by Anchorage Museum, Alaska.

Bone Coral (Phantom Museum) of 2011 is part of a collaborative project based on Jacob Marperger's early eighteenth-century treatise on cabinets of curiosities, *Die geöffnete Raritäten- und Naturalien-Kammer* (1704), a limited re-edition of which Dion produced for Salon Verlag's *Ex Libris* series of artists' books in 2002.[2] The objects on display as part of the *Phantom Museum* cabinet and installation, made from papier-mâché and plastiline, appear as pale simulacra of themselves. Placed at several degrees of remove and abstraction from their early modern existence as natural curiosities – through representation and the systems of knowledge and classification we have applied to them – they have become mere phantoms of themselves.

The fact that the *Phantom Museum* objects originated from engravings which, in turn, started out as actual curiosities, demonstrates Dion's keen interest in materiality and different modes of representation. In contrast to two-dimensional images, museum objects allow for a direct physical encounter and experience in time and space; like sculptures, they tend to present the viewer's perception with concrete 'stumbling blocks' that communicate complex ideas and demand heightened attention. In

1 Cristiano Raimondi, 'Bernard Buffet and Captain Nemo', in Sarina Basta and Raimondi (eds), *Oceanomania: Souvenirs of Mysterious Seas from the Expedition to the Aquarium. A Mark Dion Project* (London: Mack, 2011), pp. 24–35, here p. 26.

2 Gerhard Theewen (ed.), *Mark Dion präsentiert Die geöffnete Raritäten- und Naturalienkammer* (Cologne: Salon Verlag, 2002).

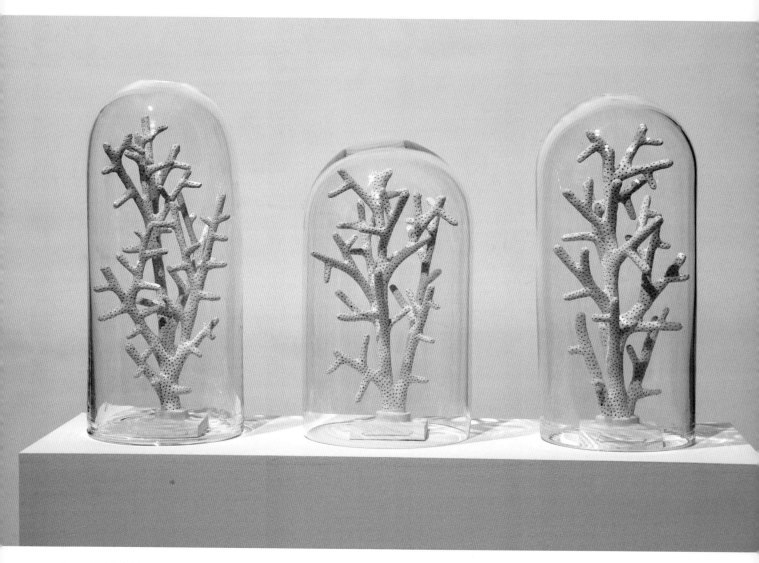

Figure 72: Mark Dion,
*Bone Coral (Phantom
Museum)*, 2011, mixed
media (papier-mâché,
glass, pedestal),
126×101.5×35.5 cm.
Courtesy Georg Kargl Fine
Arts, Vienna.

an interview with the French critic Frédéric Bonnet in 2010, Dion explained this concern with materiality:

> I am very interested in material objects rather than images of objects. For me, an important question is that of the materiality of the work and how it relates to sculpture; when you walk into a museum of natural history, you will encounter physical objects one after the other, not unlike walking through a sculpture park.[3]

This physical and conceptual 'resistance' provided by three-dimensional museum objects takes on a new meaning in view of visitors' contemporary reality of constant overexposure to images – especially virtual images on screens.

Dion and his collaborators' crude, child-like papier-mâché rendering of coral starkly contrasts with the exquisite craftsmanship illustrated by intricate *kunstkammer* objects such as Abraham Jamnitzer's *Daphne* drinking vessel (fig. 7); the coral branches lose their specific status as rarities and invite the viewer's imagination to wander. In contrast to Duprat's *Costa Brava Coral* with its overwrought branching structure that outstrips any formation existing 'in the wild', Dion's *Bone Coral* is perhaps less about a competition between art and nature; instead, the use of a surrogate material seems to convey an environmental message.

The objects' white, bone-like appearance suggests coral specimens affected by bleaching, which occurs when water temperatures rise and cause the colour-giving zooxanthellae to be ejected. Without their photosynthesizing endosymbionts, the corals suffer and begin to resemble ghostly skeletons. Moreover, neatly separated and placed under glass bell jars, the objects seem to suggest that museums can be 'dead and even hostile places.'[4] No amount of scientific study, preservation and protection under time-arresting glass is likely to halt the coral branches' decay, deterioration and decline.

References

Sarina Basta and Cristiano Raimondi (eds), *Oceanomania: Souvenirs of Mysterious Seas from the Expedition to the Aquarium. A Mark Dion Project* (London: Mack, 2011).

Frédéric Bonnet, 'Paroles d'artiste: Mark Dion', *Le Journal des Arts*, 334 (5 November 2010), p. 15.

Lisa G. Corrin, Miwon Kwon and Norman Bryson, *Mark Dion* (London: Phaidon, 1997).

Michael Taussig, *My Cocaine Museum* (Chicago and London: University of Chicago Press, 2004).

3　Frédéric Bonnet, 'Paroles d'artiste: Mark Dion', *Le Journal des Arts*, 334 (5 November 2010), p. 15.

4　Michael Taussig, *My Cocaine Museum* (Chicago and London: University of Chicago Press, 2004), p. xix. Interestingly, in the same passage Taussig describes the Gorgon Medusa, who, using her petrifying powers gave birth to coral, as 'the patron saint of museums'.

25 Ellen Gallagher, *Watery Ecstatic* (2001–present)

Marion Endt-Jones

The African-American artist Ellen Gallagher begun her series of watercolours and cut-paper collages entitled *Watery Ecstatic* in 2001. The works reflect her ongoing preoccupation with the Drexciya myth, which was propagated by the eponymous underground techno band from Detroit in their double album *The Quest* (1997). According to the record sleeve notes, Drexciya refers to an underwater world, not unlike the sunken Atlantis, which is populated by the descendants of pregnant African women who were pushed off, or jumped off, slave ships during the Middle Passage between West Africa and America. The offspring of these women, the sleeve text explains, evolved into a half-human, half-submarine species, living on in the twilight zone of the deep. By reconfiguring this myth and exploring the idea of a Black Atlantis, Gallagher sets out to recover lost souls from the ocean floor, constructing new identities for the estimated eleven million captives who never reached America.

Gallagher's works are multi-dimensional, multi-layered and densely imagined. They frequently contain references to poetry, music, popular culture, natural history and psychoanalysis. Gallagher has linked the starting point of her career to an early interest in marine biology, developed while studying pteropods – tiny marine molluscs, also called 'sea butterflies' and 'sea angels' – on board an oceanographic research vessel off the coast of Massachusetts.[1] Her interest in close observation and scientific illustration eventually translated into her labour-intensive, almost obsessive technique of drawing, painting, cutting and layering on large-scale canvasses. Although the terms 'drawing' and 'painting' are often used to refer to Gallagher's work, her practice suggests a sculptural dimension. It involves cutting and carving into thick and heavy paper, sometimes puncturing it – a technique she has likened to the old seafaring craft of scrimshaw, which was used by whalers and other sailors in the nineteenth century to carve intricate images and patterns into the bones, teeth and tusks of marine mammals. A close reader of Herman Melville's *Moby Dick; or, The Whale* (1851), Gallagher is fascinated by the relationship between scale shifts, obsession and terror: 'For instance in Melville's *Moby Dick* – why were sailors making these obsessive miniature carvings on whaleships in the middle of nowhere looking for this huge monster?'[2]

Gallagher's practice also entails a process of layering paper, plasticine, salt, gold leaf, varnish and paint, creating a palimpsest- or, indeed, reef-like structure that mimics the accretions of history and memory. An example of such a layered relief from the *Watery Ecstatic* series of 2007 shows a sequence of women's heads lining the bottom of the canvas, their hair metamorphosing into different varieties of algae, seaweed and coral (fig. 73). The dreadlocks, curls and Afro hairstyles featured in stereotypical representations of African-American women (alongside other stereotypes, such as the painted faces of minstrel shows, swollen lips, and bulging white eyes, which Gallagher refers

1 Jessica Morgan, 'Ellen Gallagher in Conversation', in Ingvild Goetz and Rainald Schumacher (eds), *The Mystery of Painting* (Munich: Sammlung Goetz, 2002), pp. 92–99, here p. 92.

2 Morgan, 'Ellen Gallagher in Conversation', p. 96.

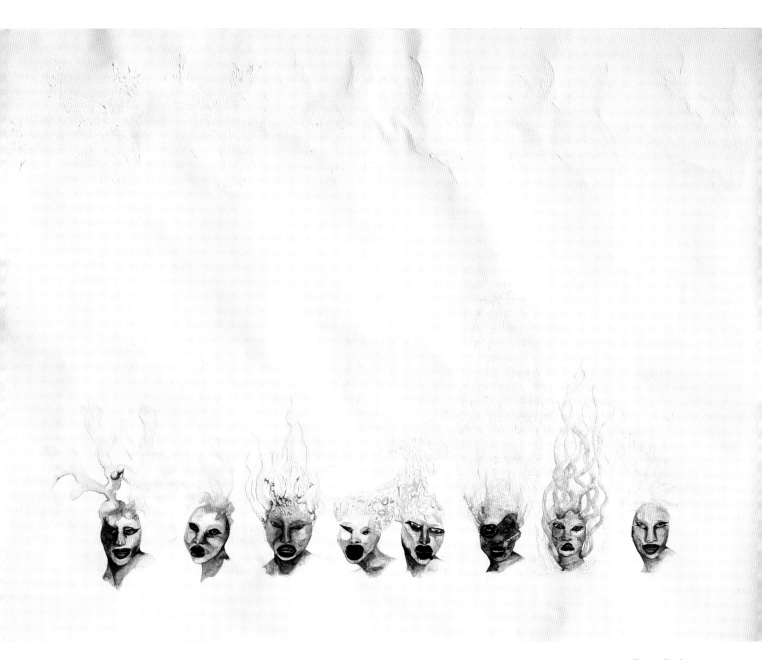

Figure 73: Ellen Gallagher, *Watery Ecstatic*, 2007, ink, watercolour, crushed mica and cut paper on paper, 140 × 190 cm, private collection. Photo: Mike Bruce. Courtesy Hauser & Wirth, Zurich.

Figure 74: Charles Frederick Worth, Design for underwater-themed masquerade ball dress, 1860s, watercolour and pencil drawing. Courtesy V&A, London.

During the 1860s, Empress Eugénie of France threw a number of extravagant masquerade balls which required the guests to wear elaborate and inventive costumes that were made up by Worth and other Paris dressmakers. This design shows an elaborate costume that combines various shells and red and white corals to create an undersea theme. Even the model's stockings are decorated with coral branches and her shoes are trimmed with shells.

to as 'the super signs of race')[3] are recoded into hybrid submarine creatures. As the famous passage from Shakespeare's *The Tempest* – referring to the transformation of the dead King's bones into coral and pearls at the bottom of the sea – suggests, they undergo 'a sea-change / Into something rich and strange' (Act I, scene ii).

Moreover, the mythological origins of coral are layered into the representation with all their ambiguous connotations. The women's snake-like, winding strands of hair are strongly reminiscent of the head of Medusa. While moments of oppression, death and danger are represented by the blood-red colour of coral and the chilling line of shrunken trophy heads, the more hopeful aspects of the myth of both Medusa and Drexciya are captured in the moment of metamorphosis: reminiscent of coral's regenerative capacity, it is a transformation that turns the dead, forgotten and lost women into proud and beautiful protagonists, salvages them from the depths of the ocean and memory, and resurrects and memorializes them with this painstakingly assembled, layered, multi-level, polysemic work.

References

Carol Armstrong, Robin D.G. Kelley, Richard Shiff and Ulrich Wilmes, *Ellen Gallagher: AxME* (London: Tate, 2013).

Paul Gilroy, *The Black Atlantic: Modernity and Double Consciousness* (Cambridge, Mass.: Harvard University Press, 1993).

Amna Malik, 'Patterning Memory: Ellen Gallagher's *Ichthyosaurus* at the Freud Museum', *Wasafiri*, 21.3 (2006), pp. 29–39.

Jessica Morgan, 'Ellen Gallagher in Conversation', in Ingvild Goetz and Rainald Schumacher (eds), *The Mystery of Painting* (Munich: Sammlung Goetz, 2002), pp. 92–99.

3 Morgan, 'Ellen Gallagher in Conversation', p. 98.

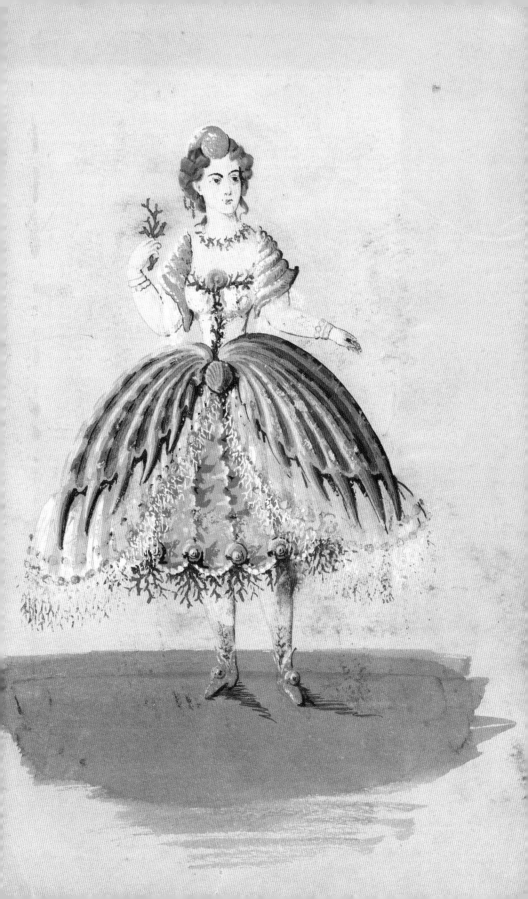

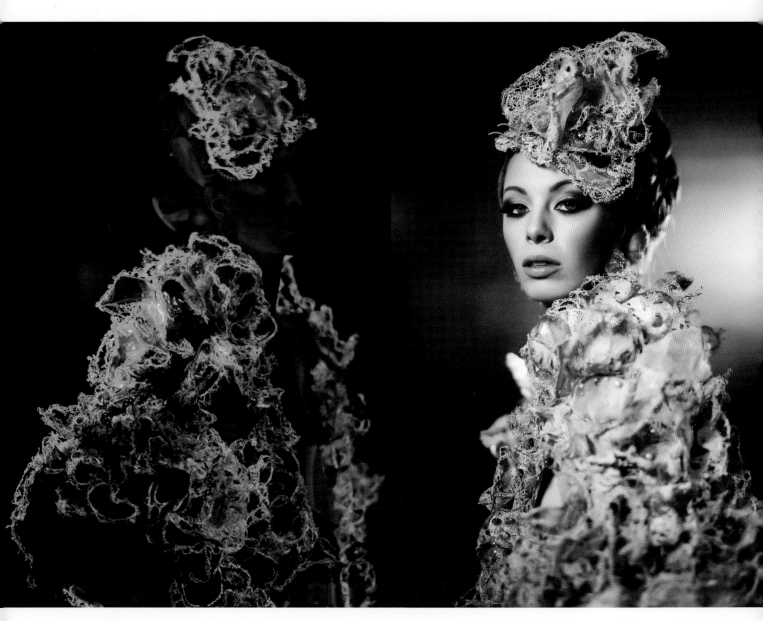

Figure 75: Karen Casper,
*Underwater Love Meets
Primal Futurism (Miss
Coral)*, 2012, mixed
media, day version
(right) and glow-in-
the-dark night version
(left). Photo: Andrew
Farrington.

"In the darkness of an evening, turning the beam of an ultra-violet lamp upon the deep-sea corals, [René L.A.] Catala suddenly reveals an astonishing spectacle. As if touched by the wand of a fairy, all the polyps change colors. The varied and beautiful hues adorning them by daylight vanish, and are replaced by a fairyland of glittering gems which dazzle the observer. Rubies, emeralds, and topaz glow here and there at the tips of the tentacles, around the mouths, along the bodies of the flowering madrepores as their outlines become lost in the deep shadows of the tanks. On discovering such beauties, visitors throng, and scientists take notice, everyone wants to observe and study."

René L.A. Catala, *Carnival Under the Sea*, 1964

26 Karen Casper, *Underwater Love Meets Primal Futurism: Miss Coral* (2012)

Karen Casper

For my textile work *Underwater Love Meets Primal Futurism*, I explored the environmental issues which threaten coral reefs and their habitats caused by pollution, destructive fishing practice, overfishing, careless tourism, and their damaging effects on sea life. Having previously worked for the BBC's Natural History Unit, I was aware of the wonderment and stunning visuals the underwater world has to offer. In addition to research drawn from numerous documentaries, visits were undertaken to the Natural History Museum, Victoria and Albert Museum and Blue Planet Aquarium. Finally, I derived inspiration from fashion designers such as Alexander McQueen and Iris van Herpen.

Using these environmental concerns as inspiration, *Underwater Love Meets Primal Futurism* represents the textures, colours and contours of the underwater world by creating 'preserved textiles'. The ideas are presented as a cape and headpiece: *Miss Coral*. The cape reflects the growth and cultivation of the natural world, using traditional textile techniques and vintage materials combined with contemporary technology to create an ethereal ensemble. *Miss Coral* represents the day colours of certain coral species alongside the glow-in-the-dark night version, created with specialist threads representing the electric creatures of the abyss.

I have recently graduated with a First Class Honours Degree in Contemporary Textiles. My aim is to produce innovative, beautiful and tactile garments and accessories. In a way, the human body becomes what a plinth is for sculpture. Using traditional textile techniques and vintage aesthetics, my practice involves 'injecting' contemporary technology in order to produce exciting, futuristic pieces that ultimately create an art and fashion crossover. As part of my textile label *Tulle and Candyfloss*, my work covers a number of genres: costume, editorials, gallery installations and commercial markets. I thrive when working with a range of mixed media, including embroidery, screen and digital print. The techniques I use range from devoré, quilting and embroidery to fabric manipulation and embellishment in order to create unique contemporary textiles. Wherever possible, I try to incorporate my passion for all things vintage into my work by embellishing with vintage items, whether that be lace, buttons or pearls. For example, *Underwater Love Meets Primal Futurism* incorporates an abundance of vintage lace which, when combined

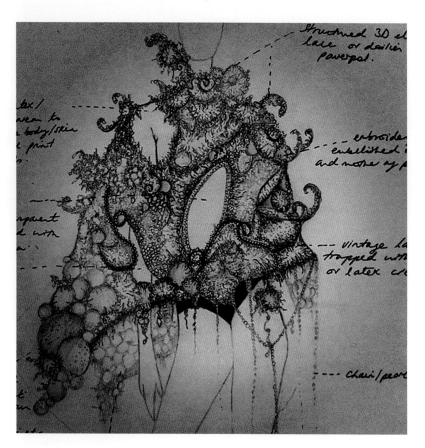

Figure 76: Karen Casper, *Underwater Love Meets Primal Futurism (Miss Coral)*, 2012, fashion illustration of the headpiece.

E. Ransonnet

Selbstverlag v. P

Figure 77: Eugen von Ransonnet-Villez, *Submarine Rocks with Green Corals*, 1867, underwater-lithograph.

The Austrian diplomat, painter, amateur naturalist and explorer made sketches of corals in the Red Sea and around Ceylon, where he had a diving bell made which enabled him to draw under water. The bell, pulled to the sea floor by six cannon balls, had a supply of air from a boat, a porthole and a sitting area. The drawings were published as coloured lithographs in Sketches of the inhabitants, animal life and vegetation in the lowlands and high mountains of Ceylon, as well as of the submarine scenery near the coast, taken in a diving bell (Vienna: Gerold, 1867).

with contemporary techniques, creates a new identity for the redundant historical textile.

Usually, the end design materializes from a chosen theme that I have researched intensively. In tandem with research, experimenting, developing and pushing samples play an important part in the design process. As a result of this creative process, the following techniques were incorporated within the piece: 3D embroidery, latex moulding, digital print, devoré and quilting.

The work has been created for the fashion market primarily. However, given the power and influence fashion has in today's society, it is also a way of highlighting serious global issues.

References

BBC's TV Documentary, *The Blue Planet* (2001).

Anne Deniau, *Love Looks Not With the Eyes: Thirteen Years with Lee Alexander McQueen* (New York: Abrams, 2012).

The Kyoto Costume Institute (ed.), *Fashion: A History from the 18th to the 20th Century*, 2 vols (Cologne: Taschen, 2006).

John Scarlett's Underwater Fine Art Photography (http://www.johnscarlett.com/).

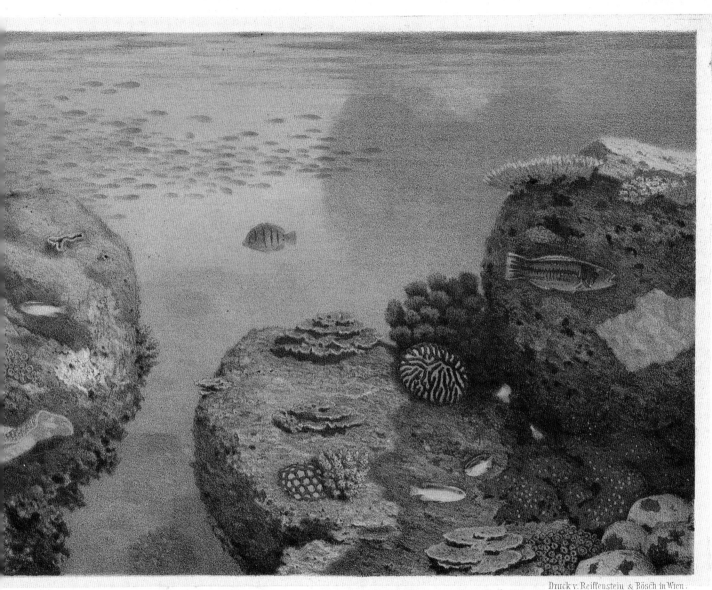

Druck v. Reiffenstein & Rösch in Wien.

EEISCHE FELSEN MIT GRÜNEN KORALLEN. † SUBMARINE ROCKS WITH GREEN CORALS.

ROCHERS SOUSMARINS AVEC DES CORAUX VERTS.

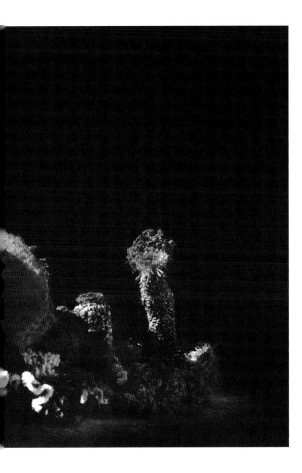

Figure 78: Institute for Figuring's *Crochet Coral Reef* project, 2005–present. Photo © The IFF.

27 The Institute for Figuring's *Hyperbolic Crochet Coral Reef* (2005–present)

Marion Endt-Jones

Figure 79: Institute For Figuring's *Crochet Coral Reef* project, 2005–present. Margaret Wertheim with the Foehr Satellite Reef, Germany. Photo © The IFF.

Threading together different strands of coral's history as symbol of metamorphosis, collective architectural superstructure, store of history and memory, and icon of climate change, the Los Angeles-based Institute for Figuring's *Hyperbolic Crochet Coral Reef* (CCR) seems to illustrate the feminist biologist Donna Haraway's observation that things are '[never] purely themselves', but rather 'compound…made up of combinations of other things coordinated to magnify power, to make something happen, to engage the world, to risk fleshy acts of interpretation.'[1]

A community-based project initiated in 2005 by the Institute's co-directors, the Australian twin sisters Margaret and Christine Wertheim, the CCR reconfigures itself anew – like self-regenerating coral polyps – each time it is exhibited nationally and internationally in scientific institutions or art galleries.[2] Mirroring 'the lively practices of connection and communicative commerce' characteristic of marine invertebrates,[3] the CCR emerges as a collaborative effort crossing the boundaries between several fields and disciplines – a weaving together, or layering, of hyperbolic, non-Euclidian geometry; feminine handicrafts; art; community activism; feminism; marine biology; and environmentalist concerns.

It also highlights the consequences of globalization, termed 'oceanization' by anthropologist Stefan Helmreich in order to prompt 'a reorientation toward the seas as a translocally connecting substance.'[4] Sub-sections of the CCR like the *Bleached* and *Toxic Reefs* draw attention to the effects of pollution and global warming brought about by Western consumer culture. Corals crafted from yarn and plastic become hybrid, post-evolutionary species pointing to the so-called Great Pacific Garbage Patch, a vast agglomeration of plastic waste in the Northeast Pacific Ocean caused by a confluence of currents. Although the toxic gyre is in reality

1 Donna Haraway, *When Species Meet* (Minneapolis: University of Minnesota Press, 2008), p. 250.
2 The CCR was on display at the Hayward Gallery, London; the Science Gallery, Dublin; the Smithsonian's National Museum of Natural History, Washington, and other venues. Licensed satellite reefs started by host institutions and local communities exist in cities all over the world.
3 Donna Haraway, 'Foreword', in Gary A. Olsen and Elizabeth Hirsh (eds), *Women Writing Culture* (Albany: State University of New York Press, 1995), pp. xi–xiii here p. xi.
4 Stefan Helmreich, 'Nature/Culture/Seawater', *American Anthropologist*, 113.1 (2011), pp. 132–44, here p. 137.

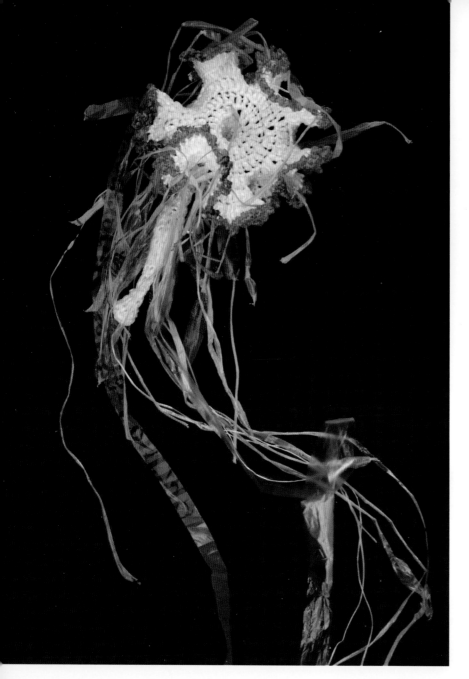

Figure 80: Institute for Figuring's *Crochet Coral Reef* project, 2005–present. Jellyfish made from plastic bin liners by Margaret Wertheim. Photo © The IFF.

difficult to measure, because most of the debris consists of decomposed microplastics, it is often described as covering twice the size of Texas. In an alarming 'binge and purge' cycle, the ocean regurgitates the cast-off commodities of short-sighted mass consumption. Plastics present a lethal danger to a variety of marine organisms: images of strangled sea turtles or disintegrating albatrosses, whose remains reveal more swallowed bottle caps than bones and feathers, are dramatic examples of the damaging effects of plastic pollution. Moreover, microplastics, which are invisible to the naked eye, accumulate in the food chain – from zooplankton through to humans.

The collaborative actions involved in crafting the CCR, which mimic the collective architectural effort of the coral polyps and the

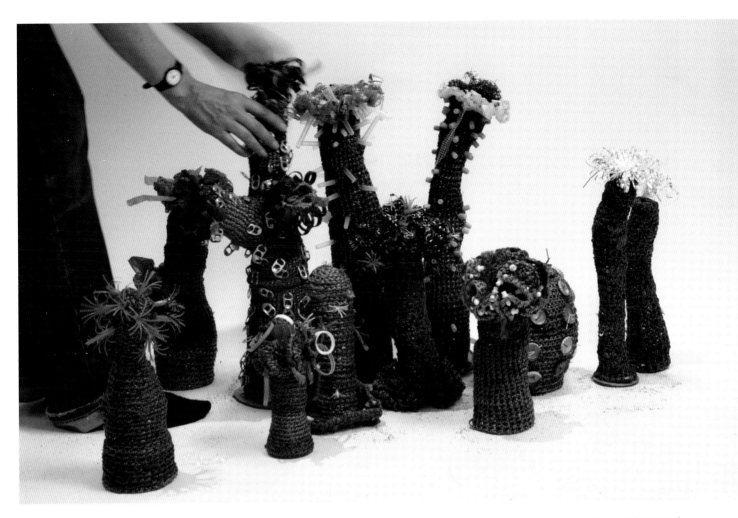

Figure 81: Institute for Figuring's *Crochet Coral Reef* project, 2005–present. Plastic anemones made from New York Times plastic wrappers by Clare O'Callaghan. Photo © The IFF.

multiplicity of relationships between reef dwellers, also seem to provide a remedy for what sociologist Zygmunt Bauman has called 'liquid modernity' – the notion of a rapidly changing, globalized culture that unmoors people from the grounds of politics.[5] Activating *oceanophilia* (a twist on Edward O. Wilson's concept of *biophilia* often used to indicate a deep, innate connection of humans with the sea) and coral's synthesizing qualities, the creators of the CCR propose a communal, cross-disciplinary, environmentalist-activist venture that counters 'the falling apart of effective agencies of collective action.'[6]

5 Zygmunt Bauman, *Liquid Modernity* (Cambridge: Polity, 2000).
6 Bauman, *Liquid Modernity*, p. 14.

References

Zygmunt Bauman, *Liquid Modernity* (Cambridge: Polity, 2000).

Donna Haraway, 'Foreword', in Gary A. Olsen and Elizabeth Hirsh (eds), *Women Writing Culture* (Albany: State University of New York Press, 1995), pp. xi–xiii.

Donna Haraway, *When Species Meet* (Minneapolis: University of Minnesota Press, 2008).

Stefan Helmreich, 'Nature/Culture/Seawater', *American Anthropologist*, 113.1 (2011), pp. 132–44.

Lawrence Weschler, 'The Hyperbolic Crochet Coral Reef', *The Virginia Quarterly Review*, 87.3 (2011), pp. 124–39.

Edward O. Wilson, *Biophilia: The Human Bond with Other Species* (Cambridge, Mass.: Harvard University Press, 1984).

> "The world of coral, which spreads like some fairyland of beauty and color over a great portion of the earth, is dying."
>
> Jacques Cousteau,
> *Life and Death in a Coral Sea*, 1971

Epilogue
Oceanophilia – Oceanocide

Mark Dion

Oceanophilia

1. In 2010 the decade-long Census of Marine Life was completed. It was the first comprehensive look at the past, present and future of life in the sea and resulted in the uncovering of more than 4,800 newly discovered organisms, of which only 1,200 have been fully described.
2. The Census of Marine Life is the world's largest and most ambitious scientific collaboration, bringing together 2,700 scientists from 80 different nations in over 530 expeditions.
3. The oceans make up 99 per cent of the Earth's living space by volume – this is the largest space in the known universe inhabited by living things.
4. The oceans contain 170 times more space for living things than all the land and freshwater habitats combined.
5. An estimated 200 million people make their living directly or indirectly by fishing or other forms of ocean harvesting.
6. About 80 per cent of the world's human population lives within 60 miles of a coast.
7. In the American Atlantic and Gulf of Mexico, sea turtle mortality due to net drowning has been reduced by an estimated 97 per cent since the US government has required shrimp boats to use turtle-saving excluders.

8. In areas where temporary moratoriums and designated off-limits fishing zones have been established, populations of fish and marine wildlife often rebound with surprising vigour and speed. The oceans are remarkably resilient when given a chance to recover.
9. Worldwide aquariums such as the aquarium of the Oceanographic Museum of Monaco and the Wildlife Conservation Society's New York Aquarium have become experts at the propagation of corals. They no longer harvest wild corals and have become coral producers.
10. Numerous aquariums and ocean protection and conservation organizations distribute guides to sustainable seafood. These seafood watch guides identify the best choices for sustainability, good alternatives and what fish to avoid. Using such a guide greatly helps the conservation of marine life.
11. Each year tens of thousands of volunteers work together cleaning the earth's beaches of plastic, discarded fishing nets, and other marine litter, which would otherwise threaten sea life.
12. Over 90 per cent of trade between countries is carried by ships, and half of international communication travels via underwater cables.

Figure 82: Reef scene with fire and mustard hill coral, Florida Keys National Marine Sanctuary, 1990. Photo: Thomas K. Gibson. Courtesy NOAA Photo Library.

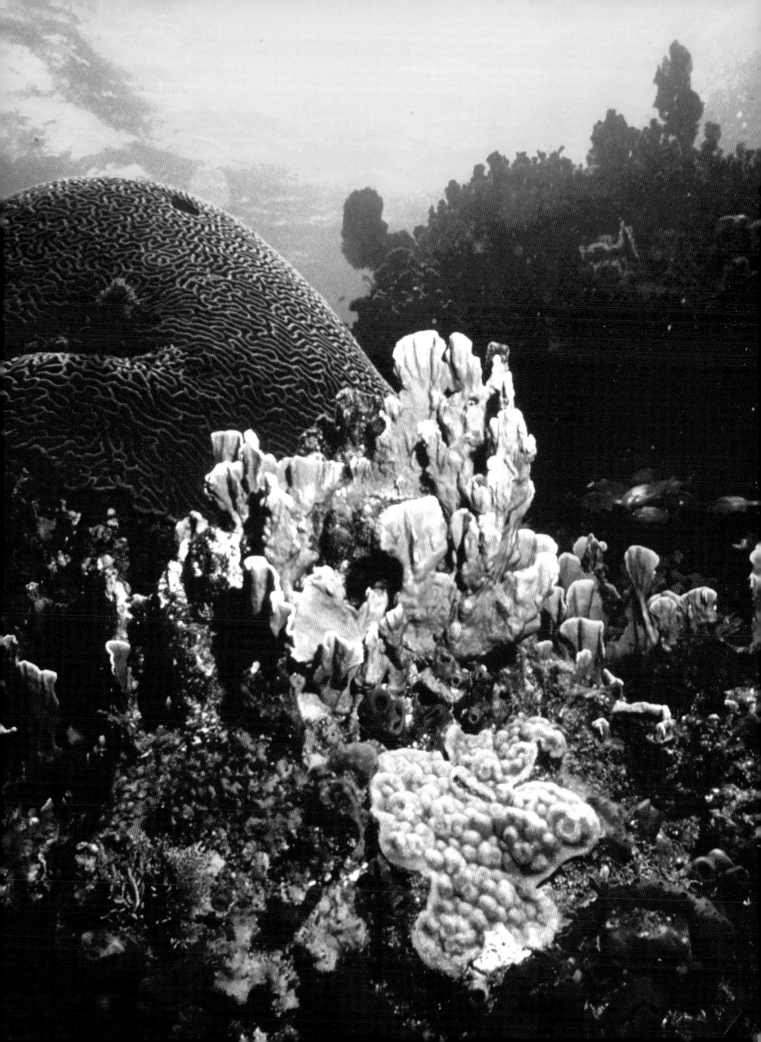

Madrepora

E.Coll. I. 1148. 2
Lucinda Milner
Accn.No.1041

Oceanocide

1. 30 per cent of all marine food fish populations are being killed more quickly than they reproduce.

2. The Food and Agriculture Organization of the United Nations estimates that of the 17 most productive fishery zones four are completely depleted and 13 others are either fished to capacity or overfished.

3. For every kilogram of shrimp netted, up to ten kilograms of other marine organisms are killed and discarded as 'bycatch'.

4. Tropical coral reefs border the coasts of 109 countries, most of which are among the world's least developed. Significant coral degradation has occurred in 93 countries.

5. Coastal development, sedimentation, pernicious fishing practices, climate change, pollution and tourism are the primary causes of coral reef mortality.

6. Almost one-third of the oceans' tropical reefs have vanished since 1980. At this rate all coral reefs could be extinct by the end of this century.

7. It has been estimated that plastic trash is responsible for killing up to one million sea birds, 100,000 marine mammals and countless fish, sea turtles and invertebrates each year.

8. The material most frequently collected in beach clean-up operations is plastic, followed by polystyrene or styrofoam.

9. The Pacific Trash Vortex or gyre is a vast swirling patch of marine litter extending over an area reported to be as large as the continental United States of America. It is primarily comprised of plastics, foams, chemical sludge and other debris.

10. BP's Deepwater Horizon oil spill released 171 million barrels of crude oil into the waters of the Gulf of Mexico between 20 April and 19 September 2010, creating a kill zone of over 210 square kilometers.

11. A single typical offshore oil rig dumps 90,000 tons of toxic material into the sea during the course of its lifetime. There are nearly 600 offshore rigs worldwide in operation today.

12. The greatest threat to life in the sea may be ocean acidification. Since the advent of the Industrial Revolution, ocean acidity has risen 30 per cent.

13. Ocean acidification is the decrease in the sea's pH caused by excessive uptake of man-made carbon dioxide from the atmosphere. The process immediately threatens certain algae, corals, shellfish and numerous other marine life by disrupting the calcification process.

Mark Dion's text first appeared in *Oceanomania: Souvenirs of Mysterious Seas from the Expedition to the Aquarium*. © 2011 MACK and Nouveau Musée National de Monaco.

"We can only sense that in the deep and turbulent recesses of the sea are hidden mysteries far greater than any we have solved."

Rachel Carson, *The Sea Around Us*, 1951

Figure 83: Stony coral (*Madrepora* sp.), Manchester Museum, Zoology collection. Photo: Paul Cliff.

Contributors

Patricia Allmer is a Chancellor's Fellow at the University of Edinburgh. She is the author of *René Magritte: Beyond Painting* (Manchester University Press, 2009), and is co-editor with Donna Roberts of the *Dada/Surrealism* special journal issue '"Wonderful Things": Surrealism and Egypt' (2013). She is the curator of *Angels of Anarchy: Women Artists and Surrealism* (2009), and is currently co-curating with John Sears *Taking Shots: William S. Burroughs and Photography* (The Photographers' Gallery, 2014).

Gemma Anderson was born in Belfast in 1981 and completed an MA in Printmaking at the Royal College of Art, London in 2007. Recent solo exhibitions include *Isomorphology* at Thore Krietmeyer Gallery, Berlin (2013) and *Portraits: Patients and Psychiatrists* at the Freud Museum, London (Wellcome Trust Arts Award, 2010). She is currently undertaking a PhD Studentship at University of the Arts London, and is Leverhulme Artist in Residence at Imperial College London and Visiting Lecturer at University College Falmouth. Her works have been purchased by a number of public collections, including the V&A, the Wellcome Trust, the Natural History Museum and the Arts Council.

Katharine Anderson (York University, Toronto) is a historian of science interested in many aspects of Victorian science and culture, including exploration, hydrography and coral islands. She is the author of *Predicting the Weather: Victorians and the Science of Meteorology* (University of Chicago Press, 2005). Her current research project investigates oceanography in the early twentieth century.

Karen Casper recently graduated with a First Class Honours Degree in Contemporary Textiles. She is currently studying for a Masters in Textiles, while also creating innovative garments and accessories as part of her label *Tulle and Candyfloss*. Karen's work has been commissioned as part of the Whitworth Art Gallery's *Tactile Too* project and selected for the *Lace Effects* exhibition at the Lace and Fashion Museum in Calais, France.

James Delbourgo is Associate Professor of History at Rutgers University, where he co-directs the *Networks of Exchange* project at the Rutgers Center for Historical Analysis. He has written widely on early modern science and empire, and his book on Hans Sloane and the origins of the British Museum is forthcoming with Penguin and Harvard.

Marion Endt-Jones is a British Academy Postdoctoral Fellow in Art History and Visual Studies at the University of Manchester. After completing a PhD on the cabinet of curiosities in Surrealism and contemporary art and museum display in 2009, her research has focused on the cultural history of natural objects (coral, insects, fossils) and the animal in contemporary art, theory and visual culture. *Coral: A Cultural History* is forthcoming with Reaktion Books.

David Gelsthorpe has been Curator of Earth Science collections at Manchester Museum since 1996. He has been passionate about geology since finding fossils on the beach as a child. David undertook his PhD in palaeontology at the University of Leicester where he studied the effects of an extinction event on marine life 430 million years ago. Key themes were sea level and climate change.

Susannah Gibson is an affiliated scholar in the Department of History and Philosophy of Science at the University of Cambridge, having completed a PhD in history of the life sciences there. She is currently researching how scientists define the kingdoms of nature: animal, vegetable and mineral.

Melanie Giles is a Senior Lecturer in Archaeology (University of Manchester). She is a specialist in the Iron Age of northern Europe, particularly aspects of death and burial, Celtic art, material culture and technology. She has also contributed to the *Lindow Man 2008–2009* exhibition and *Ancient Worlds* gallery, Manchester Museum.

Dmitri Logunov is Curator of Arthropods at the Manchester Museum (UK) and an entomologist and professional taxonomist. Dmitri's research interests focus on the taxonomy of the jumping, crab and wolf spiders. He has published more than 170 academic and popular papers and books devoted to spiders and insects.

David Lomas is Professor of Art History at the University of Manchester. He co-directs the Centre for the Study of Surrealism and its Legacies in the UK. His

books on Surrealism include *The Haunted Self* (2000) and *Simulating the Marvellous* (2013). He curated the exhibitions *Subversive Spaces* (2009; with Anna Dezeuze) and *Narcissus Reflected* (2011). A current book project concerns relationships between botany and the erotic in Surrealist and post-Surrealist art.

Professor Carol Mavor (University of Manchester; http://www.carolmavor.co.uk) is the author of four books published by Duke University Press: *Reading Boyishly: Roland Barthes, J.M. Barrie, Jacques Henri Lartigue, Marcel Proust, and D.W. Winnicott* (2007), *Becoming: The Photographs of Clementina, Viscountess, Hawarden* (1999), *Pleasures Taken: Performances of Sexuality and Loss in Victorian Photographs* (1995) and *Black and Blue: The Bruising Passion of Camera Lucida, La Jetée, Sans soleil and Hiroshima mon amour* (2012). Mavor's *Blue Mythologies* was published by Reaktion in 2013. Her essays have appeared in *Cabinet Magazine* and her writing has been reviewed in the *Times Literary Supplement*, the *Los Angeles Times* and *The Village Voice*.

Henry McGhie is Head of Collections and Curator of Zoology, the Manchester Museum. His work combines leading the Museum's curatorial team with student teaching, encouraging research on the collections, developing exhibitions and finding ways to connect people with the Museum's enormous collection. He is passionate about the natural world (especially birds), museums and the power of personal choices.

Clare O'Dowd is a Lecturer in Art History at the University of Manchester. Her research focuses on how art practices relate to the psychological, sociological and spatial experiences of modernity. Her doctoral thesis studied artists' interventions into architectural space, with case studies of Kurt Schwitters, Gordon Matta-Clark, Gregor Schneider and Mike Nelson. Her current research projects examine hoarding as an artistic practice and 'micro' interventions into the urban landscape.

Campbell Price has been the Curator of Egypt and the Sudan at the Manchester Museum since 2011. He received his PhD in Egyptology from the University of Liverpool, where he is an Honorary Research Fellow. Campbell's research interests focus on Pharaonic material culture, and ancient interactions with 'art' objects.

Donna Roberts is an art historian and researcher who has taught in the UK, Finland, Mexico and Switzerland. She has written on numerous aspects of Surrealist art and writing, and is currently completing a book on the subject of Roger Caillois, surrealism and natural history.

Bryan Sitch has worked in museums since the late 1980s and is Deputy Head of Collections and Curator of Archaeology at the Manchester Museum. During his career he has worked with a wide range of archaeological material. He became a Fellow of the Society of Antiquaries (FSA) in 2011.

Alistair Sponsel is Assistant Professor of History at Vanderbilt University. His current research focuses on Charles Darwin's early career and on the history of coral reef science. He managed the US branch of the Darwin Correspondence Project at Harvard University from 2009–12. His book, tentatively titled *Darwin's First Theory*, will be published in 2014 by the University of Chicago Press.

Keith Sugden is Curator of Numismatics at the Manchester Museum, a position he has held since 1987. He is a Fellow of the Society of Antiquaries, an Honorary Fellow of the Royal Numismatic Society, and a prizewinner of the British Numismatic Society. His particular interest is Greek and Roman coins.

Pandora Syperek is completing a PhD in the History of Art at University College London. Funded by the Social Science and Humanities Research Council of Canada, her thesis is titled *Jewels of the Natural History Museum: Gendered Aesthetics in South Kensington c. 1850–1900*. An essay on the Blaschka glass models of marine invertebrates is forthcoming in the anthology *Framing the Ocean, 1700 to the Present: Envisaging the Sea as Social Space* (Ashgate).

Gerhard Theewen founded *Salon*, an artists' magazine, in Cologne in 1977. After graduating from the Kunstakademie Düsseldorf with a degree in Sculpture in 1982, where he studied under Klaus Rinke, he has worked as an artist and teacher, lecturing and writing catalogue contributions and books – among others *Joseph Beuys, Die Vitrinen: Ein Verzeichnis* (1993). In 1995 he founded Salon Verlag, a publishing house specializing in monographs on contemporary art and artists' books.

Stephen Terence Welsh has been Curator of Living Cultures at Manchester Museum, The University of Manchester, since 2006. Prior to this he was Project Curator at the International Slavery Museum, National Museums Liverpool. His research interests are nineteenth-century ethnographic collections, cultural patrimony and the multicultural museum.

Index